Voice in the American West

Andy Wilkinson, Series Editor

Texas Dance Halls

TEXAS DANCE HALLS

■ *A Two-Step Circuit*

Gail Folkins

Photographs by J. Marcus Weekley

Texas Tech University Press

This book is typeset in Monotype Dante. The paper used in this book meets the minimum requirements of ANSI/NISO Z39.48-1992 (R1997). ∞

Designed by Barbara Werden
Typesetting at David Timmons Design

Library of Congress Cataloging-in-Publication Data
Folkins, Gail Louise, 1963–
 Texas dance halls : a two-step circuit / Gail Folkins ; photographs by
J. Marcus Weekley.
 p. cm. — (Voice in the American west)
 Summary: "Blending literary and photo-journalism, history, and
storytelling, essays examine eighteen Texas dance halls in terms of
their music, culture, and community. Also considers the predominantly
Czech and German heritage from which these halls evolved, as well as the
cultural dynamics that enable them to continue as centers of
community"—Provided by publisher.
 ISBN-13: 978-0-89672-603-1 (hardcover : alk. paper)
 ISBN-10: 0-89672-603-7 (hardcover : alk. paper)
 1. Dance halls—Texas. 2. Dance—Social aspects—Texas. 3. Music and
dance—Texas. 4. Czech Americans—Texas. 5. German Americans—Texas.
I. Title.
 GV1624.T4F65 2007
 725'.8609764—dc22
 2006033644

Printed in China
07 08 09 10 11 12 13 14 15 / 9 8 7 6 5 4 3 2 1
FC

Texas Tech University Press
Box 41037
Lubbock, Texas 79409-1037 USA
800.832.4042
ttup@ttu.edu
www.ttup.ttu.edu

To John, for sharing a dance hall life

TOM SEFCIK HALL

GAMES
BILLIARDS
COLD DRINKS

Established in 1923

OPEN EVENINGS 5:00PM TILL ?

254-985-2356

CONTENTS

Preface xi

Introduction xiii

1 Dance Hall Heritage: *Twin Sisters Hall* 3

2 'Til the Cows Come Home: *Swiss Alp Dance Hall* 13

3 War Stories and a Wedding: *Hilltop Hacienda* 25

4 Deer, Friends, and Jars of Fish: *London Hall* 35

5 Where Europe Talks Texan: *KJT, Dubina, and Freyburg Halls* 45

6 Dancing, Boozing, and Horses: *Roundup Hall* 55

7 Still Burning Bright: *Star Hall* 65

8 Spirits of Coupland: *Coupland Dance Hall* 73

9 Weekend Nights, City Lights: *Broken Spoke* 85

10 Behind the Beer Garden: *Saengerrunde Hall* 95

11 Making Texas Music: *Gruene Hall* 105

12 Dancing in the Park with Little Joe y la Familia: *Indian Springs Park* 117

13 If Alice Isn't Happy, Nobody's Happy: *Sefcik Hall* 125

14 Today's Dance Hall Family: *Saengerhalle Dance Hall* 135

15 Sunday Lunch in La Grange: *Round-Up Hall* 147

16 The 57th Juneteenth Celebration: *Wright's Park* 155

17 Uhland Secrets: *Club 21* 165

18 The Fun Everybody Wants to Have: *Luckenbach Dance Hall* 173

Afterword 185

Sources and Further Reading 187

Acknowledgments 189

Index 191

PREFACE

A curious mixture of community center and honky-tonk, the dance hall has been a fixture of back-roads Texas for well over a century. Like the high-school football stadium, or the fairgrounds, or the church, it is both event and venue, both happening and happening-spot. Evoking a larger sense of place, dance halls are a testimony to community, to people and how they live, to their past as well as the shape and texture of their present.

But without soaring spires or light standards or grandstands, the dance hall is more local, more intimate. Tucked away off the main highways, usually outside the town limits, it must be sought out to be known. As with any other garnering of the sense of a place, it requires investigation, the intelligence of the interested observer.

In *Texas Dance Halls: A Two-Step Circuit*, the first volume in the series, we are graced with such information. It is not a history, but rather a piece of the history; neither survey nor review of the literature, but rather an inventory or litany of observations, a first-person reporting. More importantly, it is in the voice of the informed observer, which you will see as Gail Folkins's introduction elegantly situates dance halls within the cultural traditions and history of Texas. Yet at its center, the fullness of this work is in the keenness of Folkins's eye, in the details that interest her and in those that draw J. Marcus Weekley, the photographer whose journey parallels hers.

Here are two compelling new Western voices, rich and concrete, speaking eloquently to shape and texture. And what they've given us, in the dance halls they know, is a contemporary spin across the floors in which the writer leads, the photographer follows, and the reader has only to cut in. In the rhythm and swirl of these images and words, we are but one step removed from the dance.

ANDY WILKINSON
Lubbock, Texas, 2007

INTRODUCTION

Past the front door of Twin Sisters Dance Hall, just outside New Braunfels, the honey-colored floor gleams. The stage in front of us is framed with the same blonde wood. We could just as easily be in the late 1800s when many of these dance halls were built except for the pickups starting to fill the parking lot outside. My husband, John, carries his favorite bass guitar. This hall is a new one for me; I scan the walls and the front stage. I may not be a native Texan, hailing from the mountains near Seattle, but I am a dance hall wife. From my first visit to Gruene Hall with friends in the early 1990s to the gigs that John has taken me to across Texas, I've learned to slide across the dance floor salt and to smell the years buried in woodsy-dust scent.

The floor boards at Twin Sisters creak under our feet. It's so early that few people are here—as with most gigs, musicians are the first to arrive and will be the last to leave. The band members of TC Taylor and 13 Days, along with spouses and a friend or two, help carry black bundles of gear. I lug what I can, usually the electrical cords, the music stand, and sometimes an electric bass in its soft black bag. Long arms out-

Twin Sisters Hall.

stretched to take his bass, John smiles at me from behind his horned-rim glasses, happy that this is his job. As the lights dim, my research starts, too.

Years after my first dance hall visit, I decided to write about the vibrant settings that had become a regular part of my life. I wanted to share the halls not only through my eyes, but also through the individuals I meet at each place who keep dance hall culture strong—hall owners, musicians, patrons, and friends. Interviews with some of my initial contacts and those of my musician-husband soon led to an ever-increasing circle of people eager to talk about their dance hall experiences.

Midway through my work, I invited friend and photographer, J. Marcus Weekley, along for the ride. Before our road trips began, some with John and others on our own, we didn't talk much about photographic style, other than agreeing that the pictures should fall somewhere between artistic and journalistic. After our first road trip, Marcus's photos began to tell stories of their own, showing the halls as meeting places filled with energy. Even the photos without people suggest the liveliness these halls have witnessed throughout the years.

The resulting eighteen essays and images strive for the rhythms and cadences of the dance halls themselves. Focusing variously on single halls or several halls in a specific region, they also chronicle aspects of dance hall life, from church picnics and community gatherings, to ethnic, family, and musical traditions. This book is hardly an exhaustive look at dance halls—there are dozens more across the state. Just the same, the eighteen I write about are fairly representative of the Texas spectrum. They are the dance halls I've come to know, both as the wife of a musician who loves them and as an aficionado on a personal quest for Texas culture. The background that follows on history, music, and culture gives an opening act to this dance hall journey.

Texas Dance Hall History

When TC, John, and the rest of the band start up a Twin Sisters show with a danceable mix of country and rock, I don't mind sitting by myself with my notebook and beer. It rarely stays that way. Terrie, a writer married to the lead guitar player, joins me with her camera. We watch the hall fill with a crowd made up of children, parents, singles, and couples in their seventies. Within the hall's jagged edges and smoothed floor boards, teenagers and the elderly alike find nostalgia that historian Gary Hartman describes as "a few hours' return to a 'simpler' time."

German and Czech immigrants built a number of Texas dance halls in the late nineteenth century as community and cultural centers. The halls served as meeting places where fraternal organizations met to conduct business in support of local farmers, merchants, and other residents. These dance halls also provided an important means of cultural identification for immigrant communities. To ease the transition of their new

lives, immigrants brought aspects of their traditional culture—music and dancing—to an unfamiliar setting. Immigrant parents also used the halls to pass along traditions of music and dancing to their offspring. In this way, the dance halls became an important link in the transmission of ethnic culture from one generation to the next.

The German and Czech immigrant cultures blended through the Texas dance halls. Czech immigrants in the mid-1800s initially integrated into German communities. However, as the number of Czech immigrants grew in the late 1800s, they formed a dance hall network of their own. From the middle to late 1900s, both German and Czech dance halls lost their specific ethnicities and started serving as public venues for all kinds of music. New generations of German and Czech Texans who moved out of the smaller communities into growing urban areas contributed to this regional shift. Another factor contributing to the decreased nationalism of the halls was the fading of European ties among children of immigrants, who were more eager than their parents to integrate into mainstream American culture.

By the 1950s, population movements to faster-growing urban areas, coupled with the growing role of television as family entertainment, meant that many dance halls fell into disuse and disrepair or were used not for music, but to house another American tradition, bingo. As more people migrated to the cities, people who once supported the dance halls found it harder to visit them, and new generations settled for music on CDs, videos, and large concert halls.

Despite these changes, the historical appeal of the halls combined with their use as performance sites helped keep dance hall culture alive. Although most Texas dance halls suffered a decline during the middle part of the twentieth cen-

Locals and tourists meet to dance and hear great music at Gruene Hall.

tury, by the beginning of the twenty-first century, many of them are more popular than ever, hosting a variety of local and nationally known entertainers and, once again, providing a dynamic and vital component for the state's larger musical culture.

At the end of a fast song at Twin Sisters Hall, Terrie returns from the dance floor with a dark-haired man, who now motions to me. The band plays a faster two-step that draws more couples to the floor. I watch the dancers flit and slide. A woman's long skirts wrap around her legs with every spin; it's hard to tell if she belongs to this world or from one years past. I take the bearded man's hand and join the circle of dancers. His fast two-step works my cowboy boots overtime. The rest of the dancers whirl past in flashes of blue jeans and cowboy boots; once in a while, I catch glimpses of the band.

When the music stops, I thank the dark-haired man and find my seat beside Terrie. Couples in the hall laugh together; singles on the sidelines turn their eyes toward the band. They wait for the next song, ready for the music that has filled this and other Texas dance halls for years.

The Role of Music

Before an afternoon show at Gruene Hall, my vocalist friend, Hilary, and I trade stories in the bathroom. She hands me a bright pink lipstick, tugs her sixties-style shirt so it hangs straight over boot-cut jeans, and frowns into the mirror. "My hair's a mess." She pulls a miniature bottle of hair spray from her purse, which has infinite depth, and sprays it onto her bright blonde hair, which is wispy like mine. "I'd better go back out there." She keeps her preshow steps brisk.

We walk into sunshine that sparkles

with dust through the open sides of the dance hall. Hilary hustles toward the rest of the band, who already line up on a low platform at the front of the room, John among them. I grab a seat near the stage area where Craig, Hilary's husband, has stashed some gear bags and CDs. An honorary band member, Craig helps run sound, loads equipment, and cheers on the band. At the back of the hall, he stands, arms folded, waiting to hear the mix. I watch the band leader, Kevin, nod a signal to Hilary, who takes a last sip of water and shimmies closer to the microphone. I lean my elbows on the table. At the tables that surround me, people listen, dance, and laugh, just as they must have years ago.

Migratory patterns and a shifting populace couldn't help but influence the music played in surviving Texas dance halls. Customers responded to a divergent regional sound, and communities once established according to ethnicity were at once broken and reformed. From the traditional polkas and folk music brought over by the German and Czech immigrant cultures, Texas musical styles began to embrace and blend western swing, honky-tonk, Tejano, and rock.

Historically, music is a common catalyst for influence and change. Through differing musical styles shared with neighboring ethnic groups, the boundaries of Texas dance halls soon emerged as permeable and open to fusion. The polka music of German and Czech immigrants, for instance, which is still played in many German and Czech communities of Texas, spilled out of regional dance halls to influence existing musical styles in Texas. One of the best examples of this is the accordion. Brought to Texas by German and Czech immigrants, it was soon incorporated into conjunto, Tejano, zydeco, and other styles of ethnic music in the Southwest.

In the midst of this trading and borrowing of musical styles, Texas dance halls emerged as a cultural crossroads, sparking entirely new forms of creativity distinct to the state. The diverse ethnic makeup of Texas was a vital factor in spurring musical innovations. Rugged terrain and a sometimes unforgiving climate encouraged people of varied ethnicities and social classes to interact more readily, sharing tasks and trading music.

One of the most notable results of this cultural swapping was the birth of several new types of music, including Texas country in the 1920s and western swing in the 1930s. While country music traditions developed throughout the South from English-speaking settlers and European folk traditions, a specialized form of regional country music emerged from multicultural influences in Texas, particularly from the country ballads of cowboys on the range. These Texas country songs and their regional influence soon achieved national popularity, particularly with the advent of radio and film technology, which showcased country artists in the 1920s and the 1930s.

Western swing, with influences that include Mexican-, African-, German-, and Franco-American, emerged during the 1930s by combining elements of jazz, country, and big band sounds. Texas artist Bob Wills, who was heavily influenced by various musical styles, furthered the unique character of this genre. Performing throughout Texas, Wills and other artists such as Milton Brown solidified dance hall culture with a danceable, lively form of country music.

In addition to country and western swing, other types of musical synergies grew up within the regional influence of Texas, including conjunto in the early twentieth century. This musical form, which introduced the German-style accordion into Mexican American

music, had several influential figures, including Santiago Jimenez Sr. and Adolph Hofner. Hofner, along with Ernest Tubb, Lefty Frizzell, Floyd Tillman, and other Texas musicians, also helped pioneer a new style of country music in the 1940s and 1950s that would be known as "honky-tonk."

Between songs at Gruene Hall, I step into an outdoor area filled with picnic tables and oak trees; a warm breeze floats overhead. This summer is a busy one for John, Hilary, and the rest of the Cosmic Dust Devils, taking them to New Braunfels, San Angelo, and places in between. Most of the dance halls they'll visit, which have been used for a hundred years or more, defy their age. Their owners keep them strong through fresh musical acts, which bring in crowds, and varied performance times, which are conducive to singles, parents, and kids alike. I walk back inside the hall and spot two friends, Chris and Suzy. We look for Craig and find seats beside him. The band bursts into a fast number as we sit down; I twist in my seat to watch a couple jitterbugging up a storm. At the end of the song, Craig and I clap extra hard and clear places for the band, along with anyone else who wants to join us. Later on, we'll linger by the screen door while the sun slants lower, hanging out with old friends and making a few new ones.

Today's Dance Hall Culture

At the end of a dance hall night in New Braunfels, John and I drive with Marcus toward Buda, where we're staying with Hilary and Craig.

"Isn't it strange how our jokes get funnier the later it gets?" Marcus asks from the back seat.

I smile and John laughs. Both of us search the dashboard for spare candy—

in the early morning hours, after a night of meeting people and listening to two opening acts and one headliner, everything tastes better, too.

The regional music of the halls is another predictor of their survival. Similar to musicians past, today's performers play a critical role in keeping dance halls relevant and thriving. From the updated western swing sound of Asleep at the Wheel to the Tejano mix of Little Joe y la Familia, bands and singer/songwriters perform a wide variety of Texas music ranging from traditional to cutting edge. And while the music helps keep the dance halls afloat, dance halls serve musicians well by giving them numerous venues in which to play. Along with well-known halls, such as Gruene and Luckenbach, smaller venues have likewise helped launch musicians' careers and kept them employed. Numbering well over one hundred, Texas dance halls thrive in a melding of history, community, and music that remains regionally rooted rather than commercially defined.

After traveling the distance through wildflower-coated hillsides or wicked summer storms, dance hall travelers will find both music and friends waiting. At the start of our dance hall tour, Marcus, John, and I pull into a darkened Buda driveway and find the key that Hilary has left for us outside. I wince as the door creaks. We shuffle as quietly as we can with a laptop computer, two overnight bags, a bass guitar, and camera gear. John and I rest our bags on the floor of a blue-green bedroom; Marcus unfolds blankets on the couch. I check on Marcus and climb into the futon where John already dozes. Sleep comes easy with droning cicada and live oaks making a thousand shadows, tomorrow's dance hall adventures just a night away.

Texas Dance Halls

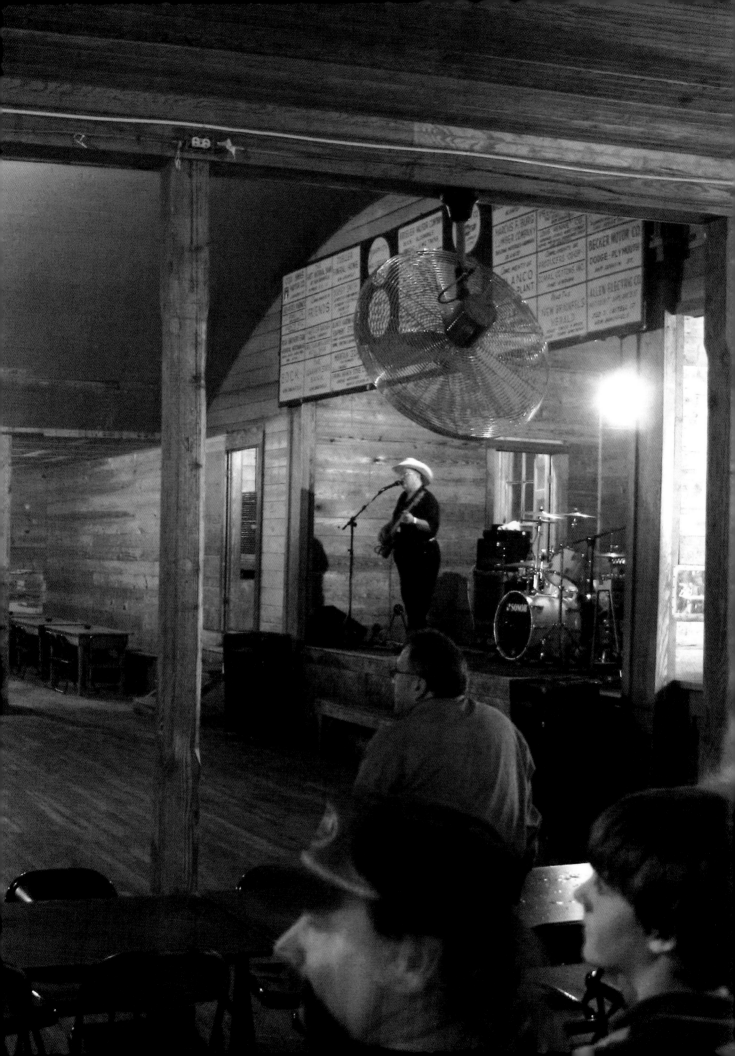

1 DANCE HALL HERITAGE

■ Twin Sisters Hall

The dancers whirled by, their feet sliding as they circled counterclockwise around the hall. While the wood floor vibrated under their collective steps, a four-year-old boy dozed behind the stage, lulled to sleep by the sound of his father performing country music. His father not only sang but also played guitar and fiddle, filling Flag Hall on the outskirts of Temple in Central Texas with danceable sound. He played what's called progressive country, with songs from Pure Prairie League and the Allman Brothers, in the hall managed by his parents. The boy slept on, unaware that not all children grow up in a dance hall with generations of music behind them.

The young boy who slept in Flag Hall, now in his early thirties, prepares to take the stage at Twin Sisters Hall, south of Blanco in the Hill Country of Central Texas. Twin Sisters Hall lies off a rural road that connects small towns in a patchwork rather than rushing by in four-lane vengeance. A faded sign above curling oak limbs announces that the hall, run by the Twin Sisters Dance Hall Club, opens the first Saturday of every month for family dances.

Past a rumbling cattle guard, a dirt road leads through the oaks. Darkness does not reveal much about the hall, which was built around 1870; but inside, hanging bulbs show a wooden dance floor and elevated stage at one end. The floor, in golden panels, is empty now as the musicians make repeated trips with their speakers, amplifiers, instruments, and plastic tubs of wires and cords. Out of this sea of black cable, TC Taylor and 13 Days will soon perform, reinterpreting country music within halls from the past.

TC Taylor's family heritage of dance hall management and performance not only provides one of his first memories but also accounts for the traditional country music he performs today. From the early days in the dance hall his grandparents managed, TC knew he would one day write and perform music.

"I grew up around music. I went and heard my dad on the weekends in the dance halls. It was a great environment to grow up in. It might sound strange, but the dance halls had a real family feel. Everyone went, from old people, to single people, to kids."

Shirley, TC's mom, helped her parents run Flag Hall into the late 1980s. "They worked so hard at it," Shirley

Usually it takes a little while for people to warm-up and start dancing. First, a couple braves it alone. Others join in. Pretty soon, the whole dance floor is full, and it's elbow room only. Members of Bimbo and the Borderline perform for the crowd.

says. "To a certain extent, you had to love doing it." Most of the time, Shirley helped her mom in the restaurant, cooking hot dogs and hamburgers. When she grew tired, her mom and dad covered her with a quilt and let her sleep in a storeroom where the hall kept its beer. The room had a full-length mirror, where girls would go to preen before they went back out on the dance floor. Shirley would lie there, watching them check themselves in the mirror.

Terry, TC's dad, started playing music in seventh grade at high schools and teen clubs. Along with Edwin Pechal, President of Star Hall in Temple, he formed a dance hall band. "We started playing in the dance halls all the time," Terry says. They played songs from Conway Twitty, Mickey Gilley, and the Eagles. On good nights, their audience ranged from seventy-five to a hundred.

When they were first married, Shirley and Terry helped Shirley's parents run the hall, cooking hamburgers and serving beer to thirsty dancers. At home, Shirley influenced their three children with the music she played around the house—artists that included Merle Haggard and James Brown. The

couple didn't wait long to bring their kids to the halls where Terry performed, communities like Temple, Caldwell, Walburg, Boerne, and Nelson City.

Today, when not stopping by with Shirley to catch one of his son's performances, Terry is still apt to be playing onstage at an area wedding or fundraiser. "It's a relief valve," he says. "Everything else can be going badly, but playing in front of a crowd is a good feeling that makes you forget your other troubles."

At Twin Sisters, car lights fill the windows and announce that the dancers are arriving. Wearing their jeans with boots and shoes designed to slide, they sit at tables that line the dance floor, claiming their spaces and awaiting the music that begins a well-deserved Saturday night out. Similar to the crowds of TC's memory, the age of the dancers varies. Parents with children fill the entryway along with young and middle-aged couples. Groups of teenagers spill in, either singly or in small groups. Humid air traps the musty smell of memory in the hall as it fills.

TC laughs at a childhood memory of playing around beer cans one night and smelling of swill afterwards. Beer is available at Twin Sisters Hall, for $2. One beer brand is misspelled on an overhead sign. Patrons in search of variety can also sample an "ice cup," a plastic cup of ice, for 25 cents or an "ice tub" for 75 cents. Toker Jones, who tends the bar at the Saturday night dances, stocks the merchandise behind the counter and waits on customers.

After changing into their vintage-country stage attire, band members step on to the stage. The elevated platform, trimmed in wood molding, frames TC's height and off-white straw hat. Dark hair waving behind him, TC smiles at his band, and on some unspoken cue, they break into the first song of the night, a Bobby Helms number called "Fraulein."

Riders from the annual Hill Country Trail Ride enjoy Cowboy Stew and a dance.

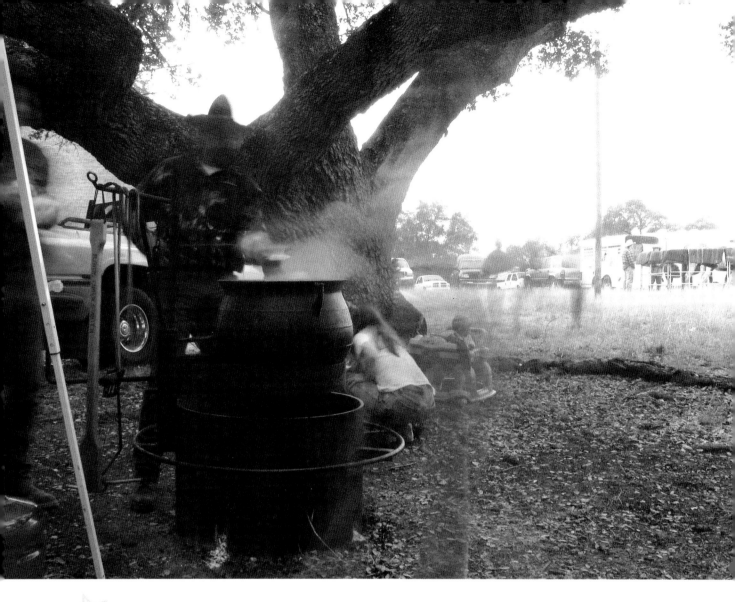

A dozen couples drift onto the dance floor, stepping with the quick-quick-slow rhythm that is the Texas two-step. Several parents teach their teenagers to dance, and a young couple pretzels one another into yoga twists that end in laughter. A woman teaching a man to dance stays near the center of the counterclockwise circle, a safety zone from the more experienced and fast-paced dancers who line the perimeter. When the song ends, TC praises the dancers; one table whoops their approval.

Before the next song starts, TC looks over the crowd, prepping them for what's to come with a hand across the guitar strings. Couples wait in expectation as he leans into the microphone.

"Here's a song from our new CD, a number you can two-step to."

Some in the crowd may not have heard the song, "She's in the Bedroom Crying," but they know the dance and respond to TC's prompt by refilling the floor with denim, soft-colored shirts, and boots dusted with dance floor salt. TC says his songs are not necessarily autobiographical but are compiled from events that have happened to him or others. The country themes he selects include love stories, bar stories, and regional Texas themes, like the old dance halls that are his second home.

"After I moved back from Nashville, a lot of the dance halls had been closed down or turned into bingo halls. A few

of the real historic ones have survived, and I hope those will last . . . places like Twin Sisters Hall and Gruene Hall. The new CD is a way of keeping them alive."

In his early twenties, following musical success at home in the outskirts of San Antonio, TC made a pilgrimage to Tennessee, home of many a musician's dreams. Although it was difficult for TC to leave Central Texas, it was in the country music headquarters of Nashville where he not only honed his performance but learned to write songs. "I went to Nashville looking for stars. Instead, it humbled me. The time I spent there was my college of songwriting. I learned the basics, got the feel of it, and also learned that simplicity in songwriting is best."

It was also in Nashville that TC met Carol, his future wife. After several years in Tennessee, TC made the decision to take Carol and his budding career back home to the Texas Hill Country. "I was worried she wouldn't like it here, but luckily she did." TC gained a Texas song publishing deal, making it easier to walk away from Nashville. The singer also knew that Texas, with its many dance halls and honky-tonks, would provide more live performance opportunities than Nashville.

Back in Texas, TC formed a band called 13 Days and recorded his first CD, *Putting the Western Back in Country,* in 1999. The band's name refers to the thirteen-day siege on the Alamo. In its early days, the group consisted of TC on vocals, Kyle Mathis on lead guitar, and Preston Buchannan on bass. The lineup today consists of Dale Birch on lead guitar, my husband, John Koehler on bass, and Doug Baum on drums. In describing their music, TC calls it Texas style.

"Texas music is unlike music anywhere else. It comes from Americana music and also from the Austin music scene that came up during the seventies. In a time of computer processing, many musicians have forgotten about the roots of music. It's easy to make everything

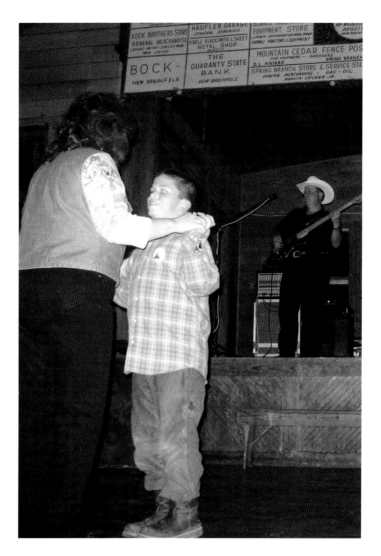

Dancing with grandmother. Kids of varying ages play on the dance floor before and even after the band starts up.

sound perfect, but people don't identify with a computer; they identify with people and performance. This is what we want to recapture."

TC's country sound from the past mingles with the present, melding music and dance hall with a sense of renewal. It's this mix of old and new that TC hopes to expand throughout Central Texas dance halls and beyond, giving his audience an updated version of traditional country music. This down-to-earth style fits within the historic dance halls in which TC performs, lending itself easily to dances like the two-step, shuffle, or waltz.

"Sometimes people need a break from technology in their lives. Whenever

Children are also a part of the Twin Sisters scene on weekend nights. At several of the halls, parents still bring their kids to participate in the lively atmosphere of music and community.

I have a few hours of downtime, I sit and listen to a Bob Wills track, and it brings me back to a time before cell phones and television."

Cell phones are not in evidence as fifty couples make the circuitous route along the worn dance floor. As the band slips into a shuffle number, a woman with a black skirt, bolero hat with silver trim, and gray-fringed cowboy boots joins the dance hall circle carrying a three-year-old girl with straw-colored hair. The woman, gliding in perfect time with the rest of the couples, circles the dance floor with her young daughter. Patrons on the sidelines smile as she passes them.

The next song, a fast number,

encourages a more experienced couple to kick their feet outward in a polka rhythm. They look as if they've danced together for years and won't be stopping anytime soon. As they dance, the woman's red polka-dot dress flits around her ankles, and the man's hat sits motionless despite the action of his feet.

Kyle and John go beyond their instrumental duties and harmonize with Tim, while drummer Phil, who is filling in for Doug, keeps a steady pace for both band and dancers.

During the first set break, TC climbs down the stairs from the stage with the rest of the band. Kyle, John, and Phil adjust their instruments before they gravitate to the table where I and the

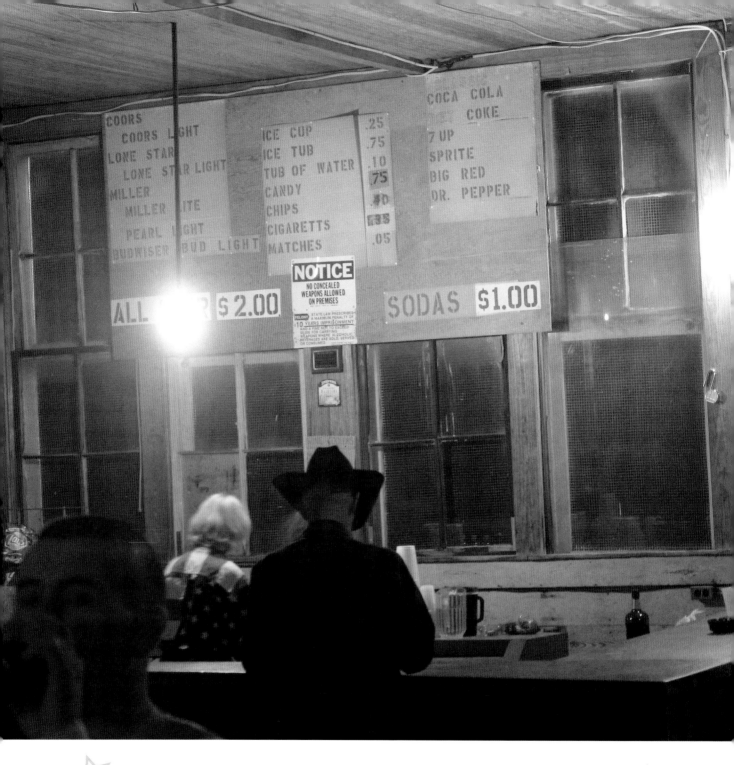

COORS
 COORS LIGHT
LONE STAR
 LONE STAR LIGHT
MILLER
 MILLER LITE
 PEARL LIGHT
BUDWISER BUD LIGHT

ICE CUP .25
ICE TUB .75
TUB OF WATER .10
 .75
CANDY .50
CHIPS
CIGARETTS .35
MATCHES .05

COCA COLA
 COKE
7 UP
SPRITE
BIG RED
DR. PEPPER

NOTICE
NO CONCEALED
WEAPONS ALLOWED
ON PREMISES

FELONY STATE LAW PRESCRIBES
A MAXIMUM PENALTY OF
10 YEARS IMPRISONMENT
AND A FINE NOT TO EXCEED
$5,000 FOR CARRYING
WEAPONS WHERE ALCOHOLIC
BEVERAGES ARE SOLD, SERVED
OR CONSUMED.

ALL ... $2.00 SODAS $1.00

It can get pretty hot with all those bodies enjoying themselves in the hall, so it's no surprise to see something like "Ice Cup" on the menu.

Texas Dance Halls

rest of the wives sit, a site near the back of the hall that's perfect for viewing both band and dancers.

Phil, a tall man with a light-brown beard, grasps his drum sticks in one hand. He asks John, "Was I too loud?"

John shakes his head and adjusts the beige cropped jacket that he wears. He sits down at the table with us and sips a glass of ice water. "No, you were fine."

Sound becomes a primary topic at any gig, and Twin Sisters Hall is no exception as the musicians and their wives compare notes. A nearby fan compliments the band, validating the sound quality. TC remains near the stage and bar, mingling with the customers, signing CDs, and even agreeing to play the chicken dance in the next set. He talks with Toker at the bar and joins in nearby conversations. No one is drunk; the dancing and moderation keeping both words and actions in check.

At the beginning of 2003, TC signed a multialbum record deal with Palo Duro Records, a small record label out of Tennessee. Helping him reach this milestone were friends Karla and Preston Buchannan. While Preston was the original bass player, his wife, Karla, held a promotions position within the music industry and helped match Palo Duro's search for new talent with TC Taylor and 13 Days. Karla died in 2002 from cancer, with Preston passing on not long after, of a broken heart, says TC. TC dedicated his latest CD to them for their friendship and influence.

In support of this new CD and with the backing of a record label, the band has toured Dallas, Houston, and Central Texas. As a result, TC spends less time in his day job, which is renovating older houses. He is poised closer to the dream nearly every musician shares of writing and playing music full-time.

"With our music, we bridge the two styles, contemporary country and Texas Americana-style." The band, in pursuing this niche, seeks to unify two sounds

that don't always speak to one another, keeping the best of the old alive in a new interpretation.

With his elbows propped on the table, fingering a Lone Star beer can, TC hopes the underlying philosophies and grounding of the band remain true despite career aspirations. Even if he performs more extensively, TC seeks to hold onto the personable, family-oriented atmosphere of the dance halls as much as possible. "I've heard people say I should act 'bigger than life,' and I struggle with that. It seems stars who act like that don't have as much talent musically."

After a twenty-minute break, the band reconvenes on the thick wooden stage and takes up their instruments for the second set. Surprising the audience, they open with a rock number, Lynyrd Skynyrd's' "Sweet Home Alabama." The dancers adapt quickly, adjusting to the space between partners that rock requires. The couples seem slower now without their spinning circle making a counterclockwise route. One couple refuses to conform, cutting a zig-zag swath as they two-step through the crowd.

With the next song, it's back to two-stepping, and a new circle of couples quickly forms. The wives of the band members are dancing as well, polite men in cowboy hats asking them by turn. Band members glance at the dancers between notes on their guitars, admiring the circle of cowboy hats below them.

"Dancers, you're looking great!" TC yells from the stage. The band roars even faster, keeping up with dancers that spill across the floor in thicker waves of denim, flashing smiles, and boots. This second set has the sidelines empty, dancers of all ages and abilities taking part in the counterclockwise spiral.

As the two-step number winds down, TC and Kyle start playing a few staccato notes. Holding hands, dancers quickly form large circles. Those who aren't on

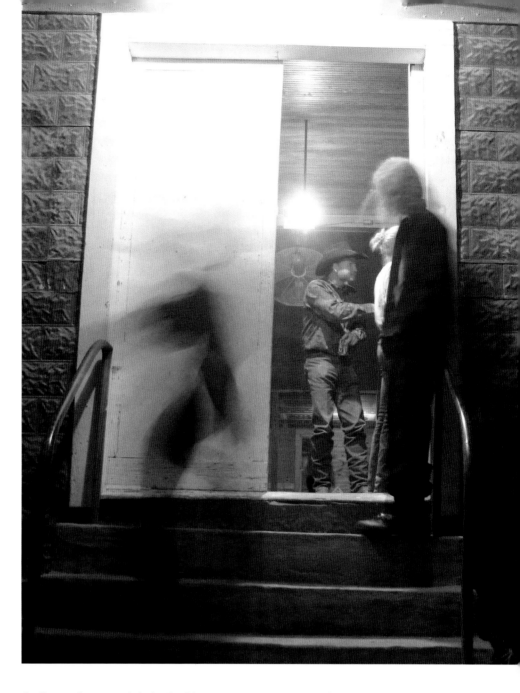

the floor gather around the back tables
with knowing smiles—the chicken
dance has begun. First come the chicken
gestures, from clapping, to elbow wav-
ing, to hip shaking. Then, during the
chorus, the dancers grab hands and
move in larger circles, each one gather-
ing speed and participants. One dancer
tries to lean, by mistake, in the opposite
direction; the rest of the circle tugs her
back into place. With the next verse, it's
back to the chicken gestures and clap-
ping. Kyle transitions to the chorus

again, strumming faster as the floor
shakes under pounding feet. Band mem-
bers laugh at the crazy circles below,
fueled by the soundtrack the musicians
provide. Some dancers last until the end
of the song, and others head for the
tables that line the floor.

TC and the band, just as breathless as
the audience, hit the last chord hard for
emphasis. With a steady smile, TC read-
ies the crowd for the next song, waiting
one last moment for them to catch their
second wind. The pleasure across his

Texas Dance Halls

face is genuine. Although TC enjoys songwriting, he finds performing the most gratifying part of music. "The crowd response, whether they're dancing, cheering, or just having fun, that's what's rewarding."

The band slips into the next song with no break in the action, no vague rumblings into the microphone, and no paper set list crumbled at a guitar player's feet. They play a few more numbers, keeping the dance floor full before the second set ends. TC assures the dancers that the band will return, before once again visiting with the individuals who come up to meet him.

As adults wander off the dance floor, some heading for the bar and others reclaiming their tables, the children take control of the space, running around the cleared area where moments before their parents slid in unison. Several young boys wrestle on its slickness, while the three-year-old girl with the woman in a black skirt runs up and down the length of the dance floor. Her head doesn't bobble as her legs shift in a nimble side-by-side motion down the slick surface. The girl's mother, comforted in the fact that her daughter will sleep well tonight, watches from a table at the edge of the floor.

TC has three of his own children: son Morgan, seven, and daughters Hanna, five, and Kyly, six. Morgan already wants to play the drums and sometimes helps his father sell CDs at the shows.

The hardest part about being a musician, TC admits, is missing time with his family. "Music is a late night activity, which makes it tough sometimes. Even if you don't feel like being up one particular night, it's your job. But, anything you enjoy comes with some hardship." He fingers the cowboy hat that sits on the table in front of him.

Shirley has similar memories of nights working at Flag Hall. "When no one came, the nights were long." She pauses. "But when the music was good, the place was packed. I can still hear a song and have it trigger memories."

TC says he will encourage his children if their musical interest continues, just as his parents encouraged him. "I would probably promote a more classical approach, where they learned to read music at a young age when it comes easier."

The third set, the final act of the night, will begin around midnight. The band will continue a strategy of danceable numbers, mixing cover songs and originals with a few rock selections. They'll read the crowd to see where the mood lies as the night grows to a close. Some of the parents are gathering their children, preparing to make the dark trek homeward. The singles and older couples remain, waiting for the next round of music to take them back on the floor.

TC remains talking with the Twin Sisters Hall crowd by the stage, listening to the feedback they offer and remembering their names. Their conversation carries the optimism of more dances to come. The cadence of the night spans time, loosening the grasp of immediacy on this 1880s hall, the laughter of dancers past intertwining with those of the present.

2 'TIL THE COWS COME HOME

■ *Swiss Alp Dance Hall*

Under a row of 1970s rock band posters, teenager Glynis Tietjen wiped down a table in the corner of Swiss Alp Dance Hall. Moving her rag in distracted circles, she shifted a strand of straight, dark-brown hair behind her ear and planned what she'd wear that night—tall white boots and hot pants, like the go-go dancers who'd performed with the Triumphs last week. Certain that her mother wouldn't approve of this outfit, Glynis snuck a glance in her direction. Marian, unaware of her Glynis' upcoming attire, just smiled and counted change in the till. Like her daughter, Marian loved Saturday nights at the family dance hall. Once customers started coming in, the mother-daughter team would collect money, hand out admittance tickets, and stamp hands.

Later on, though, was Glynis' time. After helping her mother at the door, she'd slip onto the dance floor herself, joining the crowd that almost always packed the hall. Lead guitar and bass notes would thrum, reverberating across the wooden beams and making straight-haired teenagers sway.

Glynis finished wiping the table and walked toward the hall restroom, where she dropped her rag and hurried into the vanishing sunlight outside. She slipped by the family store adjacent to the dance hall and headed straight to their nearby one-story rambler. In her closet, she'd find the boots she'd wear later, the ones with thick heels.

The rain poured that Saturday night, but dampness didn't stop Glynis from pulling on her shortest hot pants to go with her boots. Although mist cooled the summer air, the packed crowd inside the unheated, non-air-conditioned hall would make it warm enough. Glynis looked down at the mud at her feet as she walked from her house to the hall. The last time it rained, a man at the dance got his car stuck. Her dad, Egon, pulled him out using a tractor. The man got stuck a second time, and once again, her dad pulled him out. The third time was too much for him. This time, he charged the man a small fee so he wouldn't drive sloppy and end up in the ditch again.

Glynis joined her mother at the dance hall entrance. Darryl, Glynis' brother, was nowhere in sight; he only went to shows on occasion. Glynis, on the other hand, attended nearly all of them; they were built-in entertainment in her own backyard. She stood next to

Sunday afternoon downtime at Swiss Alp.

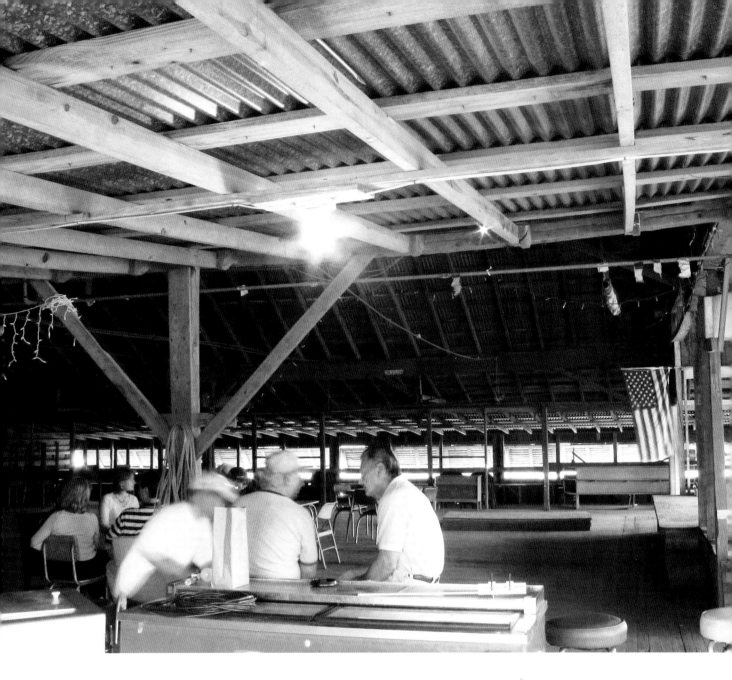

Swiss Alp before the show.

her mother and readied the hand stamp with a fresh blot of ink.

Marian had already collected cover charge from several customers. She smiled at a pair of teenagers dressed in bell bottoms who walked through the entrance. "Cover is $1," she said with a trace of a German accent.

Glynis stamped the hands of the two young men, who were about the same age as she. She followed her mother's example and smiled. One of the men gave a sheepish glance behind him. His parents were probably in the "bull pen," the roped off area where customers had a distant view, yet paid no cover charge. Parents used the remote space to keep an eye on their offspring without venturing any closer to the bands than they had to.

Glynis watched her father walk into the hall. A tall man, Egon's dark eyes scanned the growing crowd and the musicians unpacking their road cases onstage. Usually, he stayed in the concession stand at the back of the store, help-

Texas Dance Halls

ing serve beer. Later on, he'd serve Marian's famed hot dogs and chili, which she'd already cooked earlier that day. Glynis stayed with her mother, knowing better than to bother her father during a show. The responsibility of hosting so many patrons in the hall made him nervous. The next day, Glynis knew, he would be back to his more relaxed self, the man who not only ran the farm and dance hall but also danced with easy grace.

Marian, on the other hand, took it all in stride, from the band's first blaring warm-up notes to the crowd's excited whoops of response. With dark hair just like her daughter's, she flashed her smile both at faces she knew and those she didn't, collecting money or directing parents to the bull pen. She thrived on meeting new people during these late-night weekends. To Marian, who grew up a poor country girl, Swiss Alp Dance Hall was her kingdom.

Neatly dressed in a cobalt-blue suit, Marian Tietjen greets visitors to her room in the La Grange Assisted Living Center as graciously as she once welcomed new customers to Swiss Alp Dance Hall. Egon died in 1995, and she's lived at the center since her own health began failing. Portraits of their children line the walls of her pastel-painted room. Near the portraits is a large photo of Elvis. Outside Marian's window, oak trees wave their bare arms on a December wind.

Raised on a farm in the nearby towns of Industry and Shelby, Marian grew up playing piano in her father's band. While giving a performance at Swiss Alp Dance Hall, Marian met Egon. The couple became engaged at the hall and married in 1940 at the property's original farm house. After the ceremony, Marian and Egon held their reception in the dance hall, which they bought from Egon's father in 1943.

Marian recalls some of the early days of the hall, where patrons chased and caught chickens that they kept as prizes. For as long as she can remember, "it's been a place where people relax and meet friends."

During the couple's early years running the hall, Marian remembers B.J. Thomas and Bob Wills playing there once or twice. "We had some country-western and some Dixieland, and then the rock music." Rock and roll, she adds, is what proved most popular and lucrative for the hall. "Kids parked up and down the street for miles. They came from as far as Houston, Austin, and Victoria."

Although their decision to entertain crowds of people with rock music might have scared other venue owners, Marian took it in stride. "There weren't many drugs," she says. "We had a few police in here just in case, but we never had any trouble. If arguments happened, we just tried to defuse them."

Marian's eyes light up behind her glasses. "We had two guys run through here naked one time. The police tried to catch them, but they got away. It was just some foolishness."

In another late-night shenanigan, she spotted a slumping form against the fence rail one Sunday morning. "It was some guy asleep in the field; his friend had left him there." Although dance hall patrons, like the man in the field, enjoyed a chance to sleep in after their Saturday nights of music and socializing, the Tietjen family didn't.

"We went to bed around three in the morning," Marian says. "We got up at five to milk the seventy-five dairy cows." In addition to tending cows, the family spent time the next day picking up the bottles and cans that were left in the fields. "Still, we never missed church on Sunday." On Sunday nights, the family went out for dinner, a reward following long weekend nights and early mornings.

The four Tietjen children, three girls and a boy, all helped run Swiss Alp, the farm, and the grocery store next to the hall. "The kids grew up in the store," Marian said. The Swiss Alp grocery store sold vegetables, canned goods, and beer. Over a small kitchen at the back of the store, Marian cooked pots of chili for both the shows and the lunch crowd. One Dallas man, a regular, always ordered extra hot dogs to take home with him.

"It was a lot of work," Marian said. Her mouth turns up in a smile. "People still come up to me and say, 'I remember you, you took my money at the door.'" Working at the dance hall was a way to make a living; but for Marian, it was also about the people she met there, especially the kids. She glances down at the table in front of her, and then looks out the window at the wavering tree branches, just like the ones at Swiss Alp. "I'd do it all the same," she says.

Glynis Porter, now a massage therapist, walks across the wooden slats of the dance hall she'd helped her family run. Her younger brother Darryl, who works for the Public Utilities Commission in Austin, scans a back wall papered with 1970s band posters. In thick typefaces, band names such as The Charades, Telstars, Zilker Sunday, and Traits jump out as if these groups are still ready to perform live. Glynis and her brother scrutinize the 1970s and early 1980s fashions in the posters.

"Didn't you have a crush on this guy?" Darryl asks Glynis, throwing her a grown-up, little brother grin as he points to a poster. Both siblings examine a long-haired, slouching man in wide-sleeved smock and flared pants.

Glynis squints at the picture and shakes her head no. "I don't think so," she says, looking and laughing. She stares at the poster next to it, which shows band members outlined on fading yellow paper, and sighs, but not about the picture or some forgotten romance: It's the dance hall she's worried about.

She, Darryl, and their two older sisters, Brenda and Jerlyn, have met regularly to discuss the fate of Swiss Alp. On the curving hills of the Tietjen property, no cows graze, and rows of cars no longer line the road for miles on Saturday night. The last dance took place in 1987.

"We had so many good times here," Glynis says, walking around the perimeter of the dance floor. "If only these walls could talk." Sunlight drifts into the hall from spaces between the wall boards. Along with creating a way of life for the Tietjen family, the hall was the site of good memories for many local residents. "Kids need[ed] a place to hang out," Glynis says. "At Swiss Dance Hall, parents knew where their kids were at and didn't have to worry."

Darryl and Glynis walk toward the stage at the front of the hall. Glynis remembers the fog machines that 1970s-era bands brought, along with the light shows. "Mom was one of the first to book rock shows here. Western dances really never caught on at Swiss Alp, but for rock and roll it was one of the first.

"Our parents came from the Glenn Miller era. When they bought the hall from my grandparents, the swing aspect of rock appealed to them, and they decided to try rock music. You probably saw the picture in her room—she's' a real Elvis fan."

When Marian started booking rock bands at the hall instead of the customary country-western shows, business for Swiss Alp boomed. Transitioning from 1950s western swing acts, such as Bob Wills, Swiss Alp now saw the likes of white-haired Johnny Winter and local rock favorites, The Barons. The hall opened every Saturday night, with Friday night performances in summers after football season was over.

The front entrance to Swiss Alp offers a glimpse of cows across the road. Many of the halls are located a ways from the city, with only a few in larger towns.

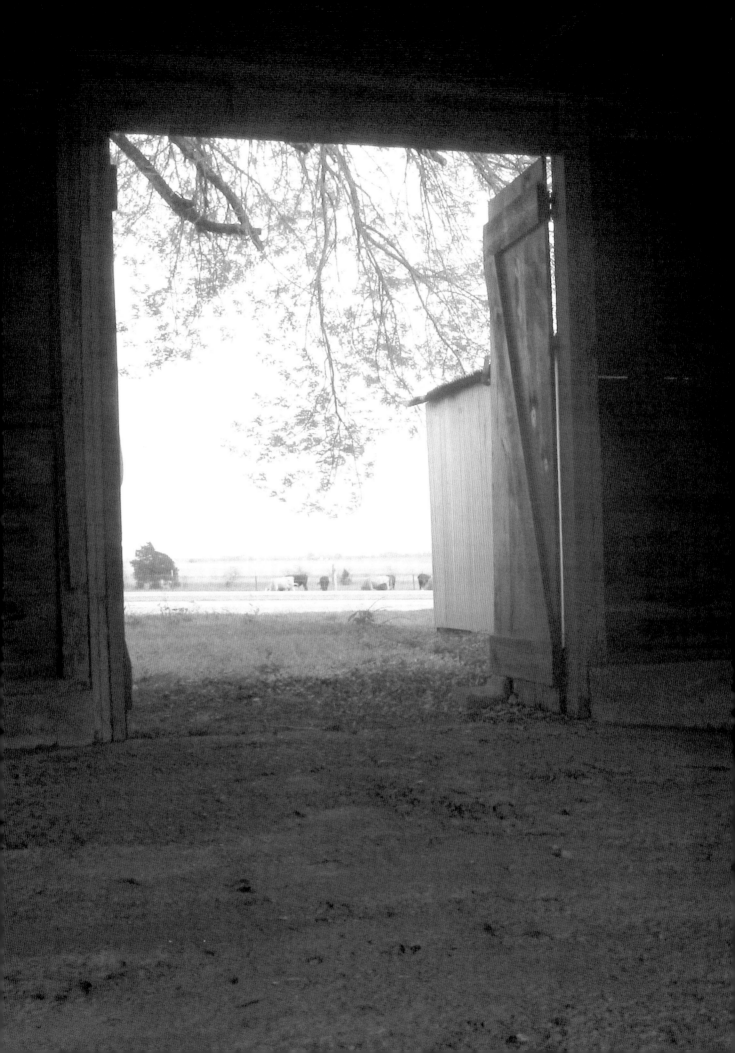

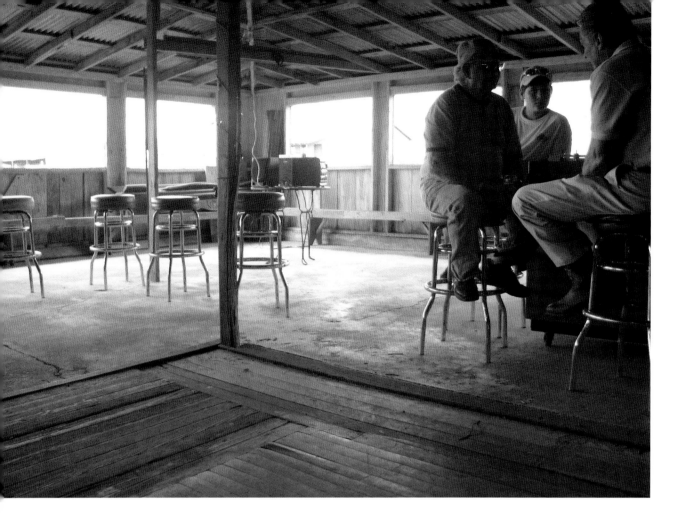

Joining local teenagers, customers came from as far as Austin and Houston to see the rock bands Marian brought to this small community. As the popularity of the acts increased, the Tietjens hosted battle of the bands events. "It was like a small Woodstock out here," Glynis says, "with blankets and beer cans." A slow crowd for Swiss Alp was three hundred; the average night drew between seven and eight hundred. "The biggest crowd we ever had was on New Year's Eve, for a band called The Barons. We had around thirteen hundred people that night, and it was like sardines in a can. I still remember the floor bouncing."

Swiss Alp Hall was so popular that Glynis still remembers a bumper sticker a fan made that said "What if Swiss Alp gave a dance and no one came?" Its message was ironic, Glynis says, because the crowds always came every Saturday night, even if it rained, and her father

had to pull cars from the muddy fields using his tractor.

Glynis and Darryl take me to the store, a building adjacent to the dance hall. They lean their elbows against the lunch counter where they once spent their afternoons working, eating meals, and catching up with their parents and sisters. The pink Formica-topped surface separates the room into two parts: tables and chairs in the front, a kitchen in the back. "We came home from school and worked in the store," Glynis says. Both brother and sister agree that working in Swiss Alp grounded all four children with a strong work ethic. "We grew up in the public. There was always someone coming to the store or just stopping by."

The back rooms include a cooler where the family stored beer along with a storage room where Swiss Alp posters from bands past lay in neat piles. The

concession stand, with side flaps that once lifted up for sales, is next to the cooler. Rows of shelving now stand bare. The Tietjen children sold some of the extra equipment, including hundreds of band posters.

Even after the dance hall closed, Marian ran the store until 2003. Midway through the year, her health began to fail. "It got to be too much for her, and we closed the store a few years ago," Glynis says. She looks outside at the sky, her eyes drifting toward the same kind of oak limbs that Marian sees through her own window, eight miles north. With the Tietjen children living in their own homes around Texas, the family home, farm, and dance hall stand empty. Glynis, a few miles down the road, lives the closest to Swiss Alp.

For a few years, the family resisted selling their family dance hall. "People asked us about buying or renting the place, but it was pretty emotional for us," Glynis says. After months of careful

thought, the family sold the hall to a couple, Kevin and Donna Ustynik, who plan to reopen the dance hall with live music. Although parting with the hall was bittersweet, Glynis is happy its traditions will stay alive.

"Especially considering it was the first rock and roll dance hall," Glynis says. She and Darryl lock up the store and walk back to their cars. Glynis is the last to leave. She looks across the fields toward the hall. "Sometimes, I can still hear the music and see all those people."

In the early light of a Sunday morning in the 1970s, Highway 77, near Swiss Alp, wound through the hillsides free of squealing tires and parked cars. The only sign of dance hall life from the night before came from tire marks in the grass and the bottles and cans scattered across the grounds.

The sole two teenagers left on the property, Glynis and Darryl, moved

OVERLEAF:
Looking toward the stage at Swiss Alp Dance Hall.

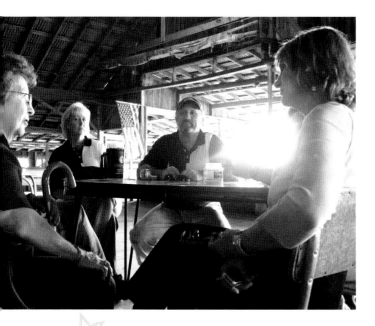

Left to right: Marian Tietjen, Donna and Kevin Ustynik, and Jerlyn Schindler talk about their own history with the halls.

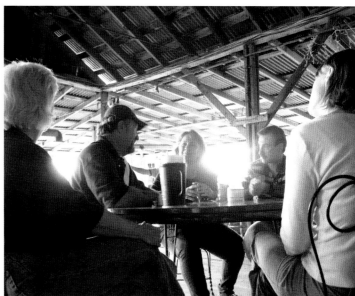

Left to right: Donna and Kevin Ustynik, Glynis Porter, Darryl Tietjen, and Gail Folkins swap dance hall stories.

across the field, bending over on occasion to pick up shiny-labeled beer cans and bottles. The morning air warmed their skin, promising a hot day to come. Glynis had changed from her hot pants and tall boots to blue jeans and tennis shoes. She hummed as she worked, thinking of the recycling money she and her brother would earn from their customers' littering.

Despite the early hour, they were grateful that bottle and can pick up was their only chore. Now that the family had purchased automated milking machines, she and Darryl didn't have to milk the cows as their older sisters

Brenda and Jerlyn once did. Glynis smiled, thinking of the time her two sisters got in a big fight before the prom and squirted each other with milk. Finding beer cans in the fields wasn't so bad in comparison.

"What're you smiling about?" Darryl asked. He looked back at his sister and flicked a sticky can into the plastic bag he carried.

Glynis shrugged. She set her bag down and remembered dancing the night before, her boots stepping in time to the music as if they'd had a mind of their own. The crowd had roared for an encore, and the band, fog swirling

Swiss Alp Dance Hall—the main hall is the building on the left, and on the right is the beer garden.

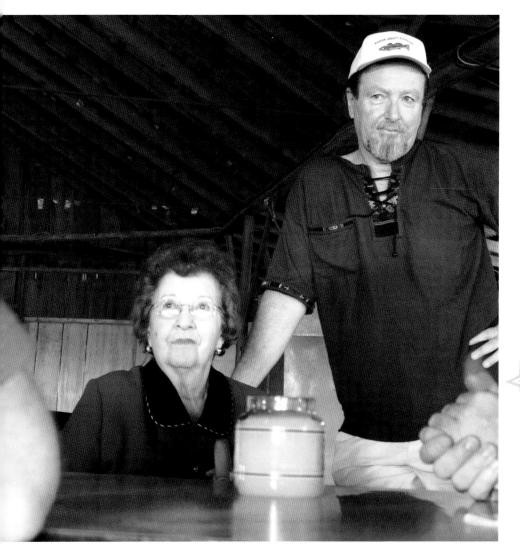

Standing next to Marian Tietjen is Gary McKee, who has been dancing at the halls since he was a teenager. Tietjen herself has worked in the hall for more than forty years.

Texas Dance Halls

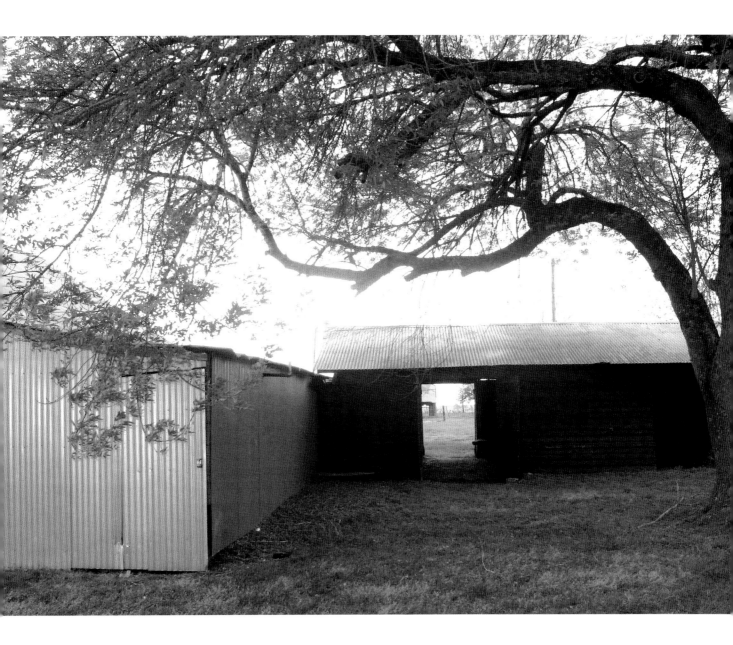

around them, delivered. Glynis danced in the middle of the crowd, shifting her weight from left go-go boot to right. She glanced back at her brother and tossed another can in her bag. "You missed a good night."

Darryl shrugged and stared out over the fields, scanning the horizon for both cans and cows. A southerly breeze brushed his forehead. It didn't matter that he'd missed last night's dance; there'd be another one just like it next weekend, and sure enough, the crowds would come.

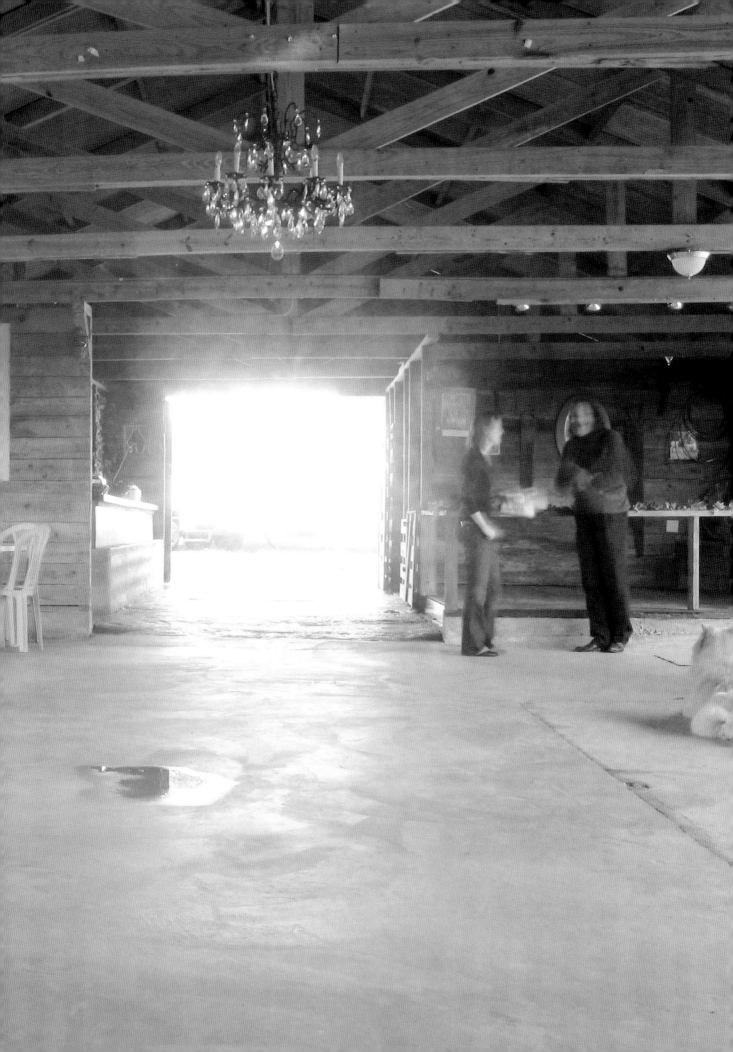

3 WAR STORIES AND A WEDDING

■ *Hilltop Hacienda*

On a drive to Bandera, a small town in the Hill Country, John and I run into Doug Baum, the band's drummer. When he's not playing music, Doug works as a camel wrangler, transporting his small fleet of camels to historic reenactments, nativity scenes, and educational programs. "Hola," he says, pulling his bronze sedan off the road and leaning across Trish, his wife, to wave at us. In the back seat are their three kids. Pecos, the youngest, greets John by calling him his band name, Slam. Trish gives an extra broad grin at her son's enthusiasm.

"We're taking the kids to a park before we go to Bandera," Doug says. "Here." He hands John a CD. "Listen to song three."

John, waving at them as they drive off, doesn't question this impromptu gift. Doug and John met in the mid-1980s at a music college in Waco and have played music together ever since. John pops the CD into the car player and flips to the third song, "Come Back to Texas," which the band will perform later that night. In a few hours, this band of old friends will set up and perform at a Hill Country wedding.

After meeting lead singer TC at his house in Boerne, we follow his car through the brown hills spotted with late summer flowers. I roll down the window so I can smell the pasture, still green from recent rains. The road curves up into one of the hills. Through the trees, we spot the stone face and fence posts of the Hilltop Hacienda, a ranch that now serves as a bed-and-breakfast and reception hall. Alongside the buildings is a dance hall pavilion flanked by two small silos. John stops the car in the grass across the driveway.

I walk into the pavilion, dazzled by the silver cut-outs in the shape of cowboy boots that dangle from the ceiling. Jewel-tone confetti in the shape of blue horses, purple cowboy hats, and tiny moon slivers spills across the table tops. Trish and the kids, who pull up in their sedan, climb out of their car and join me inside the pavilion. Doug gets right to work unloading his drums from their round, black cases.

Trish, a counselor at Baylor University, and Vanessa, her thirteen-year-old daughter, crane their necks to see the wedding party clustered on the stone patio. With their matching wavy

In the dance pavilion, Folkins talks with Michael Goodale, owner of the Hilltop Hacienda.

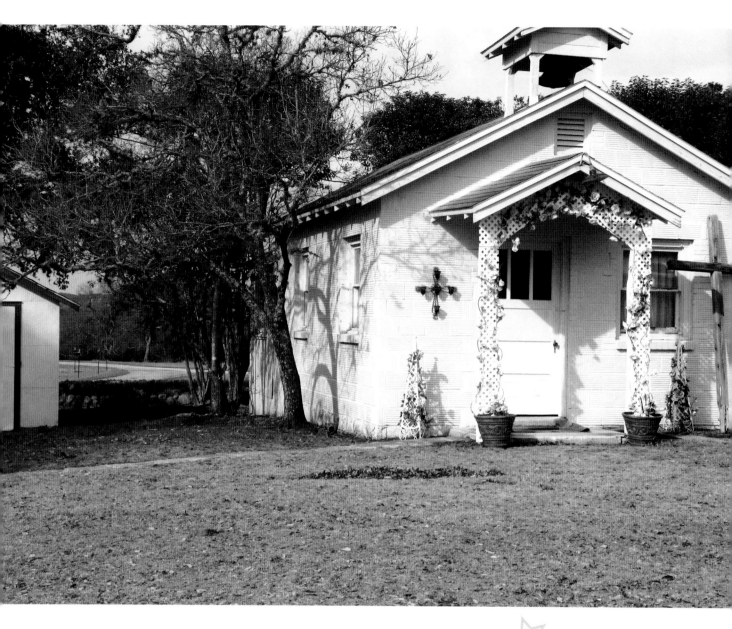

Michael Goodale says this chapel was once a one-room schoolhouse.

blonde hair, they almost look like sisters. I join them to glimpse this ranch-style wedding, where the women wear summer dresses, and the men relax in jeans and boots. Before the reception starts, I change from my shorts and sneakers into a black skirt with handkerchief hems and a lace-trimmed blouse. Just after the short ceremony, guests wander from the stone house to the pavilion, some with platters of barbeque while others tote coolers of beer and cokes.

Trish and Doug's ten-year-old daughter, Delaney, sits in a corner near the gift table playing an electronic word game while I look over her shoulder. She puts me to work, and we bury our freckled noses into the game, not noticing the guests who leave pastel boxes topped with tulle on a nearby table. Delaney flashes a smile and shows Doug her latest words. From beneath a straw cowboy hat, he grins. "Why didn't I think of that word! You're so smart."

Trish and Vanessa join us near the gift table. Guests with plates of food push the jeweled confetti aside and take seats at the pavilion tables. To give them

Texas Dance Halls

more room, Trish and I take our party outside on the shaded porch. Though we've only met a few times, Trish and I have heard enough about one another to feel like friends who share dance hall lives. John and Doug, who've set up their equipment and tuned their instruments, offer us each a plastic chair.

While I take a seat next to John, Doug and Trish lean their chairs against the pavilion—dance halls are a familiar setting to them both. Trish, originally from West, a town in Central Texas, grew up with Czech dance hall culture. Doug, a native of Colorado City, has played in Texas dance halls for the past fifteen years; he started in Elk Hall in West.

"We were always too loud," Doug says. In most cases, the dance hall used a cheap, internal public address system that amplified not only the band, but also the kitchen. "They'd use it to shout out food orders," Doug said, shaking his head. "How could I be too loud if I could hear 'order up' in the middle of a song?"

John laughs. "I remember a dance hall in Academy. On the stage behind me, on the middle of the wall, they had a sign that said "Do not play the chicken dance—it causes rude behavior." John, no fan of the chicken dance, shakes his head.

"It wasn't a joke?" I ask.

He shakes his head no and squeezes my hand.

TC, who joins us on the porch with his son Morgan, leans forward to catch the stories. "That hall also had a curtain that divided the stage," TC says. "If you pulled back the curtain, there'd be another group. They used it for dueling bands."

John and Doug first met TC in Nashville, where all three had moved to pursue their music. Several years later, the trio of friends ended up moving back to Central Texas.

I try to imagine the dance hall TC and John had described in Academy, with two bands onstage playing at once. Doug reads my confused look. "Not at the same time," he grins and sits back on his green plastic chair. "I remember when Kyle's guitar got stuck in the ceiling when he tried to flip it."

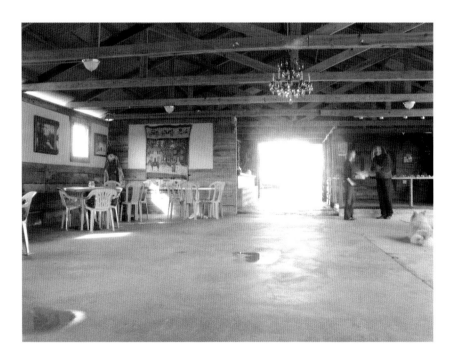

The dance pavilion was formerly a bar.

Hilltop Hacienda

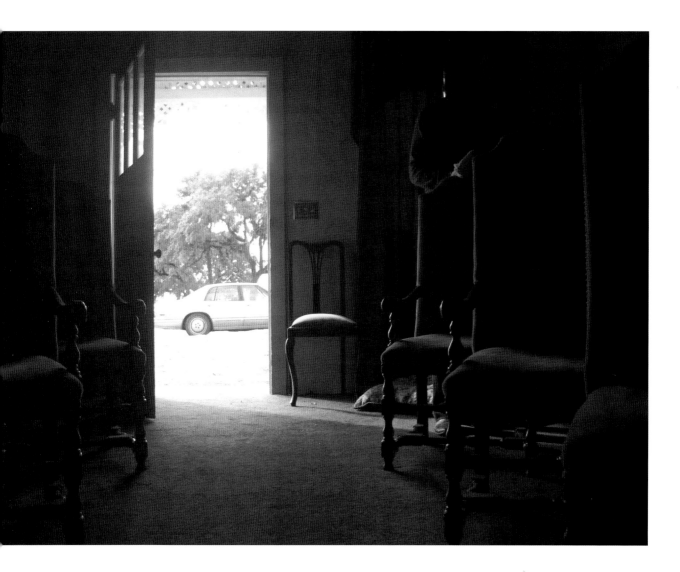

Looking out the front door of the wedding chapel.

"Then there was the Some Place Else," John says. "Fights broke out there every set. Someone got stabbed on the dance floor."

"Clarksville," Doug says. "There was so much smoke that you couldn't see the band."

"I remember playing a hall gig when the Gulf War was announced," John says. "It was so empty in there we had a chance to watch the news ourselves."

Doug remembers a gig he played in front of a large crowd at the Melody Ranch in Waco. "They really pushed the fire code there," he said. "It was a good time for country music." The club featured music four days a week that brought in everyone from twenty-somethings to sixty- and seventy-year-olds. Even though it was great attracting a large crowd, it made choosing the material difficult, Doug adds.

"We were playing a rockin' song at the shows," Doug says. "And this guy in the audience says 'quit playing rock n' roll. Play country.' Kyle just glared over at him and said 'Cool it, Pops.'" Doug shakes his head.

Delaney clutches her word game and pushes the keys of each letter, willing new words to form. I glance at my watch and back to John. The band starts playing in about a half hour, and still no sign of Kyle, the guitar player coming

from Dallas. In 1988, John and Doug met Kyle in Waco, where he worked at Ray Henning's Heart of Texas Music. John describes this guitarist as both larger-than-life and crazy; Kyle describes himself more specifically as the love child of Elvis and Bigfoot.

"He'll be here," John says. All of us glance down the road. Instead of Kyle, we spot a man driving a horse and an old-fashioned wagon. Three girls in light summer dresses step off the back. I walk up with Delaney and Pecos. "Giving rides?" I ask the driver, who is dressed in an early nineteenth century tie, white shirt, and black pants. The carriage, in flawless condition, is from 1870.

"Climb up," he answers. I scramble up after Pecos and Delaney and take the backward-facing seats behind the driver. With a smack of the reins on the mare's rump, our driver makes a circle around the hillside. We pass the pavilion, built from a 1950s barn, along with the main house, with rooms for bed-and-breakfast guests. Michael Goodale, owner of the Hilltop Hacienda, tells me later that a small chapel near the house was once a one-room schoolhouse.

From our perch in the wagon, we watch the clouds build fat, afternoon shapes over the tan and green hillside. The air smells like rain. When the pavilion comes back in view, the chestnut mare picks up her pace on her own and starts to trot. When the route gets bumpy and our hair starts flying back, I'm the most excited one on board. The driver eases the mare back to a walk when we reach the porch. We thank the driver and hop down from the wagon while children waiting for a ride pull themselves up.

TC watches us reclaim our chairs in

Goodale in his bed-and-breakfast.

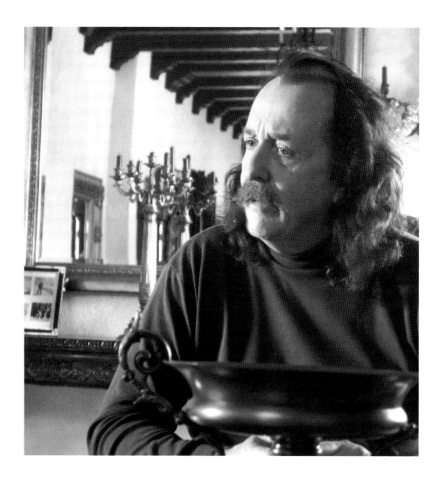

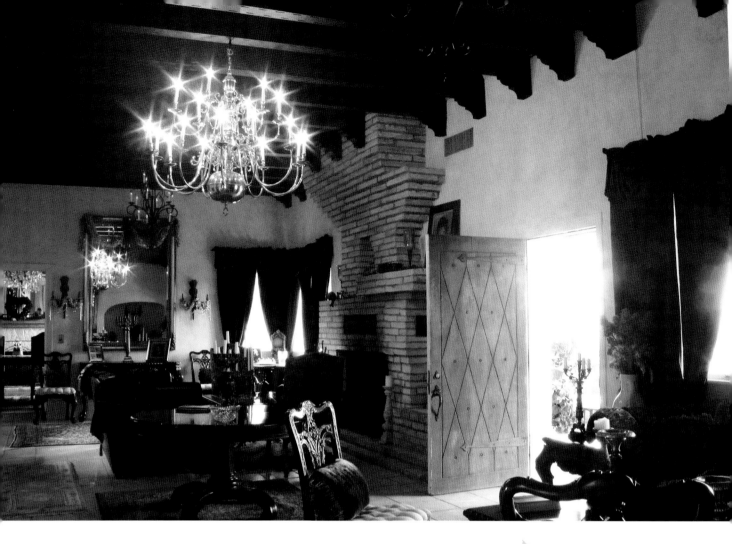

the porch circle. With his grandparents' and parents' involvement in dance hall management and performance, he practically grew up in the halls. He looks at Morgan and remembers being about the same age at a gig in Sefcik Hall, just outside of Temple. "I was about seven or eight years old," he says, "and the drummer playing that night had been drinking." The man started to wobble down the stairs, which are known for their steep pitch. TC watched the man tumble almost before the man realized it himself. "He fell all the way down the stairs–I still remember his drums following him."

"That's a different kind of drum roll," Doug jokes.

The wedding guests, having finished up their dinner, throw away their picnic plates and look toward the stage. Kyle isn't here yet, but TC motions to the rest of the band anyway—he'll play lead guitar until Kyle arrives. Doug folds himself behind the drum enclosure while John takes up his white 1966 Fender Jazz bass. TC stands in place behind the microphone and welcomes the crowd.

Trish and I head back inside the pavilion with the kids. Delaney and I take our seats by the gift table, while Trish, Vanessa, and Pecos stake out an empty table nearby. Not wanting to be wedding crashers, we drink bottled water and cokes that we've brought along for the trip.

TC, Doug, and John glide into their first song of the night, which also serves as the bride and groom's first dance. The bride, in a yellow chiffon dress, two-steps with her cowboy-hat clad groom. As they circle the floor, their relaxed

The main hall in the hacienda proper is as beautiful and opulent as it looks.

Texas Dance Halls

smiles match the tone of their wedding. By the second song, guests join them on the dance floor. Two women, one in a striped dress and the other in pastel-hued sequins, twirl each other amidst the couples. A pair of teenage girls follows their lead, both laughing as their tie-dyed skirts float up and down in time to the music. A father spins his toddler, carrying her in a gentle waltz.

Pecos and Vanessa find bottles of bubble fluid on the table and blow bubbles at the dancers, turning the floor into an instant reenactment of the Lawrence Welk Show. Morgan presents me with a pile of the bright blue horse confetti he's collected from the tables. Trish and I smile at the kids, talk about school and work, and relax.

The crowd responds to the energy onstage by clapping their hands from the sidelines and making fancy spins and turns on the dance floor. With moves and laughter of their own, the band is having just as much fun. I sip a Sprite, my eyes traveling from the men onstage to an experienced dance couple, a young blonde woman in a fluid skirt with black heels, and a man with a trim suit and cowboy hat.

Delaney and I start a new word game with the pad of paper I've brought. Through a small window in the side, we watch horses graze in the adjacent pasture, among them the chestnut mare that pulled us in the wagon around the

hillside. The clouds, which look thicker by the minute, turn a darker gray. One song later, a breath of wind gusts between the open poles of the pavilion. The pasture horses tilt their heads downwind. I glance outside in time to see the wind pick up a handful of dust and throw it off the hillside. Rain starts falling sideways.

Couples still out on the porch make a run for the pavilion. The band and dancers, protected under the tin roof, play a song about Luckenbach while the rain drums its own beat outside. In the middle of the rain and rumbling thunder, a red car pulls up outside the pavilion. Kyle, tall with a dark beard, runs from the car to the covered stage. His wife, Terrie, finds an empty chair at one of the tables. Kyle plugs his guitar into a waiting amp and starts performing along with the band as if he's been there all night long. The other band members smile and play the rest of the song with an energy that rivals the storm.

For the next song, Kyle tells a joke only the band can hear, making them chuckle into their microphones. He takes the lead on the next song, Danny O'Keefe's "Good Time Charlie's Got the Blues." Couples dance to the raindrops that pound the roof. The bride and groom mingle with other couples while they dance. Delaney and I get up from the word game and do our own special version of the twist to the faster

Goodale obtained the carriage at left from his wife, Mary. The carriage, a Skeleton Book Victoria, was built in 1870.

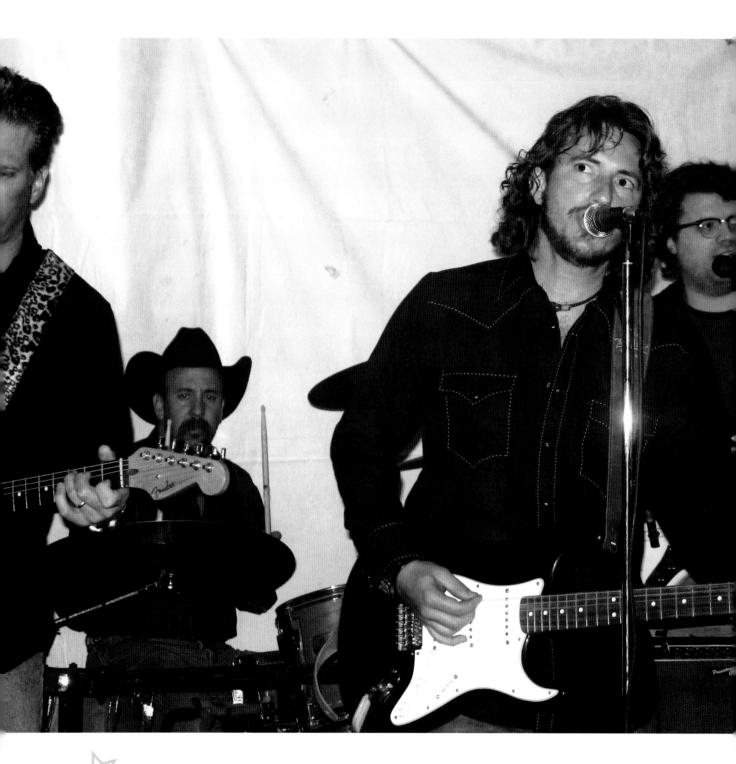

(left to right) Michael
Pfannstiel, on electric guitar,
Jamie Dunklin, on drums,
TC Taylor, on lead vocals,
and John Koehler, on bass
guitar, playing a gig at the
San Antonio Stock Show and
Rodeo.

Texas Dance Halls

moments of the song, making the corners of our skirts flap around our legs.

Several songs later, at the first set break of the night, Kyle leans back at a table with Terrie and his daughter Paisley. It's hard choosing which dance hall story to share, he says. He decides on the third of a four-night gig at the Arky Blues Silver Dollar Saloon and Cabaret in Arkansas, where a woman kept winking at him throughout the set.

"At the set break, I went over to talk with her," Kyle says. He frowns into his water glass. "Then she flipped a bridge out of her mouth," he says.

"What happened?" I asked.

"I said see 'ya later,'" Kyle says, not elaborating further on this woman's move and whether her motives were suggestive, shocking, or both. He grins at Terrie, who shakes her head in a way that tells me she's heard this story more than once.

When the music starts back up, I join the others at our table near the gifts. Delaney and I bury our heads in sketching. A woman in her sixties wearing a purple pant suit walks up to us. At first, I wonder if she's worried about the gifts piled behind us, but her open smile suggests otherwise.

"I saw you two dancing earlier," she says, beaming. Wine makes gentle waves in the plastic cup she holds. "It was wonderful. I hope you'll go out there again."

I thank her and return the smile.

"I'm the bride's grandmother," the woman explains.

"Do you like to dance?"

"Yes," she says with a wistful sigh.

Delaney and I go back to our game until the band plays another fast song. From the corner of my eye, I spot the woman in the purple pantsuit walking with slow purpose to our table. She nods to us from the edge of the dance floor, and I know we've been summoned.

"Want to dance?" I ask Delaney, wanting this grandmother of the bride to enjoy her day, particularly if our frantic dance style adds to it.

Delaney pushes a strand of hair behind her ear and follows me out on the dance floor. The bride's grandmother meets us and urges us closer to the stage. She sways beside us, her eyes dancing faster than her legs. A woman in her late twenties who must be related to the bride's grandmother steps onto the dance floor and keeps an eye on her pace. At the fastest part of the song, Delaney and I twist high and low, finishing with a hearty arm-in-arm spin.

By the end of the song, Delaney plops back in her chair. "I'm tired!" she tells Trish, who laughs at our dance style. Delaney and I sit out a few songs until the next fast one, where we dart back out on the dance floor and meet the bride's grandmother, who grabs my hand.

Afterward, the woman picks up her plastic wine glass from a nearby table with one hand and puts her other arm around Trish. I hear her complimenting Delaney. Rather than walking back to her table, the woman lingers and asks Trish something I can't hear. My eyes travel from the group of men playing onstage to our own corner filled with word games, jeweled confetti, and bubbles.

Trish leans over to me after the woman leaves. "She wanted to know if we were sisters," Trish says. I nod and smile.

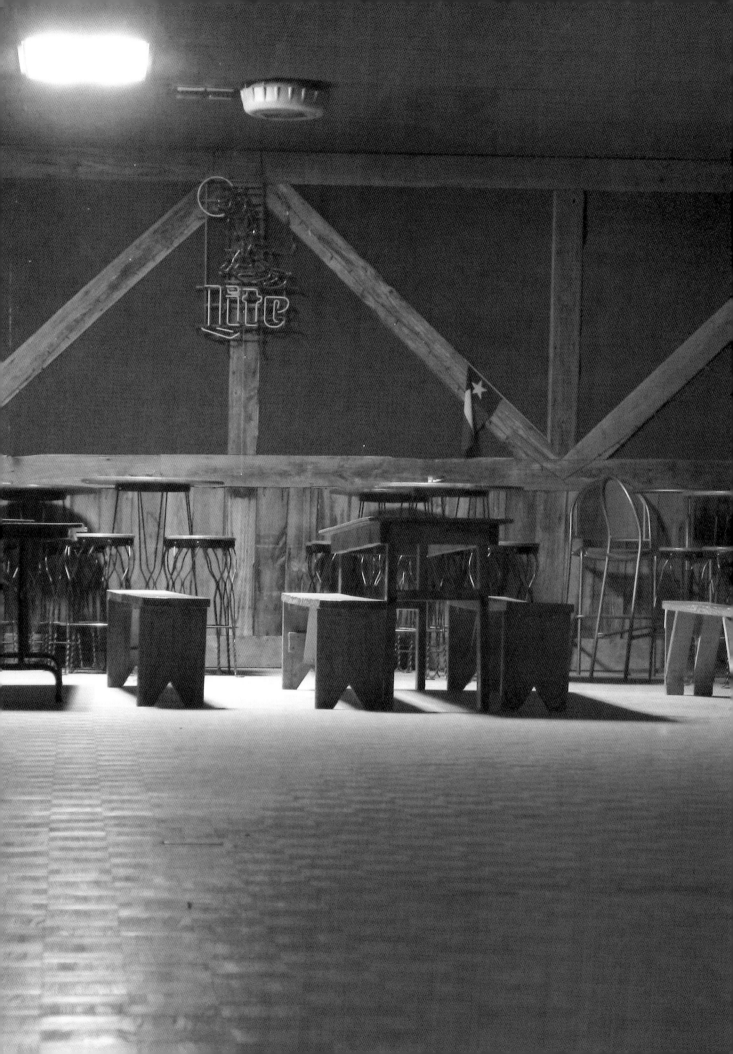

4 DEER, FRIENDS, AND JARS OF FISH

■ London Hall

Marcus and I drive down Highway 83 in October, eyes alert for deer. The slim figures poised on stick legs stay on the roadsides for now, satisfied with dried grasses along the ditch. Live oak branches curl above them into a pink sky.

"Watch for deer if you drive in the Hill Country," John warned me before Marcus and I started our latest dance hall trip. "It's that time of year." The deer flip their white tails, stare, and return to their dinner while our silver Beetle cruises down farm-to-market road 1773. Though I'm no hunter, I can see why sports enthusiasts consider this part of Texas paradise.

Wearing fall colors, a plaid shirt in rich purples and gold, Marcus stares at the Texas map. "We should be there any minute."

The trees give way to small stores that hug the roadside. London Hall rests across the street from an abandoned building with broken windows. We park next to it and grab our gear. "That would be fun to explore," Marcus says, gesturing toward the darkened windows.

I give both Marcus and the building a doubtful look.

"In the daytime," Marcus adds.

We cross the street to the dance hall porch and the golden light shining inside. Billy Ivy, owner of London Dance Hall for the past eighteen years, says the hall is more than a hundred years old. There's not a dance tonight, but the saloon perched beside the hall is open. At one end of the saloon is a bar with a trio of wrought-iron chairs in front of it. A side door leads into the dance hall, which is closed for now. An overhead tarp-like sign reads "Welcome, Hunters." Illustrating the point, a stuffed bobcat with a cigarette in its mouth leers from a shelf above us.

Jessica, a barkeep from New Jersey, greets us when we come in. She moves a curly strand of dark hair from her face. "There used to be a liquor store nearby," she says. "People bought their liquor there and drank it outside." This arrangement lent itself to occasional weekend brawls, she says. Anyone arrested for disorderly conduct was handcuffed to a large oak tree behind the dance hall and in direct view of the church. "On Sunday morning, all the people going to church would see them, so it was a pretty good deterrent."

A tall man in front of the bar stretches his legs and wipes his forehead. It may be October, but during the past

[35]

week temperatures in Central Texas have hovered between the high nineties and low hundreds. "Times are changing," he says, with a frown and no further elaboration.

"Tomorrow, archery season starts," Jessica says. Her tone is cheerful—this Texas transplant, who came here for family and adventure, likes a good crowd. "It'll be busy from now until January." In autumn, hunters of all types visit the saloon on Friday and Sunday nights, while a live band performs on Saturday nights. The Hunter's Ball, held on November 1, caps off the season. "People come year after year," Jessica says.

The jukebox behind us bursts into a country song. Around the corner of the bar, a piano painted white is flecked with black spots, making it look like a pony. Through the screen door, we hear a pickup rumbling down the road outside. I imagine the saloon full of out-of-town hunters who leave their camouflage at the door and come inside to trade stories of the one that got away.

Through the side door that Jessica unlocks, Marcus and I tour the dance hall under dimmed lights. The floor looks as if it's been redone in neat parquet squares. Long tables line the sides of the hall. I sneak into the men's room to see the car door that serves as an entryway for one of the stalls.

"Do you need more light?" I ask Marcus, who snaps a picture near the stage.

"This is perfect," he says, aiming the camera at the wall behind me. Both of us ignore the sound of scuffling in the ceiling above us, which I decide must be a raccoon.

Wandering back onto the dance floor, we spot two men in their early fifties, both short in stature and each wearing a cap. I decide one of them must be Raymond Blaylock, a man who grew up in the area and whose wife works at the Texas Tech campus in Junction, where we'll be staying for the night. Raymond, a bearded man with a soft laugh, has agreed to meet us at the hall and tell us his stories; he's invited his childhood friend, Elzy Beam, to come along. Wearing a checked shirt, Elzy greets us with a grin. Both men describe how much it's changed from the days they were regulars here.

"This floor is new," Raymond says, pointing to the light-colored squares

A car door in the men's restroom serves a function more aesthetic than practical.

Texas Dance Halls

This piano, painted like a pinto pony, was a gift from the previous owner of London Dance Hall.

with the toe of his boot. Elzy looks at the floor with a small frown. "When a floor board stuck up in the old days, you just danced around it."

Elzy and Raymond grew up in London and have been friends for years. At age fourteen, Elzy moved in with Raymond's family after a dispute with his dad. When Raymond's family moved from their ranch and closer to town, Elzy came along. Both started coming to London Hall, which Raymond's dad supervised, as teenagers. The two

friends are now retired, although Elzy still works on a ranch. While Raymond worked in oil fields throughout Texas and Colorado, Elzy worked for the Texas Highway Department for more than thirty-two years. Both men married and raised families here.

Elzy gestures toward the back of the hall, past the men's restroom. "Instead of the facilities, men used to use the oak tree outside," he says. He winks. "Beer kept it alive all those years."

The two men lean across a short rock

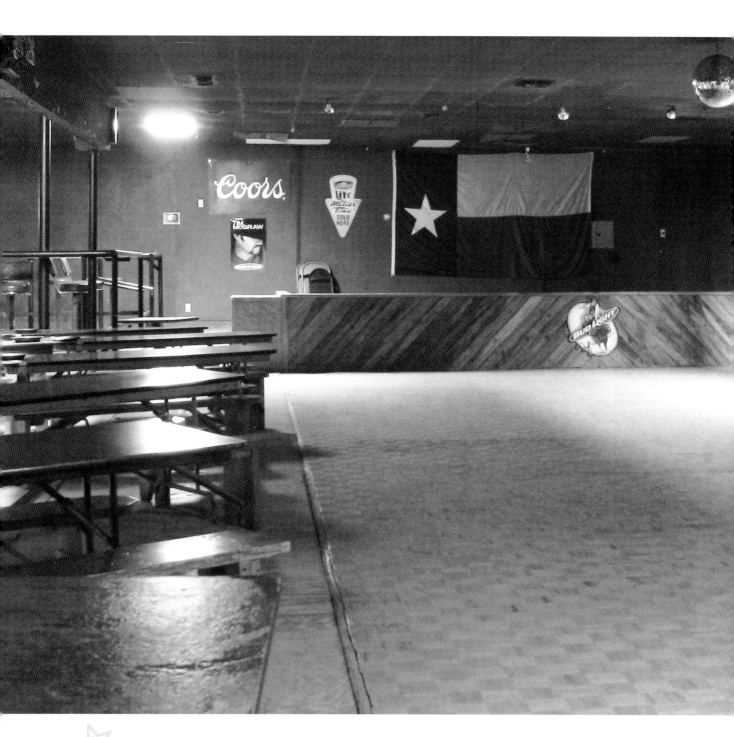

The dance floor and stage at
London Dance Hall.

Texas Dance Halls

wall partition at the front door of the dance hall. Tables line the dance floor, with a stage at the front of the room near the restrooms. Metal pie plates rest on each table. "Those are ashtrays," Elzy explains. "This place used to be filled with smoke."

Tonight, the smell of wood overpowers the memory of smoky nights and spilled beer. "Now, the hall has vents," Elzy explains. "During the Hunter's Ball, it took a pocket knife to cut through the smoke. My dad smoked, but I never did, and if you're not used to it . . ."

Raymond nods and gestures to the wooden windows at the sides of the dance hall, which are closed for now. "We used to open up these windows in the summer," he says. Not only did the windows let in fresh air, they also gave dance hall patrons a view of the fights outside. "It was easy to sneak in that way, too," he adds with a grin.

Elzy looks around the hall and leans his elbows against the stone wall. "It was a wonderful place to grow up," he says. "My mom is seventy-eight, and she used to dance here. My family danced here. I danced here, and my daughter has danced here. Now, I don't have as much of a reason to come here."

In their younger years, the two friends made it to most dances without fail. "Saturday was it," Elzy says. "None of that Sunday matinee dancing and no Friday night dancing." At the dance hall, they hung out with their friends and also made new ones from neighboring towns. "We didn't date the girls in town," Elzy says. Girls from Junction didn't come to the dance hall, but girls from other neighboring towns, like Eton, Menard, and Mason, did.

"There was the Hunter's Ball," Raymond reminds him, a weekend of dancing that transformed the town. "About 150 people live in the surrounding area," Raymond says, "Maybe 65 of those in town. Then you add 1200 people who come from the hunting camps and ranches, and things get a little tight in here." Raymond and Elzy laugh. In addition to Saturday nights at the hall, the two men have shared a deer hunt or two.

"We couldn't have been raised as boys in a better place," Elzy says. "There was a post office, two grocery stores, and the dance hall. Grandmother took us to church when we were little. Then we moved to the dance hall. And now we're back with the Lord," Elzy says.

From the saloon, we hear a pool stick smack against a ball. New voices from the saloon next door grow louder, competing with the sound of pickups rumbling down the street. Although Raymond is quick to agree with Elzy that the dance hall and surrounding community gave them a good place to grow up, he also remembers the lawless years. Before Raymond's father was named deputy sheriff in the mid-1960s, a position that gave him authority over the dance hall, Raymond says there wasn't much order; Elzy chalks it up to the times. Getting in a scuffle over something as small as opening a gate for a girl was normal back then, he says. It was just the way things were.

Raymond nods. When people fought in the street, his dad often let them go at it. "Sometimes it was better to just go ahead and get it over with," he says. "If they clinched to the ground, my dad would make them break up. It was a way to get it out of your system."

If things went too far, Raymond's dad gave citations. "He'd hand out as many as 200 in a night," Raymond says. "Sometimes women would start fighting, too. But my dad worked hard to calm things down. He made the guys take off their hats during the dance. Back then, there was no law, no liquor control board, no highway control, no nothing. Dad made it a respectable place."

London Hall

Elzy nods. "Ninety percent of the fights were over nothing. Sometimes it was over a woman. Everyone would dance and drink beers, have a fight and then go from there," he says. He grins and leans over the rock wall. "Raymond's dad fined my mother's cousin twenty-five weekends in a row, for disorderly conduct."

Raymond leaves the wall and takes a seat at a nearby table. Elzy watches him, but keeps his place by the wall. "Raymond's daddy got a lot of respect. He threw my dad in jail once for disorderly conduct because he was drunk. Mama didn't want to get him out, so Dad had me bring him his cigarettes."

Another time, Elzy remembers a fight between two friends. A third man started hitting the other two with a flashlight, but the first two didn't flinch, not even when the flashlight broke. "There were big silver batteries and a spring flying everywhere," Elzy says.

Raymond smiles over his glass of ice water. "I got thrown in jail for drunk and disorderly conduct in a public place. I found a fifth of Tequila, and I tried to mix it with everything I could think of. Next, I drank it straight. I finished it, ate the worm off the bottom, and thought to myself that I wasn't getting a buzz or anything." When Raymond spotted his dad coming into the dance hall, he knew he was in trouble. "I thought if I could make it to the back door, I could get out. But I was too drunk to open the back door, so I went to the bathroom and locked it." Raymond's dad followed him there and asked him to open the door.

"I said, 'no, sir.' So he kicked in the door, handcuffed me, hauled me out, and threw me in jail." At first, Raymond wasn't unhappy with the situation. "I was thinking of how many days of school I'd miss," he says. Later the next day, a bailiff asked me if I wanted to stay, and I said 'No, sir, I'd like to get out.' The maximum fine was $240. Because this was my first offense, the JP charged me $18.50. I wrote that check, got in the back seat of the car, and went home."

Unlike some, Elzy didn't fight. "I could, but I didn't," he says. "I fought when I was little, but that's about it. With today's laws, you have to be 99 percent civil," he says. He adds that London now has four to five city police officers, along with highway patrol officers. It's warranted, Elzy says, because of the area's population growth; Interstate 10 has made it easier to reach this Hill Country town. We hear whoops from the saloon next door, which fills with patrons as the night lengthens.

From the rock wall, Elzy looks at the ticket window. "My sister stands at the door and takes tickets on Saturday nights," he says. The Saturday night dance hall crowd still ranges in age from eighteen to seventy, just like the old days when he and Raymond came to the dances. Musical acts in the hall, for the most part, play danceable two-step music. "Back then, everyone used to two-step in a counterclockwise circle," Elzy says.

"Still do," I say.

Elzy agrees with me on dance direction but not the style. "I've watched the way kids dance now, and the way we danced, and there's no comparison. Of course, our music was better to us during our time, and to them, their music is better. We had Waylon Jennings and Johnnie Bush. I don't know what you've got now."

Raymond and Elzy's favorite performer at the hall is sixty-three-year-old Tommy Burney, who performs traditional western swing. "There's no telling how many Saturday nights he's played here," Elzy says. "My little brother is his drummer." Another country song blares from the jukebox. "If a new song comes out, Tommy can listen to that song two or three times and sing it."

Tommy, who is also Elzy's brother-

Off to one side of the hall, there was a place for minors to hang out behind the makeshift wooden fence.

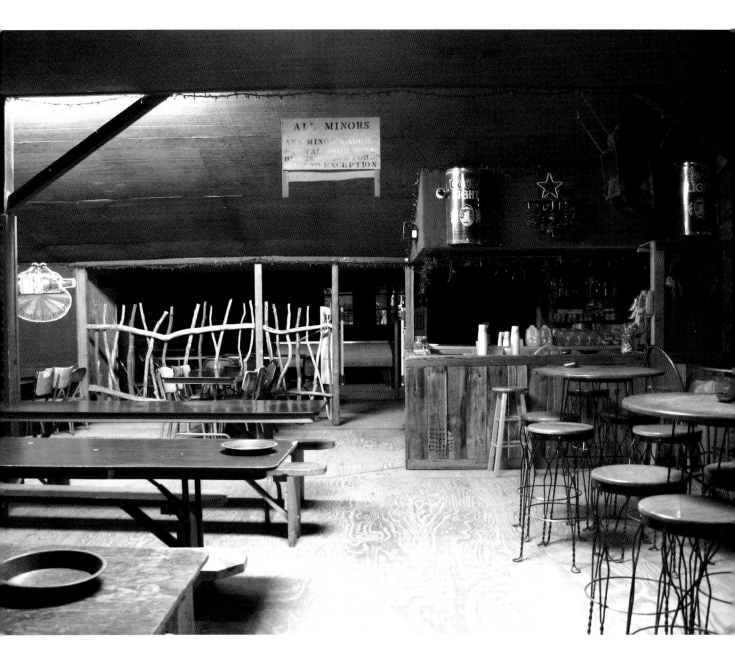

in-law, had offers to go out on the road with touring bands but chose to stay in the area instead. "They play a lot of weddings; that's the kind of music we were raised with." He pauses and smiles. "You go to the land were you were raised, and you bring it home with you."

We pick up our water bottles, drop them off in the saloon, and walk outside into cooler air. On the board sidewalk, Raymond shows us the front door of the dance hall from the outside. We look at the lights of the store across the street, also owned by Ivy. Smaller trucks zoom by, followed by the occasional eighteen-wheeler barreling down the highway. Another man, white-haired and drunk, joins us on the porch.

Marcus walks near the edge of the street, so he can take a few pictures of the store. An eighteen-wheeler, its sides lit up like Christmas, whooshes by. "Has anyone gotten hit?" he asks.

Raymond and Elzy, who've sat down

on the porch, stare into the businesses across the street. "Not that I know of," Raymond says. "They do go pretty fast out there."

A pickup slows and parks in front of the dance hall. A woman in tight jeans and a man in a jean-shirt and boots emerge from the truck and walk toward us. Elzy, who seems to know everyone, introduces them to us. A striped cat with a raccoon tail slinks up behind me to be petted.

"Where are you staying tonight?" Raymond asks me while Elzy talks to the others.

"Out at the Texas Tech campus," I tell Raymond, "in Junction." I look out into the darkness and am glad we don't have too far to drive.

Raymond smiles. "You'll see my wife there," he says. "She's got Saturday off, but she's working on Sunday."

The two men sit on the porch without speaking, their shared history filling the space. We talk about ranch life and the coming fall while trucks race by. After a half hour, Raymond stands up from the porch and thanks us for giving him an excuse to come back to the dance hall. Elzy gets up along with him and shakes our hands. Lights from the saloon show the crowd inside, their laughter drifting into the night.

Marcus and I wave to the two men before climbing into the Beetle. Unfolding the map, Marcus directs me south on Highway 377 toward Junction. We scan the roadsides but see nothing but trees. "The deer must be in bed," I say.

Marcus nods and unwraps a Starburst for me. "What struck you most about London?" He hands me an orange candy.

"The lawlessness," I say. "What about you?"

Marcus chews a colored square of his own. "The friendship," he says.

Just as the orange tang fades, Marcus hands me a pink candy square. I remember Elzy and Raymond laughing in the hall and sitting on the porch.

We stop at a gas station for directions and a few more road snacks. It's late, and the town of Junction has long since tucked itself into bed beneath curtained windows and empty streets. A young man at the store offers to lead us out to the campus, and we follow his truck across a one-lane bridge that spans the Llano River. Rather than eating along the highway, all the deer are at Texas Tech's Junction campus, resting in groups a safe distance from the driveway.

I stop the car at the campus Field House, where we're staying for the weekend. The sky is frosted with stars. Marcus sticks his head in the small building, me close behind. Under fluorescent lights, we see an office lined with fishing poles, a plastic Canadian goose on a bookshelf, and jars of fish swimming in formaldehyde. We're not sure we're in the right place until Marcus finds a bedroom with bunk beds and two sleeping bags.

Along with bathrooms and a kitchen, the Field House has a classroom with a human skeleton, rain slickers in a closet, and rubber boots ready near the doorway. We stash our belongings and ignore the skeleton. The place looks like the research lab that it is, although the last dates scrawled on a white board calendar are from 2004. "I wonder if someone will come up here in the morning," Marcus says.

"We'll close the door to the bedroom," I say and unroll one of the sleeping bags. I'm too tired to worry about visitors. I curl inside my green cocoon and adjust to pitch blackness and the wind blustering against the windows. I imagine we're camping, like the Hunter's Ball attendees at London, two friends sharing a weekend. The deer sleep outside, a skeleton sleeps inside, and Marcus and I swap stories before we, too, doze off.

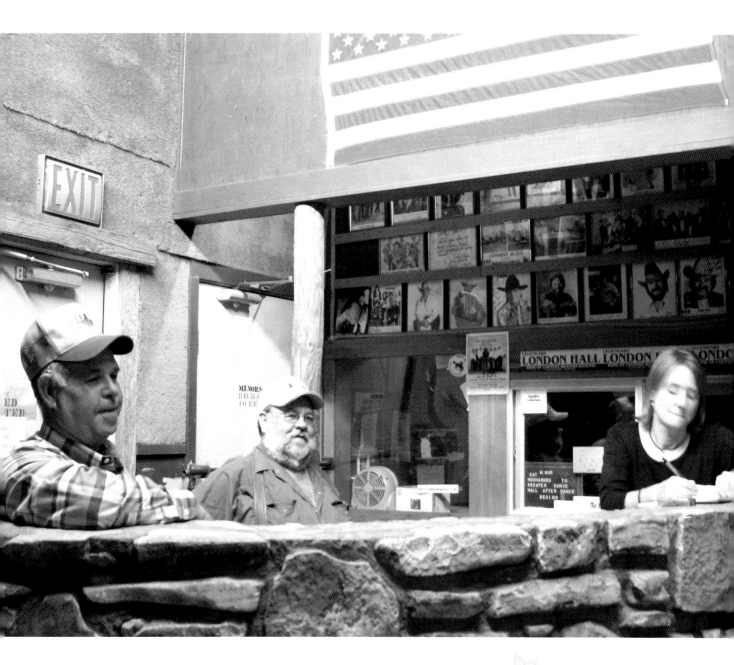

Elzy Beam (left) and Ray-
mond Blaylock share stories
with Folkins.

London Hall

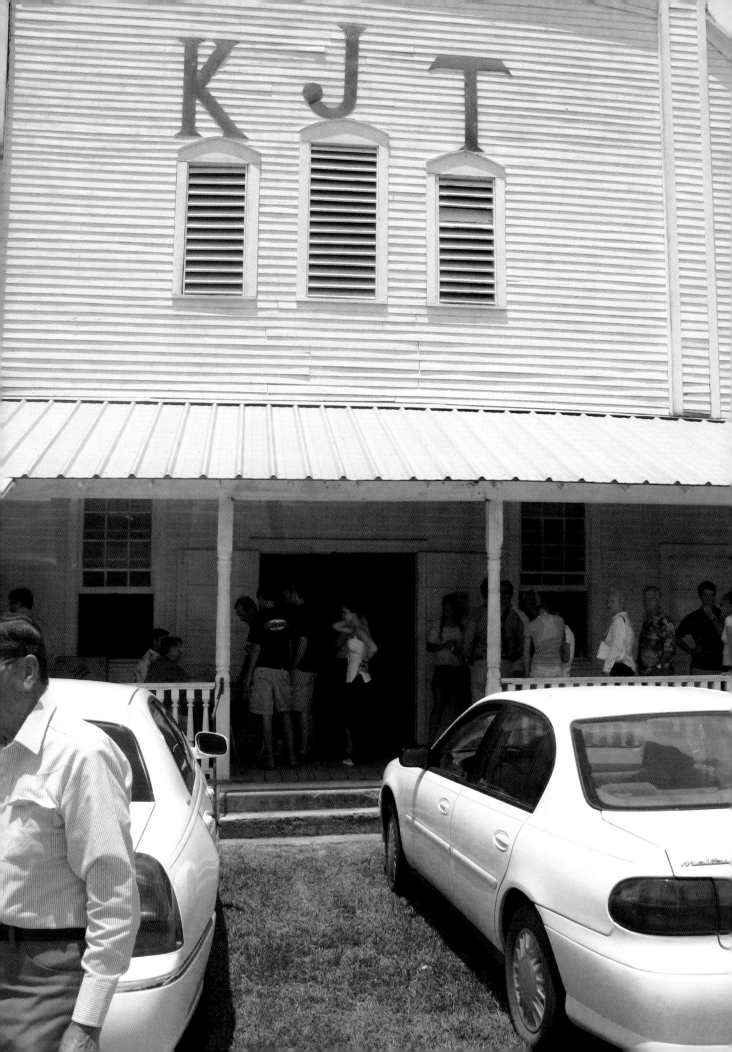

5 WHERE EUROPE TALKS TEXAN

■ *KJT, Dubina, and Freyburg Halls*

Riding in a tan van through Fayette County, I breathe in fields of blowing grasses, the narrow road we follow parting them like a comb. On a road south of La Grange, Gary's expression brightens. He adjusts his baseball cap and scans the roadway for a shady space to park. Gary McKee of the Fayette County Historical Commission has volunteered to give me an early afternoon dance hall tour. On this warm day in March, Gary plots a course to the communities of Ammannsville, Dubina, and Freyburg [pronounced FRY-burg]. The sun, straight overhead, pierces through the oak leaves and into the van.

Ammannsville, our dance hall destination, stands at a corner created by three intersecting roads—the asphalt version we drive on, a dusty dirt road that meets it from a grove of trees, and a second dusty road that I later learn leads back to Schulenburg. From the shady parking spot that Gary takes, we climb from the van. Above us towers a well-preserved dance hall, painted white with a hint of yellow.

I look up to read the tall black letters on its front: KJT, which stand for *Katolika Jednota Texaska* (Catholic Union of Texas). Ammannsville served as one of

four original lodges within the KJT, a fraternal Czech Catholic organization formed in 1889. Fayette County records state that Ammannsville, Dubina, and Hostyn were the first Czech settlements in Texas, and about 75 percent of Czech immigrants were Roman Catholics. A nearby church, painted an even brighter shade of white, points its steeple toward the clouds.

The only other car that sits in the gravel parking lot belongs to a group preparing for a picnic. Ammannsville and other local communities host church picnics, family reunions, and saint's days celebrations in their halls. "We've had parties here until two in the morning," Gary chuckles. He adds that someone can celebrate an entire lifetime in a dance hall, from baptism, to birthday parties, to wedding and funeral receptions.

Inside, a blonde woman in her forties smiles and greets us. Behind her, white chairs and rolls of ribbon cluster along a side table. A man sets up chairs and drapes ribbon across them. Gary walks up to the woman and offers his hand. "We're doing research on these halls," he says.

She stands up from the table. "Feel

A line forms outside KJT for the annual parish celebration and picnic.

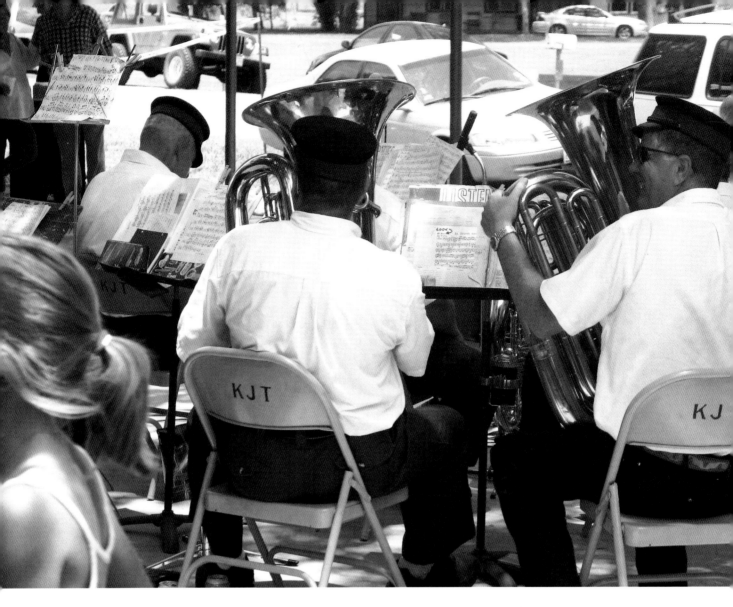

free to look around." She gestures at the scattered chairs and decorations. "We're just setting up." She sits back down at her table, returning to the papers in front of her.

Gary takes his camera and investigates a corner of the dance hall where the man unfolds the chairs in careful rows. My footsteps slide over the well-worn dance floor, which looks like it could be the original. The vaulted ceilings, painted creamy white, hold carved flowers and trailing vines. With eyes still skyward, I wander over to Gary. In his Hawaiian shirt and khaki shorts, he points his camera at the ceiling and sides of the room. Sunlight streams in

through the windows. We walk back to the front door where the woman sits. She smiles and stands up from her work to tell us goodbye. "You should go to Praha Hall, too," she tells me. I glance at Gary. A dance hall perches on every corner of this community.

A month later, the parking lot at Ammannsville is anything but empty. At KJT hall, a crowd gathers for an afternoon parish picnic. Unlike my first visit to the dance hall, where Gary and I were the only visitors, the hall parking lot this time is packed with more than 2,000 visitors drawn to fellowship, fried chicken, and live polka music. I share a plate of ham, potato

Members of the Round-Top Brass Band pause between polkas and waltzes.

Texas Dance Halls

Oak limbs, propped up due to their age, curl outside the front of Dubina Hall.

salad, and green beans with Marcus, who's made this trip with me. "I'll get some ice tea," he offers, leaving his camera at our outdoor picnic table and walking inside the hall. I make sure his place is in the shade.

Across from me, Bobby and Dorothy Fajkus, long-time Ammannsville picnic-goers, smile and introduce themselves. Bobby has light-colored hair and an easy smile; Dorothy, darker-haired and wearing a summer top, chats to the woman sitting beside her. Bobby glances at the polka band, which sets up for its next set. "We come every year," he says, explaining that he and his wife make the hour-long drive from Flatonia to Ammannsville. People come from all over the area to attend these events. "We used to dance here," he adds, glancing at the dance hall. "Now, we come mainly for the picnics. From May through September, there's a picnic in the area almost every weekend."

The Round-Top Brass Band starts up a steady polka beat from the bandstand. Picnic goers inside the dance hall lean

outside the open windows so they can watch both the musicians and the dancers outside. Marcus, who comes back with a Styrofoam glass full of iced tea, reports that the hall is filled to near capacity with picnic goers either standing in line or sitting down with their plates.

Bobby grew up with church picnic traditions as part of his Czech heritage, even speaking the Czech language on occasion. "I spoke Czech in high school, and I can read it and write it." Music is another important part of the picnic, he adds, nodding toward the polka band members in their white shirts, black pants, and black caps.

Dorothy and Bobby turn and face the band. Both hope to see the Czech traditions of Texas, like the dance hall and the picnics, survive. Bobby tells us about George Koudelka, the polka band's drummer, who has a history of playing at dance hall events and picnics.

The area's next picnic, which takes place on August 15, will be in Praha, Bobby says. I ask him how long the cele-

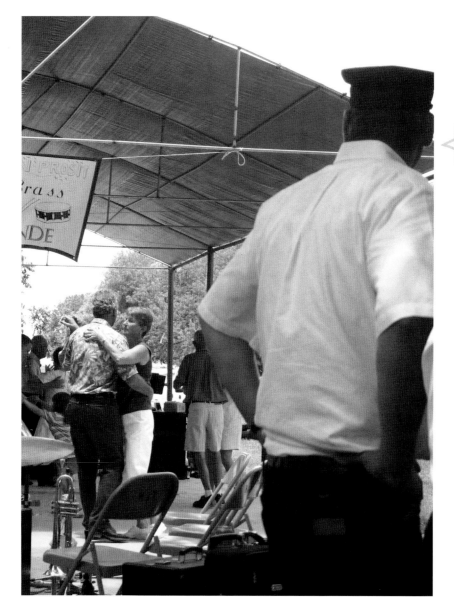

A band member looks on as couples twirl across the dance floor in the pavilion outside.

bration will last today, guessing it might linger into late afternoon. "It'll keep going for hours," he assures me. We watch the couples fill the outdoor dance pavilion, starting a celebration that'll last long past daylight.

Down the road from Ammannsville, Dubina Hall emerges as a sudden cluster of buildings hidden in an oak tree grove. Established in 1856, Dubina was one of the largest all-Czech settlements in Texas. History books tell of a sleet storm the first immigrants endured to settle the scenic

community late in November 1856. The community survived its first winter and planted for spring, but the resulting crop the next year was still only one bale of cotton.

Eventually, the town grew more prosperous, and community members built a church and dance hall as part of their settlement. The dance hall, which nestles in a small clearing next to live oak trees, derives its name from the Czech word for oak, *Dub*. Although smaller than Ammannsville, the Dubina dance hall looks no less grand with its wooden

Texas Dance Halls

Picnic goers stand in line for fried chicken, ham, green beans, rolls, tea, and cobbler.

floors illuminated in the afternoon light. A group of twenty townspeople mingles around plates of barbeque for a Sunday picnic. They invite us to join them, but we politely decline, still full from lunch earlier that day.

I look at the stairs that climb up one end of the building to a catwalk along the second floor. Gary takes a few discrete snapshots with his camera. After a few moments in the hall, we cross the green lawn to the Saints Cyril and Methodius Church, which was built in 1912. Although the community's first church was constructed in the mid-1870s, a hurricane destroyed it in 1890. Inside the double doors, Czech scrollwork covers its sides with intricate flowers in blue and green. Gary and I stand in the entryway and admire the bright colors of the detailed stenciling. The intricacy of this church, as well as others in the county, encourages both locals and those from further afoot to tour them.

On the steps outside the church, we

meet Ed Janecka, Fayette County judge, who approaches us with a determined stride. In jeans and a t-shirt, he tells me about dewberries, a wild berry that grows in the community and makes a good jelly.

"They're sour?" I ask.

He shakes his head. "Sweet."

With natural poise, he gestures at the dance hall we've just visited. "It was built in 1936," he says, "by the KJT." Mules were used to haul much of the lumber. Underneath the hall, the mules' hoof prints are preserved. "It was very wet when they built the hall," Ed says. "You can still see the clods of dirt they left."

He looks toward the open fields where a wooden platform once stood. Before Czech organizations, such as the KJT and SPJST (Slavic Benevolent Order of the State of Texas), became large enough to build dance halls of their own, the community relied on private homes or wooden platforms for danc-

ing. Dubina's was called Peter's Platform. "People came from all around for weddings and dances. The platform was on raised cedar posts, with a cover for the bandstand."

To advertise their dances, the community relied on a tall flagpole near the platform. "If a flag flew, it meant there was a dance," he says. The townspeople learned about funerals in a similar fashion from a church bell, which chimed once for a man, twice for a woman. The wind flutters around us on the steps, although the bell stays silent for now.

We move our feet aside so the church priest can pass and murmur a greeting in his direction.

With so many dance halls scattered throughout the area, Saturday night dances peppered Fayette County. "The Czech musicians played the accordion and made their own beer," Ed says. "In the 1920s and '30s, the Charleston was big." For a typical Czech wedding, which sometimes lasted as long as three days, the hall could pull in as many as 800 people; their horses would take them home afterward. "It was a place

After lunch, picnic attendees can dance outside or try to win goodies at this roulette wheel.

Texas Dance Halls

for people to get together," Ed says of the dance hall at Dubina. "I have wonderful memories of growing up here, with the polka and folk dances, along with some rock dances." He stares across the green lawn to the dance hall, where a few people finish their lunch.

Today, the rural location of the dance halls impacts the performances they host. "People don't live as close to the halls as they once did," Ed says. "It used to be, there were halls everywhere, some in the middle of nowhere." The 1930s were the golden age of Czech polka music, he adds. After World War II, many of the polka bands broke up, and the growing popularity of country and rock music soon changed the flavor of the music played within the halls.

"We give polka and waltz lessons at the hall," Ed says. Along with providing a social outlet, such efforts also keep the traditional dances alive. Gary's eyes light up at this news; I watch him make a mental note about the next sessions. "My favorite thing," Ed says, "is when the dancers all move together as one." I can't tell if he's talking about past or present, and decide he probably means both.

Saints Cyril and Methodius Church in Dubina is one of the area's painted churches.

KJT, Dubina, and Freyburg

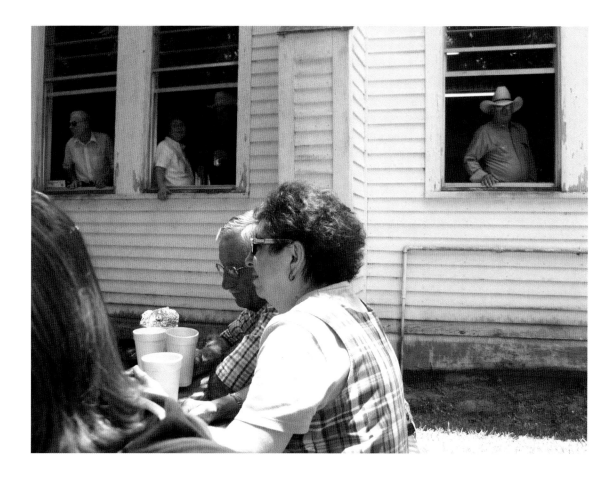

Gary's van whisks between a cluster of trees and speckled sunlight toward a landmark known as the Piano Bridge. At the edge of the Navidad River, dark wooden slats of the single-car bridge start to mumble under the tires. I look out my window to see each board dip and rise as we drive over; the van plays each board like a piano key. "Listen," Gary says while he lowers the side windows and slows down. The slats not only give as we roll over them but vibrate like a piano. On the other side of the bridge, forest trees open up to fields edged in sunlight.

In Schulenburg, a town that sits directly between Houston and San Antonio, we stop to see Gary's friend, Lonnie Pettit, who runs Freyburg Hall along with a restored 1927 combination hotel and theater, the Von Minden. Having just been out hunting, Lonnie wears head-to-toe camouflage. He leans

against his truck in the sun and stares up at the building with us. The brick structure rises four stories. This forty-room hotel was built during the height of railway transportation in the area, making it a convenient stopping point. During the 1920s and 1930s, vaudeville acts performing in the Von Minden were broadcast to Ft. Worth. Today, the hotel hosts overnight guests and shows films rather than live performances, its customers munching slices from a pizzeria housed in the same building.

Running historic Freyburg Hall also comes naturally to Lonnie and his family; various members of the family perform music, including Lonnie, who sings and plays mandolin. "It [Freyburg Hall] was a venue for us and everyone else," Lonnie says. Sister Morales, the Thunderbolts, and the Crazy Kings are a few of the other bands that perform there.

Hanging around windows and doors or sitting at picnic tables gives the atmosphere a friendly, festive air.

Texas Dance Halls

Lonnie lends Gary the keys so we can go see the hall for ourselves. The van turns down another rural road. A German community, Freyburg was founded in 1868. Today, the community has three cemeteries, a store called the Ehler Store building, the United Methodist Church, and Freyburg Hall. Freyburg members of the Schulenburg Order of the Helmut Sons, a German fraternal organization, built the hall in 1892. Along with dances, the hall also hosted weddings, political events, and silent movies.

No signs mark the country road where the dance hall stands in the shade of oak trees. "How did anyone find this place?" I ask Gary.

He shrugs. "They just knew about it," he says. "Through word-of-mouth." I watch the roadsides for landmarks, wondering how I would ever find the hall.

Gary samples several of the keys on the jangling ring Lonnie loaned us before opening up the side door to the dance hall. It's dark inside, but spaces between the boards let in thin strands of light. Gary manages to find the lights so we can take a closer look. Inside, a large kitchen nestles at the back of the hall. Vintage restaurant booths from the 1950s supplement the tables and chairs used in the seating area; white Christmas lights arc across the ceiling. Back outside, in a small pavilion labeled as a beer garden, we can barely open the doors to the massive barbeque pit, a feature Lonnie claims is one of his favorite things about the hall.

We take a last look inside before closing up. In the bright light of mid-afternoon, I imagine the hall awhirl with both darkness and dancers.

After locking up Freyburg Hall, Gary winds the van back to Schulenburg. On the way, we make a brief stop at High Hill, a community just a few miles outside Schulenburg, to visit its church and dance pavilions. The small town, founded primarily by German settlers, consists of several small communities that came together in 1858 so they could open a post office.

We step inside Saint Mary's Catholic Church, one of the few remaining structures of High Hill. Our eyes stretch up the steep gothic architecture of the church, which is reminiscent of Europe. Stained-glass windows color afternoon light. I stare at the jeweled greens, purples, and blues, along with the windows stretching for the sky in this 1912 structure. Outside, Gary points to a parish hall and pavilions that the community still uses for local events and dances. The benches and a gazebo blend with the curving oak trees that surround them, almost as if they'd grown up together.

Back in the van, I sift through the Schulenburg brochures Gary has picked up along the way. He takes me on a quick tour of the rest of the area, from schools to the 1929 Carnation plant where his father worked. Because of the multiple shifts that residents often take on, the town of La Grange has negative unemployment. When a McDonald's first opened outside of town, Gary says, they could hardly find people to work there. He grins with pride. I watch the shadows lengthen across the roadway. In the distance, no golden arches loom, but the spire of the historic church we've just visited pokes from the trees and reaches for the sky.

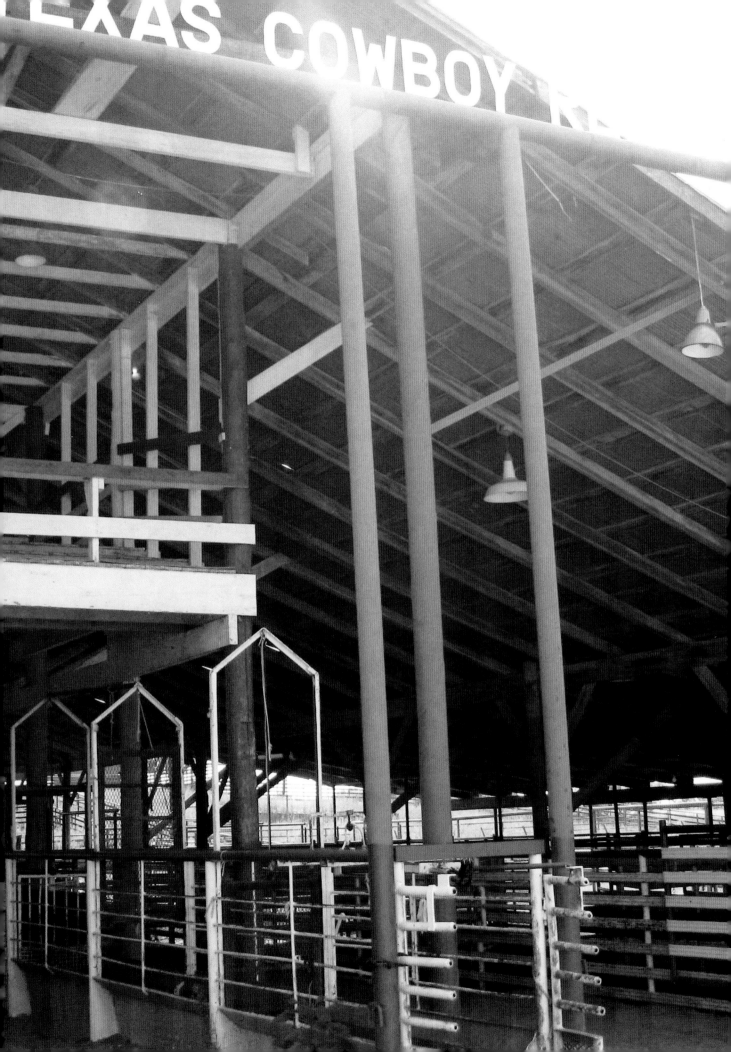

6 DANCING, BOOZING, AND HORSES

■ Roundup Hall

The road to Stamford, a West Texas town, rolls between hills green with rare summer rain. Marcus points his digital camera at the clumps of buildings and twisted trees we see out the window. Passing through one of the small communities along the way, Swenson or Sagerton, the trees open up to store fronts, and the speed limit makes a quick dip from 70 to 40 mph.

Just as I shift the Beetle into a lower gear, I notice a man in periwinkle hospital scrubs. From the way Marcus aims his metal-frame glasses at the man, I know he's seen him, too. We both stare as the man strides from a double-wide on the side of the street carrying the biggest rifle I'd ever seen. "Is that guy going to shoot us?" Marcus jokes. His red beard frames a smile.

"No," I say with fake nonchalance before I check the speedometer again. Maybe the man in scrubs is tired of people, out-of-towners like us, speeding through his community.

But the man takes his gun and steps into a van parked alongside the road. Our Beetle sails by, a little slower but unharmed. It's a near wild-west moment that isn't out of character for Stamford, a town that was the place to be in the

1950s. Founded as a railway crossroads, Stamford was named for the Texas Central Railroad President's hometown in Connecticut.

Having two versions of the town, one from the East and one in the Southwest, made me careless when I first called the Chamber of Commerce. "I was hoping to get some information on the Stamford Roundup Hall," I said.

"Hmm, I've never heard of it," the voice on the other end of the line said.

I stayed on the line and didn't know what to say. From the stories that Stamford native Ron Calhoun, introduced to me by a good friend, had told me about his town, Roundup Hall sounded too famous not to know.

"Let me go check," the woman on the phone said.

In the time it took for her to leave the phone, it dawned on me that her drawn-out r's meant Connecticut—not Texas. I apologized for calling the wrong state, but she just laughed. She would've fit into Stamford, Texas, just fine.

The Roundup Hall was built in 1939 by the Old Timers Association, a group that honors local pioneers and descendants. The association remodeled the hall in 1951, updating it with air condi-

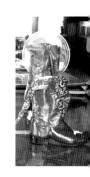

The Texas Cowboy Reunion and Rodeo is still held each Fourth of July. Participants come from all over the Southwest to participate.

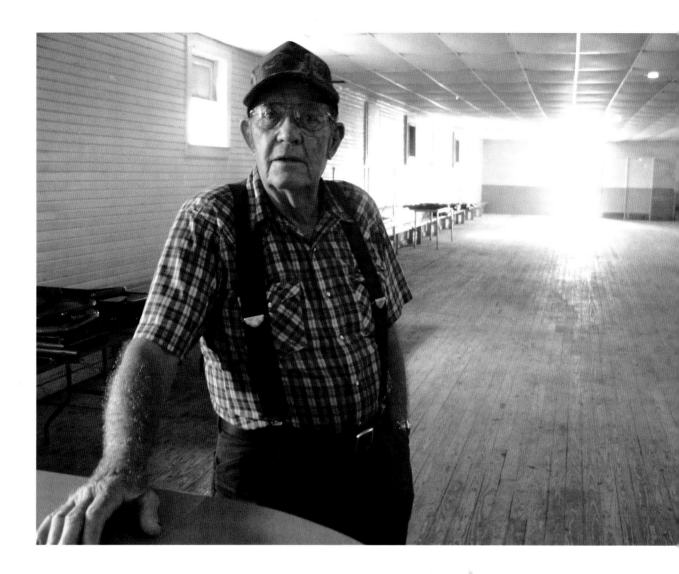

Louis Corzine, hall care-taker, pauses for a moment while giving a tour of the hall.

tioning. Over dinner one night, Ron told me that the Roundup Hall crowd in the 1950s included patrons from all walks of life, from local business types in suits to cowboys in Levi's and boots.

When Ron was a teenager, the cover charge for a show was $3.50. "But Bill Longley, promoter of the dances, would let me in free because he was a longtime friend of my parents." In addition to running the dances, Longley served as Democratic chairman of Jones County and later became an assistant to Congressman Charles Stenholm after his election in 1978.

As Marcus and I pull up to the Roundup Hall, a breeze sweeps the rock

face of the building in a gritty whisper. The western backdrop of pastureland and rodeo grounds fit the description that Ron had given me a few weeks earlier. He told me that people once flocked to Stamford's Roundup Hall from surrounding towns as far as Abilene. They came to have a good time and dance to the live performances of artists like Bob Wills, Hank Thompson, Hank Snow, and Lefty Frizzell.

Despite the popularity of the dances, citizens of Stamford had a love-hate relationship with the hall. "Most of the 'nice' people in Stamford considered the dance hall to be a sin den and off-limits to high school kids," Ron said. "My

Texas Dance Halls

mother would have had a fit if she had known at the time that I was going out, she who was such a good dancer at the country club."

At the dance hall entrance, Louis Corzine, hall caretaker, and Barbara Billington, a Stamford native and past president of the Old Timers Association, both greet us. While Louis and Marcus stroll around the hall, Barbara sits with me in the bleachers holding a Stamford history book on her lap. In the 1950s, Barbara and her friends danced to whatever band played, whether it was Bob Wills or a local band. At the time, it was the social thing to do; unless Barbara had a date at a drive-in movie or a football game, she went dancing.

"We cared more about the dancing than who was playing," she says. "We danced a million miles here as teenagers." She smiles as she talks about the rodeo grounds, bunkhouse, and dance hall. "When I grew up, this place looked like a movie set from the 1940s or 1950s."

Inside the hall, we can almost hear the sounds of feet shuffling against the soft dust of the dance floor. Joining Marcus, I walk across the empty room and gaze toward the stage where country and Tejano sounds are still played. It isn't hard to imagine a weekend dance and the hall filled with everyone from cowboys to townspeople.

An hour later, we cross the dirt driveway to look at the bunkhouse, which now serves as a museum. Years earlier, it housed cowboys who visited town for the rodeo. Louis shows us worn saddles, along with the black and white photographs of cowboys and cowgirls. He points to the head of a black longhorn, its fur dulled with years, which hangs over the bunkhouse fireplace. Smoke used to come out of its nose whenever someone made a fire, he says. Most cowboys didn't spend much time by the fire, though; on warm summer nights, they'd cross the parking lot gravel to the Roundup Hall instead.

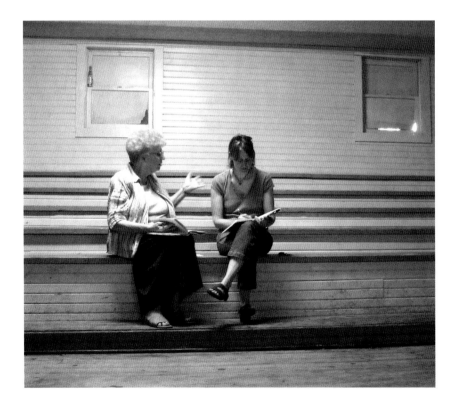

Barbara Billington, left, a Stamford native who teaches at Anson High, talks with Folkins about her connection to the Old Timers Association, which includes a role as one-time president.

Roundup Hall

"On Saturday nights, the front, back, and sides of this place were filled with cars," Ron says. One of the Roundup Hall performers Ron remembered most was Bob Wills. Wills gave several Stamford performances, most at the hall, with one 1946 appearance at the town's historic airplane hangar.

"The dance was at 7 p.m.," Ron said. "At 6 p.m., there wasn't a soul there. At 6:30 p.m., there were about three cars there. At 7:30 p.m., there were cars everywhere, more than the parking lot could handle. Cars parked down the road out front, and finally there were 'hundreds' of people there, all starved for entertainment and a good time after the war was over." Ron said it was the only instance he knew of that the airport was used for a dance, although he remembered other nights on those old asphalt runways, "two or three carloads of us drinking beer and dancing to the car radios."

He also had vivid memories of a performance he didn't see. During the mid-1950s, Ron dated Sue Ann, daughter of a Lone Star Gas Company foreman. "I was taking Sue Ann to a picture show," he said. When he picked her up for their date, Sue Ann talked nonstop about a guy she and her friends had met at a downtown coffee shop. Sue Ann and her friends had driven him around town and agreed this man was the best-looking thing they'd ever seen.

"She wouldn't stop raving about him. I told her to shut up or I was going to take her home. She wouldn't quit, and so I took her home." Ron's car pulled up to a quick stop in front of her house; Sue Ann's father, sitting inside reading a newspaper, wanted to know what the heck was going on and why they were home already. "I told him, and he said he didn't blame me, and who the heck was this 'Elvis' person?" Sue Ann didn't remain starstruck for long. After Elvis Presley left town, Ron and Sue Ann

dated on other occasions and remained friends for many years.

Both Ron and Barbara mentioned a dance called the "wolf stomp," where boys whirled the girls in the jitterbug and made their feet hit the floor. Although Barbara, who focused on dancing and her friends, never found the Roundup Hall too wild, Ron's memories are different. He remembered, for instance, the man in the Navy uniform who walked into Roundup Hall, strode up the center of the dance floor toward the band and started a fist-fight for no particular reason.

"Jones County was the wettest little dry county you've ever seen," Ron said. "Driving around the parking lot during the dance hall intermission, it was easy to spot the beer in all the open trunks. The Roundup Hall had a reputation. Charles Brownfield, the county attorney, had plenty of criminal cases here, from fights to bootlegging. A lot of ex-cons came from Abilene, too. But it was good music and good booze, a great old time."

Two of the biggest bootleggers in Stamford were brothers Roy and Cleo Macon. "And I mean 'big,'" Ron said. "Both were well over six feet tall and had a rough and tough reputation to match." Ron befriended Cleo Macon's son, D. C. (Dick), who gave him insights into the family business.

"In the evening, Cleo would open a pint of whiskey and set it on the kitchen countertop, with a jigger and a water container. Any friends or customers were welcome to come by and have a shot, and maybe a pint or two, at six bucks per pint." Ron said that Cleo loved fast cars, drove a Cadillac, smoked a big cigar, and had gotten into trouble a time or two. "Word was he could outrun any law enforcement vehicle that might accost him on back roads from Fort Worth to Wichita Falls, the nearest whiskey-store points in those days."

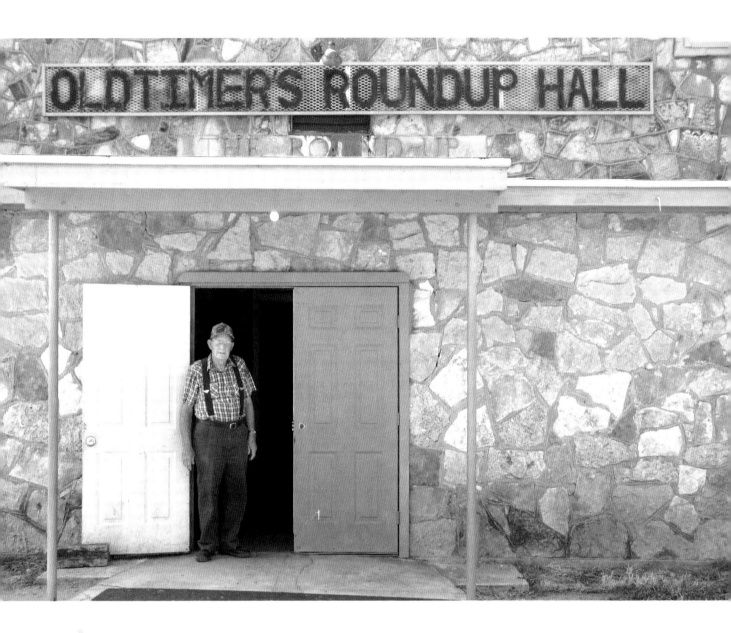

OLDTIMER'S ROUNDUP HALL

THE ROUNDUP

Cleo's brother, Roy, meanwhile, showed much more discretion as a bootlegger. Ron said he operated his business under a cover of operating power mowers, which were new and unusual at the time. The one time Ron saw him in action was when friends called him from a card game; he showed up in his Cadillac with two bottles of bourbon, which all the card players chipped in to buy.

Another town bootlegger, Aunt Dora, had a large, ramshackle house at the edge of town. "You pulled up in her driveway," Ron said, "and she would

come out and ask what you wanted. You would say, 'Aunt Dora, we want to make a contribution to your church.' She'd ask 'how much?' If you said $5, she would have her girls bring five quarts of cold beer." Ron went inside Aunt Dora's house a couple of times. "A big room in the back had a music player and served as a dance floor, with three or four girls sitting around waiting to dance with any 'church members' who happened by."

A more discrete bootlegger had an old house southeast of Stamford. He sat on the front porch of his unlit house and

The museum is part of the original bunkhouse, which was built between 1934 and 1935.

Texas Dance Halls

shone a light on those who approached him; all you could see, Ron said, was the light. "He would ask you who you were, who told you to come there, and had you been before." If he was satisfied with the answers, he'd have one of his helpers bring back beer. If he wasn't, you never knew; word was that he kept a shot gun on his lap.

Yet another bootlegger was "Roundy," named for his muscular stature as well as the rounds he made of the parked cars for weekend events at the Roundup Hall. Roundy got arrested, according to Ron, for wearing a long coat on a warm night that had too many pints and half-pints of whiskey tucked inside it. "He tinkled like 'bells' as he walked along, which betrayed him to the liquor control boys."

The irony of the good times in Stamford was that as wild as the Roundup Hall could be, neighboring towns like Anson forbid dancing. "People in Stamford were just different and fun-loving," Ron said. "We went to church every Sunday, but the preacher never went past noon; he didn't want to interfere with the Dallas Cowboys or peoples' golf games." Ron attributed the free-spirited ways of his hometown to the Swedes who settled the territory in the late 1800s. "They loved to have fun and still do, whether it's dancing or playing golf," he said.

Like many Stamford residents, Ron grew up there but didn't stay. The population of the town, which in the 1950s hovered around 5,000, is now around 3,600. Ron attended Texas Tech in the late 1950s. When some of the students rode horses into the old student union building and blocked the entrance, it didn't surprise Stamford-born Ron. After getting a bachelor's degree in journalism with a minor in history, Ron served as a copy editor for Lubbock's *Avalanche Journal*. He worked as a political reporter for the *Dallas Times Herald* from 1967–1989,

meeting George Bush Sr., George W. Bush, and Lyndon Johnson. After working at the Texas General Land Office from 1989–1999, Ron retired and now lives in Austin with his wife, Marilyn. They still drive to Stamford to visit Ron's mother, Louise Calhoun, and to take part in the Fourth of July rodeo celebration. The family has a history of involvement in this affair; Ron's mother was honored as event hostess, and his father has served as a parade marshal.

Stamford, a cowboy town to start, is reborn with each year's Texas Cowboy Reunion and Rodeo, an event held each Fourth of July. During the rodeo weekend, hundreds of horses invade Stamford; they're everywhere, from downtown to the rodeo grounds to the city park, where many people camp. Their presence, Ron added, is evident not only in the pastures and on the rodeo grounds, but from the horse apples left on the streets.

Even after the rodeo ends and the competitors move on, the town stays horse-friendly. "In the evenings people would ride their horses around town," Ron said. "It wasn't unusual to see four or five people, young and old, on horses going down the street." Ron grew up near a neighbor, Bob Johnson, who owned several horses. Bob let Ron roam among the stock tanks and sometimes ride the horses.

One year, Bob was appointed grand marshal of the annual rodeo parade and asked Ron to ride along and help him organize the event. It was a big production, Ron explained. "There were all sorts, from townspeople, who kept horses at home, up to the regular, working cowboys who lived out on ranches."

"Bob wanted me to ride in the parade on Light Foot, a gentle mare of his I had ridden before. I told him I had no cowboy getup, no boots, no hat, no nothing. He said that didn't matter. So I showed up on Light Foot, riding her

across town dressed in Levis, white t-shirt, tennis shoes; the regular get-up of kids my age.

"There were about a hundred or so junior cowboys and cowgirls from all around the countryside and nearby towns to ride in the parade. They, of course, razzed the hell out of me." Ron took the ribbing with a shrug and helped Bob organize the parade participants, from registering them to lining them up so they'd flow into the parade. After everyone was ready, Ron untied Light Foot, who'd been left by a nearby utility pole. "I got on Light Foot, and she bucked me about ten feet in the air. I hit the gravelly ground, busting my knees and elbows." When Ron looked under Light Foot's saddle, he discovered a small rock someone had placed there.

"I rode in the parade, suffering the hoots of my friends who were part of the big crowd that lined the downtown streets around the square. Afterward, I rode Light Foot to her enclosure at the Johnson home, took off her saddle and bridle, and never rode a horse again."

After talking with Louis and Barbara, Marcus and I tour the rodeo grounds, walking through wild grasses and flowers that had sprouted up near the arena and live-stock pens. It's a place where calf rop-ing, barrel racing, and bull riding still take place each year. On the way back, we pass plastic flags near an arena and a sprig of blue flowers. A breeze wavers and the afternoon sun burns.

Barbara remembers the rodeo as one of the best times in Stamford. When it started in 1930, it was billed as the largest amateur rodeo in the world. "Cowboys came to town for the rodeo and stayed for the Saturday night dances," she says. Although Stamford still hosts rodeo events and a parade, the dances take place in a pavilion instead of the Roundup Hall.

"Now, it's used for private groups and their dances," she says. The hall hosts a dance about once a month. It's not the weekend dances of the 1950s, but such events provide money to keep the hall going. "Our [small] towns are dying," Barbara says when asked about West Texas dance halls. Without a larger urban area nearby, dance halls face a struggle for survival. "It's a sad thing," Barbara said, but adds that the Roundup Hall will keep going, right along with Stamford.

We leave behind the spacious floor and vacant benches that await the next dance; I imagine the parking lot filled with cars. Before walking to his truck, caretaker Louis locks up the rural dance hall and bunkhouse while the sun edges lower and a western wind blusters.

Texas Dance Halls

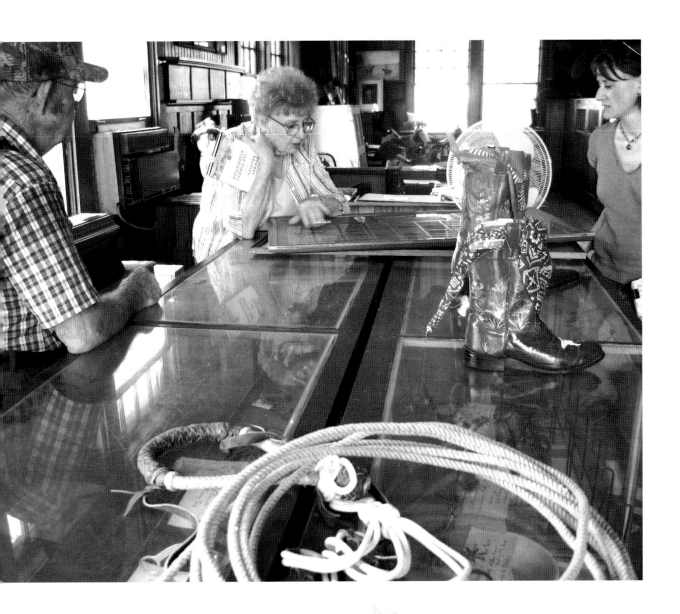

*Corzine, Billington, and
Folkins studying the list of
past Old Timers Association
presidents in the museum at
the bunkhouse.*

7 STILL BURNING BRIGHT

■ *Star Hall*

On a late summer day at Star Hall, a dance hall located about seven miles east of Temple, the dancers are shopping. I join the group of regulars who prowl rectangular tables covered with donated items—plants, thick-frosted cakes, bottles of wine, and one stuffed bear in a blue shirt. Many trade jokes as they scan the table. Others, like me, do their shopping solo. From the picture window behind the table, the sun takes its time dimming cornfields outside.

I watch a brunette woman in jeans and a red shirt scribble her name and a price on a slip of paper and place it back beside a German chocolate cake. On these bits of paper, prices creep up as shoppers write down their bids. It dawns on me that this is a silent auction, with the banter of an auctioneer unspoken. I look toward the end of the table at the teddy bear wearing a bright t-shirt with SPJST across the front. This group was formed in 1897 by Texans who preferred to form their own fraternal group rather than join existing national Czech organizations.

From a founding branch in La Grange, additional SPJST lodges sprang up in settlements with large Czech populations across Texas, including the town of Seaton, where Star Hall now

stands. Underneath the letters on the bear's shirt, a tagline reads "Insuring and Enriching Lives." The paper beside the bear is blank; I write my name and pledge a dollar beside it, touching the bear's shiny button nose afterward.

Near this table packed with merchandise, musicians take turns lifting equipment on to the stage. My husband, John, hefts a speaker cabinet up the wooden steps as if it were Styrofoam. TC spots me at the merchandise table and introduces me to Edwin Pechal. Ed, a tall man in his fifties, serves as president of this local SPJST and its dance hall. As Edwin and I take seats at a table on the dance floor sidelines, I watch shoppers circle the table, write down their bids, and hope for a prize.

Just over a hundred years ago in rural Seaton, Joseph Sefcik visited the store of his friend and neighbor, Frank Motl.

Frank opened a paper bag and started pouring flour into it. "I've been thinking about a lodge, right here in town," he said as he measured the flour. He hesitated and looked down at the countertop before meeting Joseph's eyes. "What would you say about starting a dance hall right here in town?"

The dance hall floor and stage at Star Hall.

Joseph nodded and took the small container of flour Frank handed him. He, too, had been thinking of a way to draw Seaton settlers to town, something besides the practicality of area businesses and the solemnity of church. Farmers in this community lived miles apart from one another. A social gathering place was what this town needed, something apart from the everyday. Along with free time activities, the group could provide fringe benefits, such as insurance and financial support. He'd heard of just such a group forming in La Grange. "I'll join if you will."

Frank's son, John walked up to the counter. "I'd like to join, too," he said without asking his dad, who just smiled.

Joseph whistled as he left the store. In the space of a few minutes, they'd found three charter members. With a little work, they'd soon have a community center to look out for one another, maybe even a dance hall to celebrate in. Before heading back to his team of horses, Joseph stepped into the blacksmith shop of his friend, Thomas Mikulastik. "What would you think about a lodge in our town?"

Thomas set down the iron shoe he'd been hammering and took a step back. He ran his finger over the shoe before answering. "It's a good idea," he said, agreeing to be the new lodge's fourth member. Before Joseph Sefcik headed for home, Joseph Holan had joined as the fifth, while Joseph Jez agreed to be the sixth, on the condition that he discuss the idea with his wife first.

The new members of Lodge 47, Seaton Star Hall, held their first meeting on March 1, 1903, in Thomas's blacksmith shop. Frank gave the lodge its Czech name of "Hvezda Texasu," meaning Central Texas. After the first few meetings, the group moved their sessions to the Seaton School. The new lodge prospered through both eager participants and a growing membership. Joseph later recalled treasurer Joseph's description of those first meetings: money entrusted to him, Holan said, embodied precious hard work, as solid as a blacksmith's anvil.

Three years later, on Labor Day 1906, Joseph poked his head outside the door of the new lodge dance hall. Rain drops drifted from a slate gray sky. Inside, cou-

In 1903, lodge members held their first meeting in Thomas Mikulastik's blacksmith shop.

Edwin Pechal, president of SPJST Lodge 47, shares the history of Seaton Star Hall.

ples laughed and spun around the dance floor, too caught up in their celebration of the hall's first dance to notice the weather. Joseph ducked his head back inside. Raindrops quickened, but the couples kept dancing, all forty-two lodge members and their families ignoring the coming storm. Joseph, too, shrugged it off. It was their first dance in the new hall; it would take more than a little rain to keep them from celebrating.

At a break in the music, a woman opened the door for air. She frowned at the damp sky. "I wonder how we'll get home tonight," she murmured to her husband, who walked up behind her. Her eyes drifted from the clouds to the ground below the hall steps, which was thick with mud.

He looked back at his wife, radiant in her best dress. "It'll be fine," he said. "Come dance with me."

A few hours later, Joseph stepped outside again. With hours of rain, the mud had spread beyond the doorway toward the road; their wagons might not make it. Back inside the humid warmth of the dance hall, Joseph didn't tell his

wife what he'd seen. Tonight was about celebrating. He placed his hand on her elbow and led her back to the dance floor. Rain competed with the music, and latecomers to the dance tracked in fresh mud, but the lodge members laughed and kept dancing.

In the first light of dawn, Joseph helped his wife into the buggy for their drive home; he felt lucky they didn't live far away. Avoiding the slickest spots, he scrutinized hoof prints and wagon tracks. It took twice as long, but Joseph and his wife made it home, as did everyone else who celebrated at their new hall.

A year later, Joseph again drove his team of horses toward home, this time braving thick summer air instead of mud. He wiped the sweat from his brow. Before turning down the dirt road that led to his house, he glanced across the street at the dance hall. A bright light shone through a window. Joseph frowned as he reined in his team and drove a few steps closer. There wasn't a meeting scheduled in the dance hall that night. Clicking to the horses, he stared

The blacksmith shop is just down the road from the current hall.

at the shining light that didn't make sense. It looked as if it were flickering. A few steps more, Joseph knew it was flames that danced between the building's cedar posts.

Joseph slapped the reins against the backs of his team and urged them home. Foaming saliva flicked from the horses' bits as they stopped in front of his house. Inside, Joseph roused his wife, who grabbed a shawl and ran with Joseph to Thomas's house for help. All three loaded guns and buckets of water into the wagon before driving back to the dance hall. By that time, flames reached the roof.

"Looks intentional," Joseph yelled. His mouth set in a firm line, he handed Thomas a gun. The two men fired shots inside the structure, Joseph aiming in the kitchen while Thomas pointed his gun inside the dance hall itself. Other than the crackling flames, the men heard no one.

Joseph's wife thrust a bucket of water into her husband's arms. The two men doused the fire from the bucketfuls of water she handed them. All three worked in determined silence for what seemed like hours, though it was only a few minutes. The flames hissed with every bucket. Sweat from heat and exhaustion ran down Joseph's face. He wasn't about to give up the hall, especially to an arsonist. Wiping his face on his sleeve, he grabbed another bucket from his wife and heaved it at the fire.

A half hour later, the dance hall kitchen smoldered in steam; charred and dripping beams were the only evidence of the recent flames. After standing around the hall in disbelief, Joseph lifted a weary arm to help his wife climb into the wagon. He realized they'd been lucky—they could've lost everything. The next day, Joseph found a half-gallon container filled with kerosene near the hall. Joseph picked up the container and rechecked the windows, grateful once again that the dance hall had escaped disaster. Neither he nor any other lodge member ever found out who started the fire.

Years of dances and community events passed. During a quiet afternoon in 1920, Joseph's wife watched a pot of bubbling goulash while Joseph kept his eye on a similar basin nearby. They cir-

Pechal and Folkins bracket the Seaton landscape.

Texas Dance Halls

cled the hot pots of stew with chicken wire to keep away hungry chickens, goats, and dogs.

"It's almost ready," she told Joseph. She reached into a pot with a long ladle and took a careful sip, laughing at Joseph as he imitated her and ended up spilling most of the goulash on his beard. She looked across the yard where children played tag and adults set silverware on long tables. Satisfied with her contribution to the lodge's first picnic, she began dishing out hot bowlfuls of goulash.

The early years of the twentieth century saw more active roles for women in the lodge, from the annual picnics established in 1920 to philanthropic projects begun in WWI. During 1917 and 1918, women volunteered their time to the Red Cross effort by rolling bandages and packing boxes with socks, toothpaste, and other personal items. The lodge took a special interest in Czechoslovakian people overseas; Seaton farmers sent bales of cotton, from which women volunteers sewed clothes. They also donated used clothing. These and other projects earned the lodge women their nickname of industry, the "bees."

Mrs. Sefcik watched the guests eat, her mind already working on the next picnic; maybe they'd hold a fundraiser. Behind her, the dance hall, a steady fixture over the years no matter what history, disgruntled individuals, or the weather threw its direction, shone white against a perfect blue sky.

Back at the auction table, the paper beside the bear in the blue shirt has another name and an additional dollar amount written next to it; I have competition. I take the pencil beside the sheet and add another dollar. Other shoppers peer over the paper slips just as I did, most raising their prices. It's early still, with most bidders unwilling to give in. A few teenagers admire the shiny green leaves

of a plant before moving to the manicure kit sitting beside it.

Edwin leans back and watches the dance. The hall is a family tradition; his father served as president, his mother reports on chapter events, his brother runs the bar and is chairman of the board, and his children grew up in its youth group. He remembers when he was six years old and the local schools in Seaton taught Czech. Although participants in SPJST activities aren't required to have Czech heritage, the 2003 centennial booklet of the hall is filled with Czech names on its listing of social and civic events. Skits, choral groups, dancing, and a youth group are a few of the activities organized by the SPJST. The group also offers life insurance programs, annuity plans, and mortgage options to its members, a tradition of financial aid that was originally available to area farmers.

Today's SPJST still uses the dance hall for monthly dances and other group activities. One of the most recent renovations to the hall includes the youth hall where Edwin and I sit—a comfortable space that includes a meeting area, storage space, restrooms, and central air and heat. It's a far cry from those first meetings in Thomas's blacksmith's shop, which still stands across the street. Edwin takes me to a side door of the dance hall and points out the white structure. On a follow-up visit, he tells me that the lodge hopes to move the building and set it up as a museum, complete with vintage blacksmith equipment.

We walk back inside the hall and find seats near the stage. Band members, ready to start the first set, take up their instruments. I watch the auction shoppers shift their attention from the table of merchandise to the stage. The windows outside are dark, but the weather stays clear; unlike Labor Day 1906, the skies on this twenty-first century dance hall night are rain-free.

This foyer contains photo-graphs of former presidents of Lodge 47.

From our table on the sidelines, I watch as the overhead lights dim, and couples pair up and move toward the dance floor. Some look as if they've been dancing together for years, while younger couples in tight jeans and miniskirts dart across the floor with moves more experimental than graceful. Although tonight's dance brings a crowd of mixed ages, Star Hall generally caters to an older audience, while neighboring Flag Hall, two-tenths of a mile away, attracts a younger group.

The band starts a polka number that sends the experienced dancers darting across the floor. From a nearby table, a seated group cackles at a joke only they can hear. After the song ends, the band lets the dancers take a quick breather before launching into their next number,

a George Strait cover. The dance floor suddenly fills with most of the room's one hundred attendees. Amber light drifts from the ceiling and across the floor, but this time it's the stage lights instead of arson flames that shine. Dancers spin one another in large arcs. The band ends a song with a dramatic last chord, releasing the dancers and bringing smatterings of applause.

At the end of the first set, a few dancers stray off the wooden floor to check on their silent auction bids. Volunteers will soon tabulate the votes and announce the winners. Edwin tells me that funds from this auction and other events, just like fundraisers past, help keep both the SPJST and its dance hall running. I watch the musicians stroll off-stage and blend into the crowd. Bar-

beque smell mingles with the salty tang of the peanuts in front of me. In the kitchen area to the side of the hall, a man wearing an apron stirs a pot of beans. A woman beside him cuts brisket in careful slices. Earlier that night, John and I ate brisket, beans, and dark bread, with potato salad and coleslaw filling the spare corners of our plates. The other band members joined us at one of the long tables covered in white paper. All of us thought we were full, but the lure of the golden-crusted desserts, especially the peach cobbler, was too strong.

In the middle of tonight's dance, there's still plenty of food left, and many people in the crowd come back for seconds; a $25 admission price includes cover charge, beverages, and a meal. Feeling full doesn't stop my sweet tooth and I get up from my chair, ready to try a piece of cake with pink frosting. The faces of the regulars are evident from their easy conversation with one another; many have been coming to this hall for years.

As the nineteenth century lengthened, the local lodge and dance hall, having survived both flood and fire, faced the slower yet persistent challenges of area growth. Lodge #47 became one of the largest branches in the SPJST, while nearby Temple became the site of state SPJST headquarters. In addition to bolstering the lodge, the area's population increase prompted a 1960s highway project that changed the hall in ways that the natural elements had not.

In 1963, the planned widening of nearby State Highway 53 forced lodge members to tear down the hall originally built in 1906. Rather than giving in, lodge members set to work building a new hall not far from the first. To keep the memory of their first dance hall alive, they used boards from the original hall to construct a new version. Although it wasn't easy leaving the old dance hall behind, lodge members found a silver lining in the additional space afforded by their new hall, which gave them an opportunity to lease the space when it wasn't being used for SPJST activities.

Today, a historic marker near the dance hall entrance celebrates Star Hall's one hundred years. "We worked over two years on the paperwork," Edwin says. "My wife and I were married in the old hall, before it was torn down. We had our anniversary in the new hall."

Close to midnight, I watch dancers circle and cross the parquet dance floor. I wander back to the silent auction to check on the blue-shirted bear. Looking over the tables of food and plants, I imagine women of years before setting out jars of preserves with children peeking at the nearby desserts. The men, having gone outside to mind the horses, carry their hats in their hands in preparation for dancing. I check the auction paper beside my name and learn that tenacity, a main ingredient in the history of Star Hall, has paid off; I've won the bear in the bright blue with the white acronym spread across it.

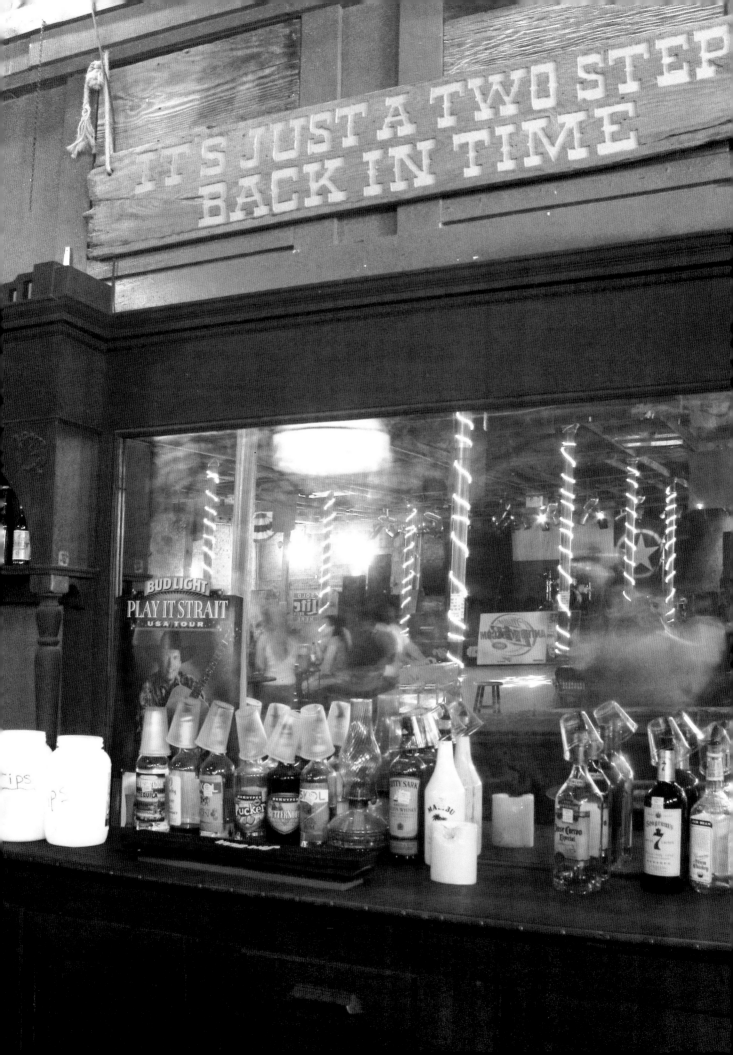

8 SPIRITS OF COUPLAND

■ Coupland Dance Hall

Early in the twentieth century, a clerk at Coupland Mercantile reached across the broad counter and spilled hard peppermint candies on its wooden surface. He'd seen his customer, the woman with the auburn hair, stare at the peppermints as she walked by, admiring them without buying any for herself. When she smiled at their bright shapes on the countertop, the clerk kept focused on the ledger in front of him, not acknowledging the kindness of his act.

The woman smoothed back her auburn hair. She kept most of it swept up in a tight bun behind her head. Her smile wandered from the candies on the counter to the man behind it. "Thank you," she said. She added the candies to her satchel one at a time, losing them in the blue flowered cotton fabric and small sacks of flour and sugar she'd just purchased.

"My pleasure, Ma'am," the clerk said, smiling back at her. She was a good customer. He turned back to his shelves, rearranging dry goods. He'd tossed in the candies for her children, knowing she probably wouldn't purchase them herself. What people bought or didn't buy told a lot about them.

He watched the woman disappear outside the door, her skirts blustering into the wind. Her shadow lengthened on the raised sidewalk as she walked toward the drug store. She'd better hurry; the shop owner had already drawn the shades, and would soon be clicking the lock on their black safe. The holidays were only a few days away, keeping most residents home for the last of their tree trimming and baking. Through fine dust on the windows, he watched the last rays of sunshine slant past the railroad tracks. In another hour or so, he, too, would find his way home.

One hundred years later, the Coupland Mercantile remains, but the wooden floor holds dancers rather than flour and fabric samples. A band onstage plays a few warm-up chords while the first patrons of the night gather by the front bar. Tall ceilings of the building, which was constructed in 1904, reach overhead. Afternoon light from the sparse windows isn't enough to fill the vast space and its rows of tables. The small Texas town of Coupland [pronounced COPE-land], formed in 1887 by a Confederate soldier, waits quietly for sunset.

Dating from 1886, a historic bar placed at the front entrance has large beveled mirrors and original buckshot

A sign over the bar illustrates Coupland Dance Hall's history, kept alive through the people who come here.

still buried in the wood. A second bar, also more than a hundred years old, nestles in the back of the vast room near the stage. A black chandelier lingers above the dance floor, its amber light making a soft haze where dancers will soon slide. In a back corner, a nineteenth century shoe shine chair sits.

Visitors laughing by the front bar might not notice the image of a man in turn-of-the-century attire and a drooping mustache, any more than he notices them. Acting as if he's still employed at the mercantile, this ghost floats in and out of the hall in a work schedule known to him alone. According to Coupland Dance Hall owners, Larry and Kathleen Kelso, along with several customers, a clerk from the early twentieth century is one of several unusual figures making visits to the hall.

"At first, I thought it was just that the building was old," Kathleen says. Blonde ponytail swinging behind her, Kathleen walks between the main bar and the restaurant, joining me at one of the small, raised tables that line the wall. Larry brings two cold beers to the table before heading back to the front bar. Kathleen thanks him and smiles before answering a question one of her employees asks about tonight's cover charge.

While acknowledging the sightings that occasionally take place, it's the practical aspects of the hall that occupy Kathleen's time the most. From her perch on a raised chair, Kathleen looks

James 'Cricket' Grant, bar manager of Coupland Dance Hall, comes through the curtain leading from the restaurant into the dance hall while visitors purchase tickets at the door.

Texas Dance Halls

across the dance floor toward the stage at one end. TC, stage lights bathing him in gentle reds and blues, sings a few bars of a song. It sounds like the opening set, making me turn along with Kathleen. But the band stops just as soon as it starts, saving the real show for later. TC, John, and the other members of the band, satisfied with their tuning for now, wander offstage toward a mesquite bar-beque smell that drifts from the restaurant and party room next door.

At the front bar near the entrance, Larry visits with the first customers of the night. His mustache doesn't quite cover the grin he offers almost everyone. Larry bought the 7,000 square foot building in 2001, converting what was then a store to today's dance hall. Although the building has spent most of its one hundred-year history as a general store, it also served as the Casa Grande Dance Hall in the mid-1930s. Today, Larry and Kathleen team up to run the combined dance hall, restaurant, and bed-and-breakfast. While Larry coordinates the dance hall operations, Kathleen manages the adjoining restaurant in what was originally the drug store next door. The couple also recently renovated

A view down the hall that leads off of the men's and women's restrooms at the back of Coupland Dance Hall.

Coupland Dance Hall

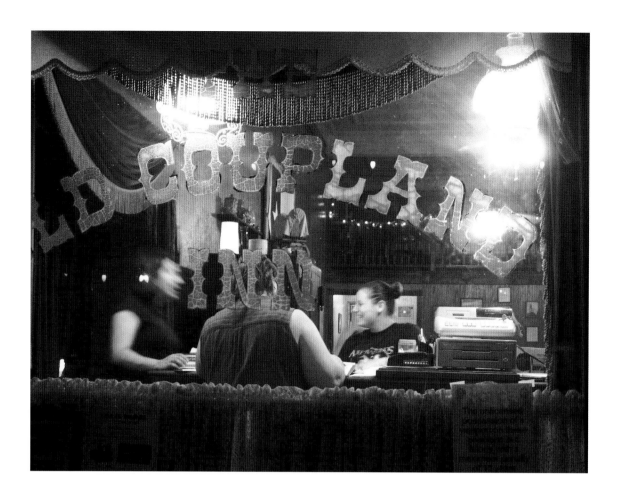

rooms above the restaurant and dance hall structure, which once housed doctors' offices, to create a bed-and-breakfast inn with the theme of an early 1900s brothel.

"We added the inn in 2003," Kathleen says as she climbs up the stairs, gesturing at a large parlor area filled with red upholstered furniture and floral print cushions. Several bedrooms open off this central parlor, each done in late nineteenth century bordello decor. Having a bed-and-breakfast gives out-of-town guests a place to stay when visiting the dance hall, Kathleen says, adding that they've even hosted a wedding or two.

Back downstairs, Kathleen glances at the front bar, now lined with a growing number of visitors on this early Saturday evening. Their laughter mixes with the clinking of bottles and glasses. The sky darkens. Band instruments wait in their

music stands while dancers start to fill the tables that surround the dance floor. Kathleen smiles at customers as we pass through the hall. I gaze at the front bar, searching for anyone who belongs to the past.

The mercantile ghost in period clothing has made several appearances within the hall. "Three different customers have described the same figure to a 'T,'" Kathleen says. Sitting back in my chair, I imagine this man, who for now eludes our view, wiping the counter, unruffled by the change in his store. Placing the rag on a drawer, he admires the merchandise he's arranged, from candies in their bins to flour in its tight sacks, and waits for the next customer.

On the sidewalk, the auburn-haired woman in the dark blue skirts strode the few steps from the mercantile to the drugstore;

Friends talk inside the Coupland Inn Restaurant, which is situated next to the dance hall proper.

Texas Dance Halls

she'd almost forgotten her husband's snuff. It looked dark inside the drug store, so she stopped for a moment, peering through the drawn shades. She touched the door and pushed it forward. After a moment, it creaked open. Christmas bells on the door made a nervous jingling. The woman looked around. A young woman mopped the floor, but no one stood behind the counter to take orders. Dim lights shone over bare countertops. Even the metal safe stood closed, a padlock clasped like a buckle across its stout, black form. The auburn-haired woman sighed, wondering if the mercantile might have the snuff instead.

She felt a little foolish going back to the store, but knew that the clerk behind the counter, the one who gave her

candy, wouldn't mind helping her again. He was always polite to her, respectful. Her skirts swished around buttoned boots as she picked her way across the floor of the drug store, trying to avoid the fresh-mopped spots. The young woman with the mop didn't seem to notice her. The auburn-haired woman walked out the door, holding her satchel close as the bells repeated their thin ringing into the open air. She paced the few steps down the sidewalk into the neighboring mercantile, her blue hemline rustling behind her.

The curtain separating the dance hall from the restaurant ripples behind someone's departing footsteps, making me wonder if it's the woman in the old-fashioned

The band starts up, bringing a couple onto the dance floor.

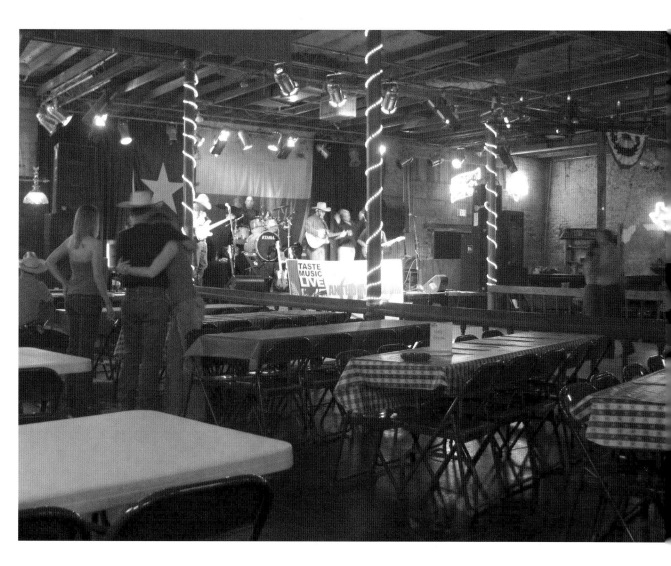

boots, the one Kathleen and Martha saw glide through the restaurant a few Decembers ago. Around Christmas, a woman in a late nineteenth century dress and button-up boots swept past the restaurant curtain into the dance hall. It happened at closing time. Martha, one of the restaurant employees, had just closed up the safe full of napkins and plates. While she mopped the restaurant floor, Kathleen finished up in the back kitchen. When the Christmas bells on the front door rang, Martha looked up, expecting to see Kathleen.

Ignoring the flutter of the dense velvet curtain, Kathleen gestures to the black, armoire-style safe. Although it

While Kathleen talks to the staff, I read the menu. Known for barbeque and distinctive marinade, the restaurant has a clientele of 50 or 60 percent regulars. Its mesquite-fired offerings, which include steaks and salmon, draw customers not only from the immediate community but also from cities miles away, including Austin, Dallas, and Taylor. Many among this Friday night crowd are repeat customers. "My favorite thing about running this place is the sense of community," Kathleen says, calling many of her visitors by name as we stroll between the red checkered tablecloths. Dress is casual— jeans, cowboy boots, light shirts, maybe a cowboy hat or two.

OVERLEAF:
The front bar at Coupland Dance Hall has beveled mirrors and buckshot buried in the wood.

 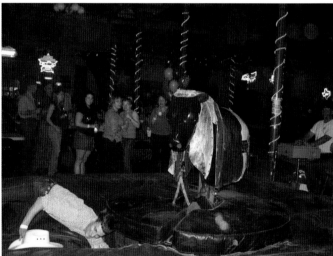

originally stored cash and other valuables prized by the drug store, the stout cabinet with proud gold lettering now holds napkins, salt and pepper, and other restaurant extras. Historic photographs of Coupland and the dance hall cover the walls. The band members, seated in a table near the center of the room, finish their pre-performance meal of barbeque, potato salad, and iced-tea while they tinker with the set list. Kathleen leads me toward a party room near the back of the restaurant, which once served as a feed store.

There's no period clothing in sight. Kathleen remembers Martha's glimpse of the woman in long skirts. "Martha saw someone come in through the restaurant door," Kathleen says, "and thought it was me." She pauses a moment. "But I was back inside the restaurant." Once she realized that Kathleen hadn't made the bells chime, Martha held the mop and froze; the edges of a woman's skirt slipped through the red velvet. Martha stared after the departing form, but the wavering curtain was all that remained of the

A cowboy tries his hand at Coupland Dance Hall's electric bull.

He lasted about six seconds, maybe longer.

woman whose skirts and buttoned boots brushed by.

In the early 1940s, a band warmed up on the raised stage of what was then the La Casa Grande Ballroom. The mercantile shelves of dry goods were replaced by a well-stocked bar and beer taps. A man with pepper-gray hair leaned against the bar, his eyes wandering between a beer mug on the smooth bar in front of him and the young couple beside him. He wanted to strike up a conversation, but they were oblivious to everything but themselves and the music that surrounded them. The man shrugged to himself and stumbled his way to the potbelly stove. He almost tripped into its rough, black sides before he caught himself on a chair. After warming his hands, he hiccupped, turned back to the bar, and reclaimed his beer.

Next to the stage, a bearded man settled his angular frame into the elevated shoe shine chair. Taking a white cloth to the bearded man's boots, the boy at his feet smoothed the rough-worn leather with a bit of spit and polish until the boots shone a dull brown. The bearded man stared down at the emerging color of the boots. A few moments later, he handed the boy a few coins.

Without anyone in the dance hall realizing it, the night turned to early morning. The band, their hair askew and faces pink from effort, played a final song of the night, a Bob Wills number. The dancers, their faces just as red, swept round the dance floor in laughing pairs. The gray-haired man at the bar slouched further over his beer, a stained cowboy hat pulled down over his forehead. The bearded man with now-polished boots lingered close to the stage, content to soak in the music without dancing. He patted the six-shooter at his side and wiped a sweat bead off his chin while the dancers whirled by.

Unable to stand the heat any longer,

he reached to a large fan sitting near the stage and flipped it on. Air blew through the crowd in thick waves as the fan's whirring motion drove back the heat. For the first time that night, the bearded man's face crinkled into a smile. Men near the stage crowded closer to the fresh breeze, sharing it with a woman whose blue skirts, now calf-length, swirled from the draft.

Kathleen watches as TC Taylor and 13 Days play their opening song of the first set. One or two faces in the crowd have a timeless look that might place them in the early twentieth century, but modern cadences of dress and speech give them away. I can't discern anyone in the shoe-shine chair, and for now at least, no one carries a six-shooter. Couples in Wrangler jeans and smooth-soled boots spill onto the dance floor instead, eager for the chance to two-step before the crowd gets thicker.

Today's Coupland Dance Hall hosts a varied clientele, from families with kids to singles who come to dance. Cooder Graw, Reckless Kelly, Johnny Bush, The Derailers, and Gary P. Nunn have all performed there. Larry, who is in charge of entertainment, books the bands. In addition to musical performances, Coupland Dance Hall has also served as a movie set for the original *Lonesome Dove, A Perfect World,* and *Cadillac Ranch.* Stevie Ray Vaughn shot a music video there, and Kevin Fowler made a live recording within the hall.

Kathleen keeps her digital camera nearby, ready to take pictures. She's interested not only in capturing the performance, but also chronicling other visitors who might be near. Along with colored lights that illuminate the bands onstage, less tangible lights, or jellyfish-like orbs, appear in her photographs. Kathleen places a few color prints from her digital camera on the table. In each image, small halos of light float above the performers' heads, watery circles of

red or violet. "They tend to hover over certain bands," Kathleen says. One band member gave Kathleen a snapshot that not only showed the crowd near the stage, but a white outline of an apparition, its shape almost face-like.

Some photographers have told Kathleen that the orbs found within her snapshots could be caused by swirling dust. "But how does that explain this?" she asks, setting two more photographs on the table. "This is the same room, on the same day. I took both of these within minutes of each other." She spreads the two photographs slightly apart. Each shows the red cushioned parlor upstairs. One focuses on the sofa, interrupted only by the faint outline of a single orb.

The next photograph reveals the same parlor setting, only this time with sofa cushions covered in iridescent orbs.

In addition to these nebulous circles, several visitors to the dance hall have reported the wavering figure of an old drunk. Other guests describe a second western figure wearing a six-shooter that might've contributed to the bar's buckshot. We look around the room again, but all we see for now are visitors in contemporary jeans and cowboy hats. Onstage, the band breaks into its next song, a faster two-step number that fills the floor with dancers.

Kathleen glances at the pool tables and the nearby shoe shine chair. Some children visiting the dance hall refuse to

One of the bedrooms at the Coupland Inn. The Inn is a bed-and-breakfast where couples or friends can come to relax and get away from the noise of daily life.

Texas Dance Halls

walk near it. One little boy screamed when his father tried to sit him down in the chair, insisting that a man already sat there. It's hard to believe now, watching visitors saunter around the pool tables. A cue smacks into an eight ball, sending it to a corner pocket home.

During one closing, Kathleen walked the length of the dance hall toward a pool table. She bent against the green felt surface, expecting several handfuls of quarters that night. Something rumbled behind her; a tuft of air touched her face. The standing fan near the stage roared to a start on its own, fan blades spinning in their wire cages. It ran for a few moments, turning off as Kathleen stared at it. It must be a power surge, she said to herself. "Larry, come look at this."

Larry crossed the wooden dance floor from the front bar, looking from the fan to his wife. He, too, had seen the fan spring to motion. Together, Kathleen and Larry stared at the power cord to the fan, which wasn't plugged into the wall. Neither of them said anything. After a moment, Larry spoke a few quiet words. "Give me a sign."

The pair watched, a few careful steps away, as the fan whirred to life. Either its motion was the charged result of an electrical oddity, or the yearning remembrances of visitors past. After a few moments, the fan stopped altogether.

No single, overriding event within Coupland Dance Hall's history explains such restless visitors. To this day, otherworldly appearances within the hall remain sparse, just often enough to remind the couple of their dance hall's varied past as both a neighborhood store and a 1930s dance hall. Most of the time, the night of music ends with nothing more unusual than the dollar brisket sandwiches served at midnight while the band plays its last set. Close to our table, a couple on the dance floor spins across the floor, the mirror ball dappling them in glittered light.

Kathleen and Larry, like any good hosts, will stay up until their last guests have left, which can mean three to four in the morning on weekends. Kathleen walks through the hall, picking up bottles and pushing in chairs. The pastel neon of a beer sign softens the room after stage lights dim. Band members drive away towing trailers of stage gear. Dancers laugh and head out the door. A few remaining visitors lean against the historic bar, the one with bullets in its wooden sides, to share their last stories of the night.

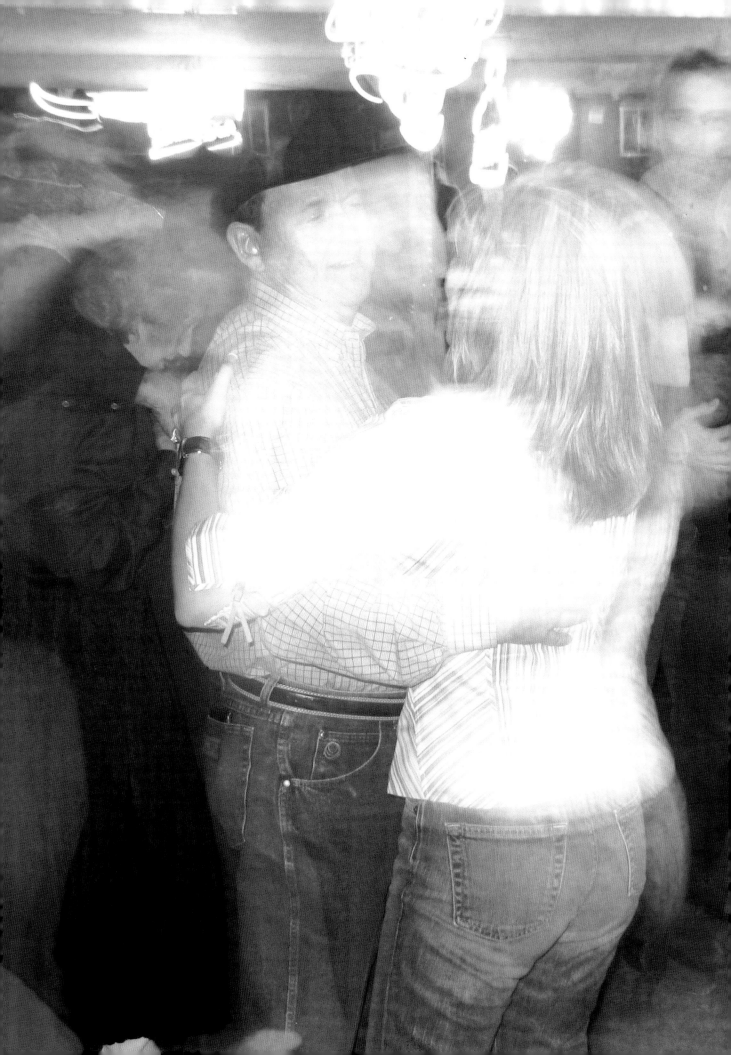

9 WEEKEND NIGHTS, CITY LIGHTS

■ *Broken Spoke*

A 1948 Flex Flyer bus with a dusty interior light glows outside the Broken Spoke entrance. Past the rounded sides of the bus, a wooden wagon wheel leans against the porch railing. It only takes a glance up South Lamar to remember that glittery downtown Austin is just a few miles north of this kitsch country scene. Although the dance hall stood outside the city limits when it first opened in 1964, the city and accompanying music scene have both grown up around the Broken Spoke and embraced it.

Wearing shorts and sandals, Marcus points his camera at the wagon wheel, while my husband John glances inside the bus. It originally belonged to a western swing band from San Antonio called The Texas Top Hands, who performed at the 'Spoke and wrote the hit song "The Bandera Waltz." Band leader "Easy" Adams gave the bus to Broken Spoke owner James White, who planned to restore it once he hauled it back to Austin. After James moved the bus into the gravel parking lot, however, he decided just to leave it as is. Instead of the bus going places, bands now come to the bus as a backdrop for their CD covers and artwork; the most recent band to use it was Asleep at the Wheel.

We walk under the neon sign and into the dance hall. At just past 9:30 p.m., men and women dressed in jeans, cowboy hats, and vintage cowboy boots crowd the Broken Spoke bar and restaurant. James strides by in a red western shirt with black trim. He shakes a few hands, his cowboy hat tipped back to show off his smile. Almost every night, he dresses up and comes out early to greet visitors to his 1964 hall. James's love of country music, which influenced his decision to build and run a dance hall, was born through travels with his parents to Texas honky-tonks, such as old Dessau Hall, Moosehead Tavern, and the Barn.

James's wife, Annetta, sits at the bar. Her wide-brimmed hat with pink flowers follows the direction of her gaze toward the stage. Although she visits the Broken Spoke just a few hours a night, she dresses up for the occasion in sandals and tailored pants. On a later Broken Spoke visit, she'll tell me how James built the bar himself. "Only he and I know how it's all glued together," she says. To this day, James manages the plumbing and serves as a contractor who can fix just about anything. "The only thing he doesn't like is electrical work," she says.

The Spoke has all kinds of visitors, from cowboys to urban couples and out-of-towners.

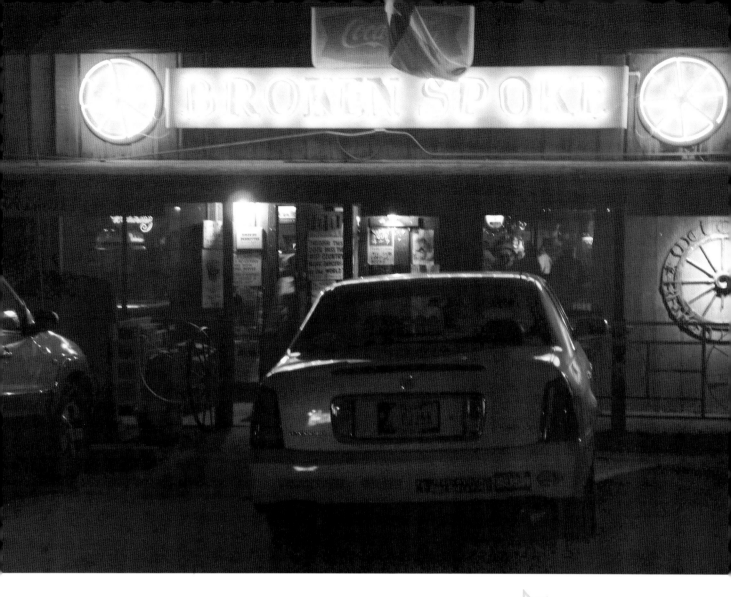

Building the hall was the first thing James did after coming out of the army. Annetta describes James in fatigues, nailing the place together. He named the hall Broken Spoke based on both a radio show called "Broken Arrow" and the image of wagon wheels. On opening night in November 1964, the Broken Spoke attracted 300 people. "The dance went out the door and came back in," Annetta says. From 1965 to 1967, the couple expanded the dance hall, resulting in a structure that's longer than it looks and layered in different sections, starting with a restaurant, easing into a bar, progressing to the "Tourist Trap" museum, and ending with the dance hall and stage at the far end.

To this day, the hall features touches from James's dance hall past, such as lazy Susans on table centers that spin slow circles of condiments. The parking lot is dirt and gravel, which is good for a dance hall, according to James. "We could pave it with beer caps," he jokes. The city of Austin would probably not approve the building had it been built today, he adds.

We walk through the restaurant and inhale the smell of chicken fried steak, a dish the Broken Spoke kitchen is famous for. During the early Broken Spoke years, James worked sixteen hours a day to run the business, time that helped hone his culinary skills for the restaurant. "I ate what he was practicing,"

Broken Spoke Dance Hall.

Texas Dance Halls

Annetta says. James was good at break-fasts, and Annetta helped him with the rest, including the chicken fried steaks the couple has perfected.

At first, Annetta kept her job at the University of Texas, joining James in the dance hall business a few years later. From her first floor office of the UT Tower, she experienced firsthand Charles Whitman's shooting rampage, watching some of the victims fall. "It was a scary time," she says. She called James on the phone, who told her to get under her desk. After coming back to the Broken Spoke, "I was a nervous wreck," Annetta says. Some of the customers at the Broken Spoke wanted to go back for Whitman, but police had already caught him. One of the women working behind the bar reminds Annetta that police surrounded the Broken Spoke parking lot just the night before as part of a criminal chase. Annetta nods, but shrugs it off. Last night was no problem, she tells us. We all just stayed inside.

On any given night, both James and Annetta banter with the bar and restaurant staff in a manner that's professional and familiar. Most Broken Spoke employees have worked there for years, whether they're family members or just seem like it. Broken Spoke employees include two of the White daughters, Terri and Ginny. Ginny, who works in a management position and claims the Broken Spoke has kept her busy her whole life, says treating everyone who works there as family has kept employee relationships strong.

Annetta agrees, noting that some have been at the restaurant as long as eleven, thirteen, even fifteen years. When Annetta joined James in running the Broken Spoke, she had never waited on a table in her life. "I just wait on people the way I would want to be waited on," she says. James walks through the bar area, cracking smiles and a few

laughs with a joke he tells. From the bar, he moves to the restaurant to thank customers for coming. Other customers hug Annetta, asking about her health; she recently recovered from breast cancer. She enjoys every minute of her time at the 'Spoke. "After living the night life for forty-one years, I'm not much of a television bug," she says.

A Texas wind chime, consisting of a wooden board with beer cans attached, wavers above our heads at the bar. The smell of coffee spiced with cinnamon wafts from full glass pots behind us. Past one of the checked tables, I do a double take at a cowboy wearing a bright red scarf. Rowdy, the mannequin regular who claims a table close to the bar, fools me again with his costume and posture. "Everybody loves Rowdy," James says. "The girls give him lots of hugs and kisses. They also want their picture taken with Rowdy. He's always fun to sit down with so you don't have to eat and drink alone." Though he's getting quite a name for himself, he doesn't give out autographs much, James says. "Bashful, I guess."

James found Rowdy along Highway 620 north of the city, "hitchhiking into Austin," James explains. "I got a lot of stares when he rode down to the Broken Spoke in my pickup truck. Well, that's show business." Originally, James wanted to make Rowdy the bus driver of his 1948 Flex Flyer bus, but Rowdy had other ideas. "I set him down at the table and he didn't want to go out to the bus. He said he didn't want to get that far from the bar."

Tonight's band, the Derailers, is already deep into their first set; the sound of an electric guitar tempts us from the rear of the dance hall. Before we walk back to hear the music, James offers me a guided visit of the Broken Spoke "Tourist Trap" museum, a room crammed with photographs and other artifacts that rests just opposite the bar

between the restaurant and the dance floor. He starts with museum items that spill into the restaurant, including an intricate western saddle trimmed in silver. "My father rode with that saddle in the Rose Bowl Parade," James says. "Three years ago, it was stolen." He waits a moment before telling me that the police nearly shot Rowdy, whom they mistook for the burglar, before catching up with the real suspect.

We move inside the museum proper, toward a series of cowboy hats under a glass cover. One of them belonged to Alvin Crow, a regular performer at the Broken Spoke, while other hats were worn by Bob Wills and George Strait, both of whom have played at the 'Spoke. All three hats were stolen one night, only to be returned when James overheard several men boasting about the theft. "They probably just wore them right out of here," Annetta tells

me later. A fortified lock now surrounds the hundred-year-old case to prevent any further temptation.

I pause at a display with a cigar smoked by Bob Wills in 1939. The story behind this half-smoked stogie is that Wills left the cigar at his girlfriend's house. Because he was already well-known at the time, the girlfriend's mother kept the cigar and wrapped it in a napkin. Years later, Wills' granddaughter donated it to the museum. Along with artifacts, the museum walls bulge with photographs and album covers. In the pictures, both color and black and white, the Whites appear with the likes of Willie Nelson and George Bush.

While the museum and Broken Spoke artifacts make up an important part of the dance hall atmosphere, it's the music that defines the hall. James leads me out of the museum, handing me a Broken Spoke postcard and an

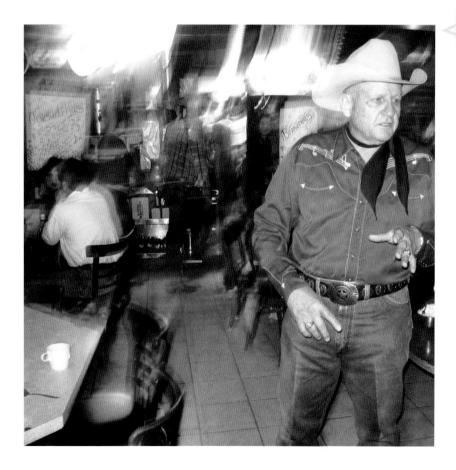

James White, owner of the Broken Spoke, says there've been some wild times—including the night Rowdy almost got shot.

Texas Dance Halls

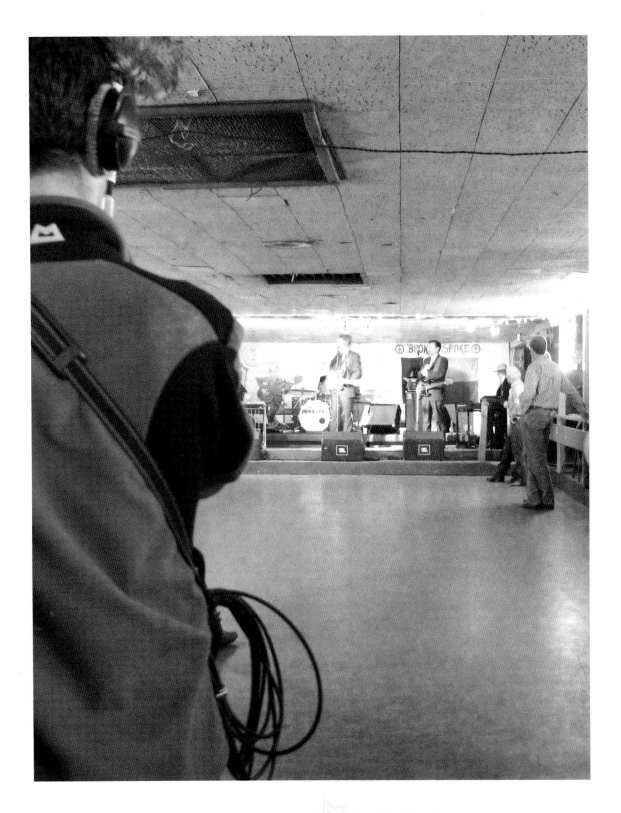

A member of the BBC stands on the dance floor, along with the other audience members, before the Derailers start their show.

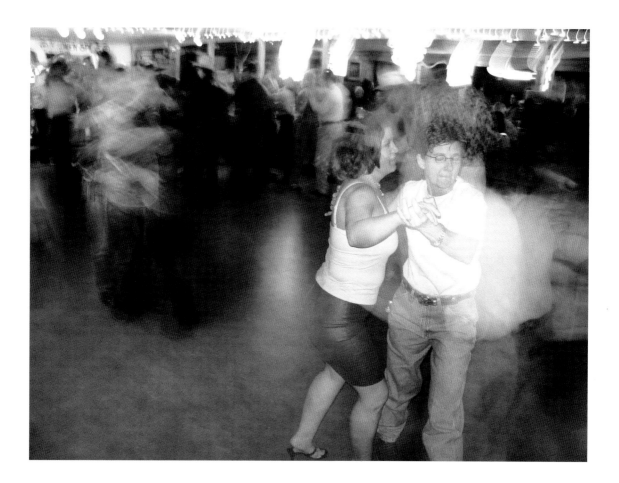

A couple of ladies shake a leg to the Derailers.

Alvin Crow CD. "You're my guests tonight," he says, including Marcus and John in his invitation.

At the far end of the hall we spot the Derailers dressed in thick glasses and skinny pants. Both dancers and onlookers shimmy to their fast-moving sound. At the edge of the dance floor that fronts the stage, I scan the crowd: a versatile mix of trendy urban singles and experienced two-steppers dressed in Wranglers. Two women in what look like prom dresses, pink and yellow with ruffles, dance with one another to a Buck Owens song.

James, greeting everyone who comes in, takes the diverse crowd in stride. "There's no other Broken Spoke," he says, watching a group that's just arrived. He has a knack for remembering names and faces as he circulates

among the hall visitors, both new and returning. The hall is no stranger to famous faces, such as recent visitor Elijah Wood. "He was just in here last night," James says. Willie Nelson also recently broadcast a Nashville network performance from the Broken Spoke. As part of a sound check the night before, he gave the staff a practice show in the bar. It was an experience that Ginny won't soon forget. "They were gearing up for the show and wanted us to yell out songs for them to play," she says.

At 10:30 p.m., James will roll out the wagon wheel and sing the first song he ever wrote, "The Broken Spoke Legend," which serves as a welcome speech to the hall. With Annetta's encouragement, James shared the lyrics with Alvin Crow, who put music behind it and included it on his *Honkytonk* CD. "It's a

song about some people wanting the Broken Spoke to have hanging fern baskets and Perrier water but how it's not the place for that," Annetta tells me later. Many fans who come here know the speech and song by heart. The wheel presentation comes next, with a member of the Broken Spoke staff guiding a wooden wagon wheel just in front of the stage. James has trained a number of wheel presenters over the years, including High Kickin' Emily, a tall blonde who does a kick over the wheel as she parades it across the floor. Troy Kimmel, a meteorologist on a local television news station, also enjoys rolling the wheel, James adds. "You gotta make some fun in this old world," he says.

The eclectic crowd dances hard and fast for the Derailers. A BBC news crew, meanwhile, tapes the show, their crew members wearing headsets and carrying papers. I scribble some notes in my notebook, so I look just as official.

"Excuse me," says a man with a British accent. He leans over and watches me as I write. "Are you with the BBC?"

His accent throws me. Maybe he's with the BBC and thinks I'm part of their crew. I'm tempted to answer "yes" and play along, but the music gets louder, everything is harder to hear, and I decide to play it straight. "No," I say. "Are you?"

"Oh, no," he says with a look of embarrassment. "So sorry."

I try to explain to him that Marcus and I are working on a Broken Spoke essay and pictures, but the man has already turned back to his friends and their glasses of beer.

"That guy thought I was from the BBC," I tell Marcus.

"You should've said yes," he says. He holds a digital camera poised to snap, but the man has disappeared in the crowd.

The Derailers camp up their per-

formance for the taping, rising to their newfound fame. To James, it's business as usual. The Broken Spoke receives visitors from all over the world. A few visitors from Russia once told James that the hall fit their view of Texas exactly. That's what my Swiss friends told me, I tell James, remembering the cold Saturday night we all went out.

Three years earlier, I walked inside the Broken Spoke, past the old bus out front and Rowdy at his usual spot at the table in the restaurant. Past the museum and the dancers in their swirls of color and slick boots, I looked for Maya and Daniela, two friends from Switzerland. Maya flagged me down with a now-practiced American wave as I wove between the crowd of dancers and bystanders who sat at a table on the sidelines. Maya and Daniela wore a mix of European trim and vintage western—long-sleeved black shirts for the cold outside, dark blue jeans and chunky-heeled boots for dancing inside.

"Have you been here long?" I asked in German.

Maya shook her head and took a sip of water. Daniela smiled and swiveled her attention back to the dance floor, which was filled with both beginners and experienced dancers. Although the band name escapes me now, they played good music for dancing. I was just about to ask Maya and Daniela what they thought of the place, when Chuck, his hair wavy and eyes expectant, walked up to our table. A friend of a friend, Chuck loved to dance. "Join us," I said.

He sat down while I introduced him to Maya and Daniela, but he looked as if he'd just as soon jump down onto the floor with the rest of the dancers; I knew he wanted to two-step in the worst way. He turned to Maya first, whose short dark hair bobbed in time to the music.

"Oh, no," she said before he could

finish asking. "I don't dance." She looked at the circle of dancers below, watching their graceful movements with a smile. Being close to the music was enough for her.

"I will," Daniela said with just the slightest Swiss German accent, pushing her beer aside. "But I've never done it before." She gave him a quick look, to make sure he'd understood.

Chuck's eyes grew brighter as he led Daniela by the elbow to the center of the dance floor. We saw him talking to her, giving her tips. His own face stayed alight with enthusiasm. Daniela's face, which had begun with lines of concentration, looked just as alight as his by the time the song ended.

"This is a great place," Maya said, swirling the ice of her near-empty glass. "Too bad we're going back tomorrow." She looked at her watch, as if calculating the hours it would take them to prepare and get ready for the flight back to Switzerland. After working in Austin for three months that winter, her work visa had expired and it was time to go home.

I watched her eyes travel across the old photos on the wall. The band struck up a waltz, its one-two-three rhythms bouncing between the ceiling and floor. Rather than climbing up the stairs and back to our table, Chuck and Daniela

stayed on the dance floor for another song. In slow circles, the pair rounded the dance hall floor, making me wonder if Daniela and Maya would go back to Switzerland after all.

Looking out at the dancers in the Derailers crowd from our stage-side table, I wouldn't be surprised to see my Swiss friends back in town. A first-time two-stepping experience must take place every Saturday night, because an out-of-towner now drags one of my Texas friends around the dance floor. The three of us at the table crane our necks from seats along the railing, watching our friend make his way in a careful circle around the center of the dance floor. She's an experienced two-stepper, and while he's not, they both laugh all the way. James walks into the room, smiles in our direction, and chats up the rest of the crowd. A cardboard cutout of Marilyn Monroe leans over my chair. When I'm not looking, Marcus takes a picture as if I'm sitting at the table with the fake Marilyn. On the dance floor, a gray-haired couple who've been dancing together for years sway across the dance floor, oblivious to the happy chaos that surrounds them.

The Broken Spoke sign hanging at the front of the hall.

Texas Dance Halls

Broken Spoke

10 BEHIND THE BEER GARDEN

■ *Saengerrunde Hall*

Onstage, the band played Americana music; offstage, red, white, and blue streamers floated over the crowd. Fundraiser attendees wore campaign buttons pinned to their work attire, which consisted of pressed shirts and blouses. Sandra, a friend and coworker, browsed through the campaign brochures displayed on rectangular tables. I searched for a few stray pieces of the red, white, and blue sheet cake that sat in neat squares nearby.

"I never knew this place existed," Sandra said. Her red hair floated around her face in a breeze stirred up by the air conditioner. She gazed, eyes turning to widened circles, at the streamers that floated down from the ceiling and almost touched the dancers.

"Me either," I said. I was more transformed by the dancers sashaying across the floor or the politicos who laughed between blue and white bites of cake. The atmosphere mixed business with fun so well that I almost forgot it was a political fundraiser. I grabbed two pieces of cake, one for Sandra and one for me. Onstage, John kept a steady beat on his bass, its rhythms echoing beneath our feet.

Hilary, her blonde hair covered by a

cowboy hat, belted out her song with a sweet strength that always made her taller. At the end of the song, she greeted me on the microphone. "Hey, Gail!" She grinned and turned back toward John, who cued the band for the next song.

I waved to Hilary and guided Sandra closer to the stage. John's dark hair stood out against the red velvet backdrop of the curtains and the dark wood of the stage. He told me later that playing in Saengerrunde reminded him of his first musical performance in fifth grade, from the enclosed stage that wrapped around the band to the dusty curtains and the out-of-tune piano staying untouched in the back.

By the time we'd finished our cake, the band was playing its last song of the night. I hummed along to the lyrics. Under the fluttering streamers, our feet slid across fallen confetti and cake crumbs. After the final chords of the song faded into applause, John hopped offstage to where Sandra and I stood. I handed John a Styrofoam plate of blue-frosted cake. Hilary started chatting with the campaigners, many of whom she knew.

John took a bite. "Have you seen the bowling alley?" he asked.

Saengerrunde Hall's front door.

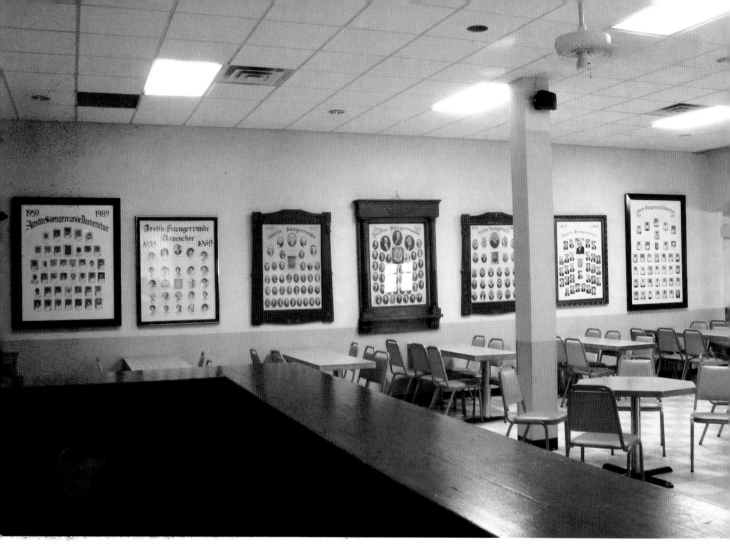

I shook my head, confused. We were here for music, the fundraiser, maybe even the cake, but not bowling.

"You need to see the bowling alley."

Sandra and I followed John through the fundraiser crowd, down a short wooden hallway, and into a clubhouse area and 1950s-style bowling alley. After looking at the smooth gold of the tables, we wandered downstairs to admire the molded fiberglass seating in retro colors of turquoise and coral. Beer and cigarette smells competed with the fainter scents of foot powder from the bowling shoes and cooking grease from the snack bar.

"They still bowl here," John said. Back upstairs, he pointed toward the bowling pictures and trophies along the wall.

Sandra and I leaned on the hexagon-shaped tables in the clubhouse area and admired the trophy cabinet along with him, mouthing the German names to ourselves. I took a last glimpse at the bowling lanes and imagined 1950s laughter rumbling down them.

Several years after John's fundraiser performance at Saengerrunde [pronounced San-ger-OONDA] Hall, the bowling alley doesn't look much different, from its fifties-colored seating to the retro-style scoring stations. I turn around in my chair toward the back cabinets, which are now even more packed with bowling trophies and plaques. Helmut Hartmann, who before his retirement worked as a cabinet maker, built both

The walls of Saengerrunde Hall are lined with photos of past singing club members.

the hexagon-shaped tables in the club area as well as the trophy cabinet.

Helmut, who's looked after the hall for twenty years, sits at one of the tables with a no-nonsense expression. It's taken some juggling to schedule this interview. When I first called the Saengerrunde Hall phone number, Helmut told me the hall was only open for private parties. After hearing my personal angle on dance hall stories, Helmut told me to call him back when I came to town.

During this weekend visit with friends, the timing clicked. Helmut agreed to meet me at this private dance hall, which is also part of the city's most public beer garden. I watch him fold his tanned, craftsman's hands on the wooden table top he made years ago. While cabinets were his trade in Central Texas, in Germany Helmut applied his craft to building pipe organs. He never played them, preferring a behind-the-scenes role in making the instruments resonate. Helmut's daughter, who shares her father's interest in music, blends craftsmanship and performance by repairing the bassoon and clarinet as well as playing the piano.

Outside the hall, sunshine sneaks between the live oaks leaning across a patio filled with tables. Scholz Garden, where mobs of weekend guests cool off over barbeque and drinks, sits in a corner made by an indoor bar and restaurant on one side and Saengerrunde Dance Hall on the other. Unsuspecting restaurant and beer garden guests can easily miss the adjacent dance hall, or at least mistake it for another downtown building. Those who traipse down a hallway from the indoor bar, however, will find a dance floor facing a framed stage. If they're lucky, they'll stumble on a live performance. Those still hungry for more can explore the vintage bowling alley.

Across the straight sides of one of those hexagon-shaped tables, Helmut and I face one another. Fluorescent light hovers over the bowling lanes below. Although it's Saturday afternoon, the bowling alley is silent, dark, and closed for summer. Hammering sounds from the distance. Helmut tells me that dolls dressed in German costume, part of a display kept above the dance floor, rest in one of the second floor rooms until

Helmut Hartmann, caretaker of Saengerrunde Hall for twenty years, built window boxes where air conditioning units used to be. The boxes hold dolls dressed in traditional clothing from different regions of Germany.

Saengerrunde Hall

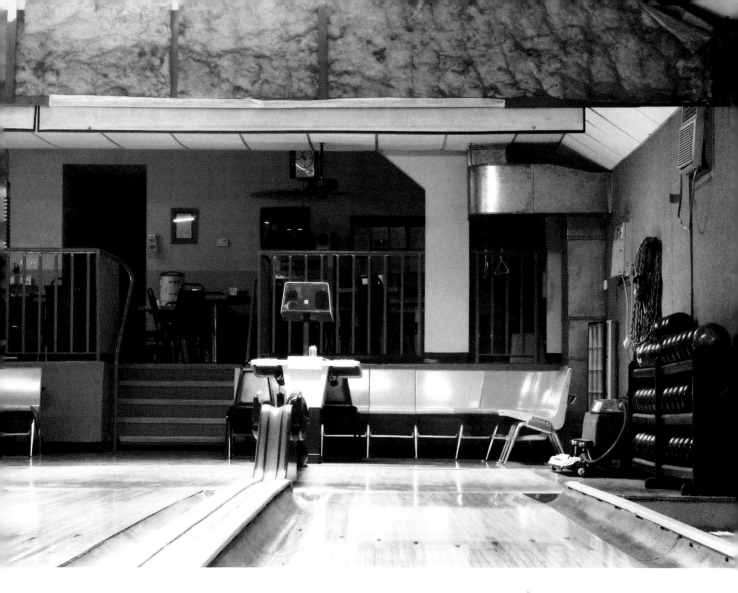

they're finished remodeling the hall.

He points to one of the original Saengerrunde gas lights, its ornate metal resting on the floor until workers can reinstall it. Helmut tells me that today's work on the dance hall is designed not to revamp the hall, which hasn't changed much from its original architecture, but rather to repair it from a recent fire. He'd showed me the damage when we first walked inside the hall. The same stage where John and Hilary performed now held scaffolding instead of musicians. Behind workers making repairs, I made out singed spots of cracked plaster and wires.

The fire started, Helmut said, when dead leaves resting beneath the sheet rock ignited from the fluorescent lights.

The leaves had been there around fifty years, remnants of a prior renovation. Although the fire started during a bar mitzvah, no one was hurt. "No one even knew the leaves were there," Helmut said, that's how buried and forgotten they were.

Before my first visit to the hall, it'd been just as buried and unknown to me as those leaves, despite the years I'd lived in Austin. Anxious to catch up, I page through the booklet Helmut hands me about Austin Saengerrunde, the 1879 singing group that gave the dance hall its name and now owns the hall. This group, with a German name that translates to "singing in the round," was one of many singing clubs formed by German immigrants to Central Texas in the

A number of the halls have bowling alleys; some, like this one, are still functioning.

Texas Dance Halls

late nineteenth century. Like the dance halls, singing clubs served a social function as well as practical goals of preserving language and culture. Many of the singing clubs, like the dance halls, survive to this day.

The booklet's black-and-white photographs show celebratory archways spanning the width of Congress Avenue, a major downtown street that leads to the front door of the state capitol building. To commemorate its birth as an organization, Austin Saengerrunde hosted a music festival in 1879 that brought singing groups from across the state. The event, which proved successful, continues to this day, rotating between Texas cities that include Austin, Houston, and San Antonio.

Growth in Austin Saengerrunde membership encouraged its leaders to first lease, and later purchase, a larger, more permanent place to rehearse and perform—August Scholz's downtown dance hall and beer garden. This hall, which had once served as a way station for Texas immigrants in their covered wagons, became the site of the singing group's rehearsals and performances. In addition to using the hall for club events, enterprising leaders of the group allowed other organizations, such as the Austin Symphony and the Austin Theatre Guild, to use the hall. "Not everyone knows that the Austin Symphony spent its first two seasons in the Hall," Helmut says.

To this day, Austin Saengerrunde leases out its dance hall for private events, along with the well-known Scholz Garden bar and restaurant, which are open to the public. The singing club contracts with The Green Mesquite, a local eatery, to provide the restaurant's menu items. Regular lunch customers slip inside the restaurant for a workweek break, munching barbeque and relaxing in the shadow of a mountain mural splashed across a back wall.

Hartmann pauses to reflect in his conversation with Folkins.

Helmut says the Austin Saengerrunde-owned dance hall, beer garden, and restaurant combine to form one of the longest continuously operating businesses in Texas. Despite its behind-the-scenes business presence, Austin Saengerrunde is also one of the oldest ethnic organizations in Austin. Only one event, WWII, threatened the club's activities; because of the group's association with German culture during a time of war, some Austin citizens proposed banning the club. "It went to court," Helmut says. "But the court ruled that a singing group had nothing to do with Nazi Germany."

Helmut joined Austin Saengerrunde in 1957. Along with giving him a break from a growing cabinetry business, it also gave him the opportunity to participate in the area's German culture. "When I first came over here [from Germany], I would go to Sears, or JC Penney on Congress Avenue, and I always found someone who could speak Ger-

man." Helmut describes another moment when he and his wife drove from San Antonio back to Austin and gave a hitchhiker, a native Texan, a ride to a gas station. Helmut's wife made a comment in German, assuming their passenger wouldn't understand. She and Helmut were both surprised when the man fired back in perfect German. "He told us he was born in Kyle on a German farm, and learned German in the first grade," Helmut says.

Along with participating in Austin Saengerrunde, Helmut and his wife sought German culture in other ways, such as attending German church services in Walburg, a farming community about twenty miles north of Austin. Many of the people they've met, although happy to build a new life in Central Texas, hold tight to their origins. "I remember one woman, who was volunteering to clean the church between services," Helmut says. He smiles as he remembers. "She told me she wasn't sure if God could understand English."

Dancing thrived in Texas through the 1950s, Helmut says, and Saengerrunde Hall was no exception. In the early days of the hall, dance styles progressed from square dancing, which was designed to teach people how to dance, to more complicated country and ballroom steps. In the old days at Saengerrunde, men wore jackets and brought three changes of shirts, because they grew so hot dancing; now, Helmut says, there's central air conditioning instead. The club still holds regular, private dances for its members. I try to imagine their group dressed to the nines, but Helmut tells me their attire is much more casual, unless it's a special occasion, like a New Year's Eve performance of the Clover Leafs, a New Braun-

fels band that's a favorite here.

The club also keeps its singing traditions alive by holding practices and performances in the dance hall. Their selections, which range from operettas to choral presentations, include a mix of traditional German songs and contemporary material. Today membership of Austin Saengerrunde hovers around 320, with fifty active singers in the men's choir and thirty-eight in the women's. Although German descent isn't required to join the club, members often have German ties through family or friends. "Many third and fourth generation Ger-

mans are part of the club," Helmut says. "Singing is optional."

Active members of Austin Saengerrunde give several performances a year, including a free holiday show the first Sunday in December. The group also participates in the area's German Christmas services. Every ten years, they hold an international performance in Germany, usually a city on the Elbe River called Glückstadt, which translates to "lucky city." For their performances in Germany, Austin Saengerrunde members sing German songs, along with some English selections because that's what Germans

This sign hanging above the dance floor translates to 'The German Song.'

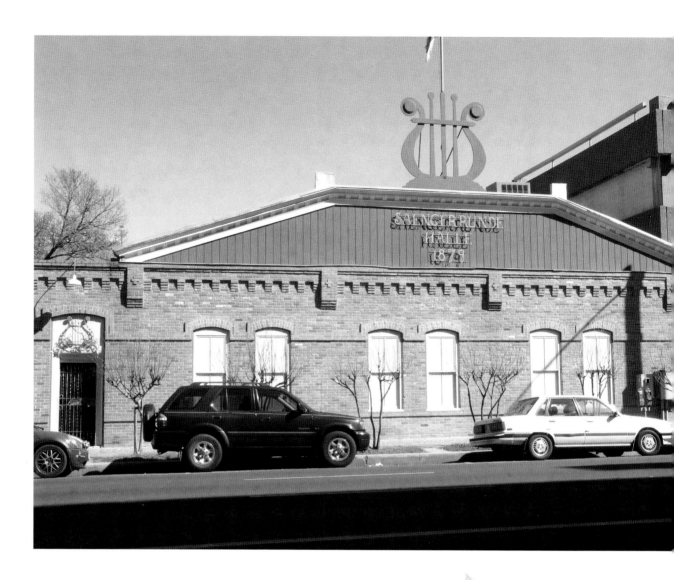

prefer. "Europeans like to hear American songs," Helmut says with a shrug. "The German songs they already know; they sing those themselves."

When the hall isn't being used for club singing events and dances, Austin Saengerrunde continues its tradition of leasing the space for outside weddings, bar mitzvahs, and fundraisers. Over the years, the dance hall and beer garden have served as a central meeting point for various Austin groups—from UT students celebrating Longhorn victories to politicians jostling for supporters. Campaigners, attracted by the venue's history as well as its downtown location, hold numerous events at the dance hall. "A lot of politics are made here," Hel-

mut says, "from lobbying, to campaigns, to fundraisers." And while the general populace might not know about the hall, area politicians do. "City councils have met here and all the legislators know where it is."

Although the hall was once heavily Democratic in its politics—both Presidents Clinton and Johnson have visited the hall—it now plays a more bipartisan role through the various working events it hosts. The Scholz Garden Web site claims that liberal supporters congregate in the outdoor garden, with conservatives meeting inside the restaurant. On a local level, the hall has seen the likes of U.S. Representative Jake Pickle. I tell Helmut about my husband John's per-

Hartmann designed the harp at the top of the hall, whereas the former owner of Weigel Ironworks (where the current Ironworks Barbeque is housed) designed a chandelier that hangs from the dance floor.

Texas Dance Halls

formance at the dance hall for a political fundraiser a few years ago. Helmut leans back in his chair, trying to remember.

I walk from our table to the bowling lanes downstairs, the same lanes I'd discovered at the fundraiser. Helmut explains that the bowling alley, another lesser known feature of the hall, is probably as old as the hall itself. Both men's and women's bowling clubs at Austin Saengerrunde are just over a hundred years old. League play runs from May to September, filling the hall with bowlers during the weekdays. Helmut tells me that the bowling alley hasn't changed much aside from two lanes that were added in 1927. The club plans to install new scoring tables soon. I run a hand over the avocado trim on one of the original scoring stations, sorry it isn't staying.

After a last look at the detailed woodwork on the tables and cabinets, I close

my notebook. We walk through the hallway toward the dance hall and the side door where we'd come in. Workers have left their scaffolding for the day. From the cool shadow of the dance hall, we stroll into hot sunlight that fills the patio. Helmut locks the dance hall door.

Outside the hall, I consider the good times that have filled it, from campaign fundraisers with blue cake to regular singing performances in German and English, and dancing—just because. "It must be fun working here," I say.

"What does fun mean?" Helmut says, his teasing smile telling me that once the repairs are made and the books balanced, there are good times to be had. We pass a few visitors lounging in the sparse patio shade, and I wonder if they know about the dance hall, just behind the beer garden, that's both business and fun.

Scholz Garden bar has been around since the hall's beginning.

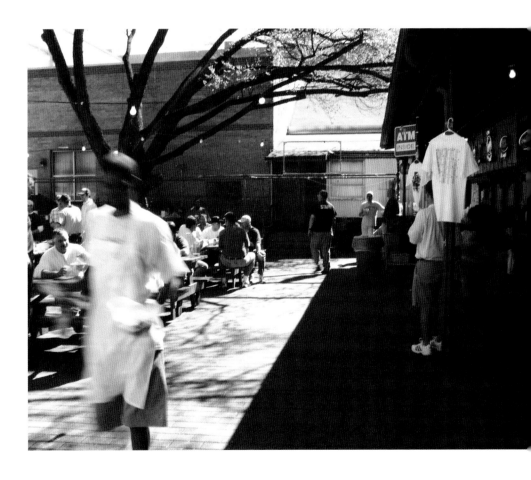

11 MAKING TEXAS MUSIC

■ Gruene Hall

Past the gentle whine and slap of the screen door, I pull my wet hair back and walk inside the dance hall. A fast two-step number from a country/Americana band fills the hall. Fresh from floating on inner tubes down the river, a group of friends and I settle on Gruene Hall's wooden benches with glasses of iced tea and beer. I drink in the music and the wood floor smell faster than the glass of tea in front of me. The crowd laughs and dances as if it's a Saturday night.

Just outside New Braunfels in Central Texas, Gruene [pronounced Green] Hall is a music destination that satisfies both locals and tourists. Black-and-white photographs that frame the entrance chronicle notable musicians who've played there, from George Strait to the Dixie Chicks. One of the wall photographs captures band members of Asleep at the Wheel, a western swing band that has performed many times at Gruene Hall. To five-time Grammy winner Cindy Cashdollar, who toured with Asleep at the Wheel for nearly nine years, Gruene Hall is a familiar place.

A full-time musician who makes her home in South Austin, Cindy laughs at the memory of her own first visit to

Gruene Hall in the 1980s. At the time, the slim, blond steel guitar and Dobro player performed with Americana/blues artist Leon Redbone, who toured Texas regularly. "I was blown away," Cindy says of her first glimpse of Gruene. "I grew up in upstate New York, and had never seen anything like it before. It looked like a movie set . . . the original advertising on the walls, the burlap bags on the ceiling to help with the sound." The thick humidity of a Central Texas day failed to dampen her enthusiasm. "At first, I thought I'd pass out from the heat because there was no air conditioning, but then I thought what a great place it was; it piqued my interest."

After her first gig at Gruene Hall, Cindy started to perform at other area dance halls, including Twin Sisters, Leon Springs, Luckenbach, and Saengerhalle. Every time she plays in one of the dance halls, Cindy says she can't help but feel the history, from wooden floors worn with dancing to the initials carving history into wooden tabletops. "America is preserved in Texas with its dance halls," Cindy says. "It's family entertainment, a part of life you don't see anywhere else."

On a Saturday afternoon, the first sunny one after weeks of rain, the

A couple leaves one of the front doors of Gruene Hall.

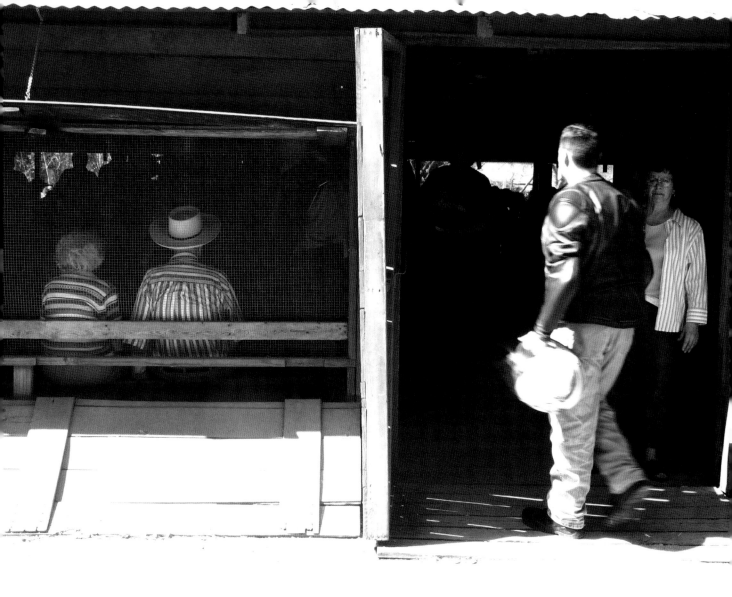

roughened floor of Gruene Hall is barely visible under pairs of boots and tennis shoes. Visitors to the hall rest their elbows on the rows of wooden tables, filling seats to near capacity as they listen to country music artist Bret Graham play an afternoon set. He smiles and rallies his band for a fast song that fills the back dance floor with two-steppers. Later that night, Jerry Jeff Walker headlines. The show is sold out, according to a chalked message on the blackboard in the front of the hall. A few fans lounge near the front bar entrance, lingering over cold beer or lemonade. Others pause at the historical marker outside the door before going inside, curious to learn about the hall's origins.

Ernst Gruene, namesake of the hall, emigrated from Germany to Texas in 1845. Rather than settling in the established community of New Braunfels, Gruene created a picturesque settlement further up the Guadalupe River that became Gruene. About twenty to thirty families joined Ernst and built a thriving community primarily on cotton production. Henry D. Gruene, Ernst's son, built several houses in the growing town, and he also directed the construction of Gruene Hall, which was built by Christian Herry in 1878. The hall, which served as a combined saloon and dance hall space, became a focal point for

All ages frequent Gruene Hall. It's a tourist spot as much as it is (or because it is) a piece of Texas history.

Texas Dance Halls

social activities. Although these early years were prosperous for Gruene, the community fell on hard times as the 1930s ushered in the economic devastation of the Great Depression.

Gruene, which was abandoned throughout much of the early twentieth century, experienced a renaissance beginning in the 1970s. The hall escaped demolition by developers when it was placed on the National Register of Historic Places in 1970. In 1975, Bill Gallagher and Pat Molak of San Antonio purchased Gruene Hall, along with several other historic buildings in the riverside community. After making minor repairs to the dance hall and restoring its immediate surroundings, the new owners began booking musical acts that both reflected and contributed to the local culture. Within a couple of years, the hall had become a popular venue for Texas musicians and their fans.

During a set break, dancers at Gruene Hall lounge on the wooden benches around the hall. The musicians set down their instruments, talk with the crowd, and get ready for the next after-noon set of fast-paced Americana/country, a style that feels at home in this hall. Dance halls and radio both impacted country music, Cindy says. The influence of western swing, which blends folk music with jazz, mariachi, and big band styles, created a unique sound reflecting the diversity of Texas; artists such as Bob Wills helped solidify this musical genre, along with the roots country music that's prevalent at Gruene Hall today. Cindy adds that acts like Robert Earle Keen, The Texas Tornados, and The Flatlanders demonstrate a border sound that furthers a regional feel, contributing to the blended style that is Texas music. "You can tell these artists are from Texas," Cindy says. "You can just hear it."

Cindy moved to Central Texas in 1992. Her hometown of Woodstock, New York, provided her with early artistic influences; she credits her start in music to the large and varied influx of musicians who lived or performed there at the time, such as Paul Butterfield and Happy and Artie Traum. The first instrument Cindy took up was the gui-

The dance floor at Gruene Hall.

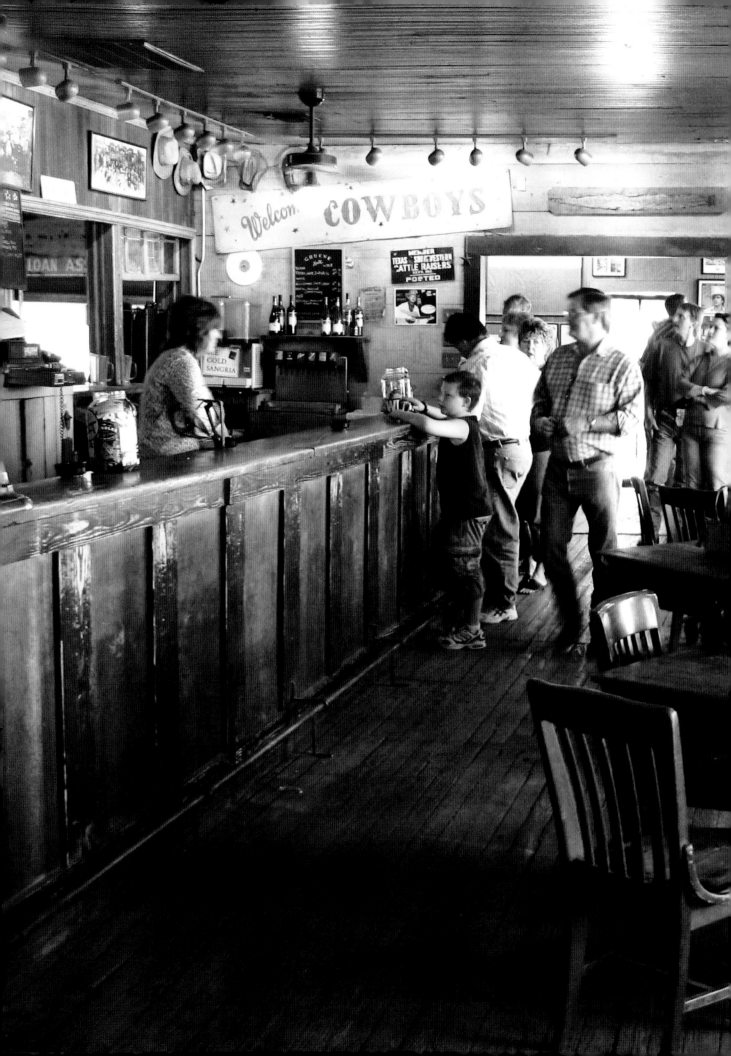

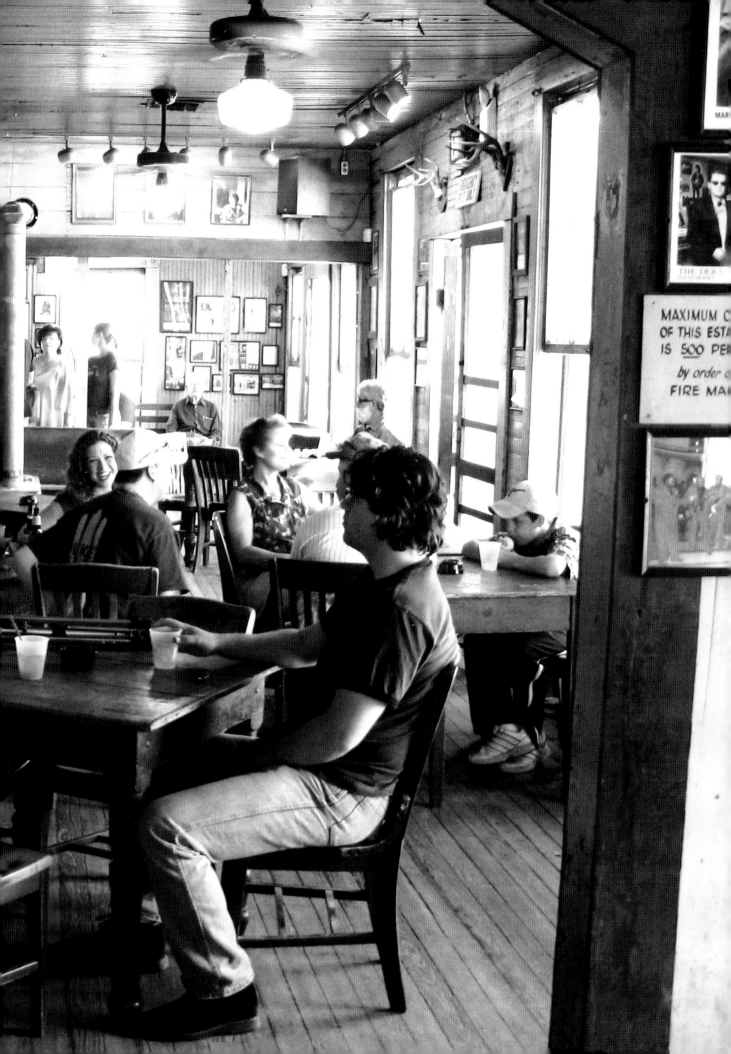

MAXIMUM C
OF THIS ESTA
IS 500 PER

by order o
FIRE MA

tar. Later, she transitioned to the Dobro and steel guitar.

"I started playing Dobro in my twenties," Cindy says. Playing the instrument attracted her mainly because it offered something unusual and different. "Everyone played the guitar," she says. The musical versatility of the steel Dobro had an appeal for Cindy, giving her an opportunity to play bluegrass, country, blues, and swing.

Having a versatile career, which lends itself to varied musical styles, also appeals to Cindy. "I've never been married to one style; I like so many different types of music." Cindy describes her enthusiasm for country, rock, and everything in between as an exploration of different musical textures. Her versatility and skills have made her a role model for other musicians, a mainstay of Texas music, and a frequent performer in its dance halls. She's part of a growing trend of women playing instruments in addition to singing. "I see so many women accompanying themselves,

The front bar area at Gruene Hall, where people sit sipping their drinks and watching passersby outside.

Texas Dance Halls

OVERLEAF:

This is the entryway to Gruene Hall, where there's a bar, but also photographs hanging of musicians who have played there, including Cashdollar's old band Asleep at the Wheel, the Dixie Chicks, and George Strait.

artists like Shawn Colvin and Allison Krauss," Cindy says. And although the steel guitar and Dobro aren't common among women, more women have taken them up over the years, Cindy adds.

Similar to Cindy's musical style, which blends traditional touches with a restless, contemporary style, Gruene Hall has retained its original charm with occasional nods to modernity. Cindy, having played in both large concert halls and smaller spaces, appreciates the vintage quality the dance halls offer. "Playing in a dance hall versus a regular venue is like the difference between having a condominium versus an old house," she says. Although both get the job done, the dance hall focus on history paired with contemporary sound makes them unique.

During the set break, some dance hall visitors take advantage of the spring sunshine, letting the weathered screen door of the dance hall bang behind them as they wander through nearby shops for books, antiques, and pottery. A few inner tube riders take an early float down the Guadalupe River. Beside the dance hall, gentle lawns lead up to the Gruene Mansion Inn, a thirty-room facility with carriage house, corn crib, and barns that was once Henry D. Gruene's home. Barbeque scent floats from the nearby Gristmill River Restaurant and Bar, which once housed the Gruene cotton gin. After stretching their legs outside, visitors wander back to the hall for a few more songs, ready for whatever comes next—acoustic folk, country, or the ragged guitar-edged chords of rock.

Cindy Cashdollar has played many Gruene Hall performances. Photo courtesy of Rob Buck.

Cindy says the dance halls are good for Texas music as a whole. While some bands bring a danceable sound onstage, such as Asleep at the Wheel and their western swing style, other bands have less of a dance focus. No matter what the particular musical style of a certain act, visitors to Gruene Hall want to dance. When Cindy first performed in Gruene Hall in the 1980s, enthusiastic dancing was one of the first things she noticed. "People here [in Texas] love to dance. It's a comforting environment that's not stifling; it's a sweet tradition, a place families can still feel good about visiting."

Several area halls, including Gruene, offer afternoon musical performances in addition to the evening shows. Such family friendly shows help encourage fans of all ages, from young couples, to the elderly, to parents with young children. The Bret Graham band starts off a new set, encouraging more visitors through the front door toward the stage just behind the bar. At the back of the room, an open space free of tables and chairs, dancers fill the floor. Some are couples who've danced together for years, while others are groups of friends, laughing through the steps as they glide together.

Cindy hadn't planned on living in Central Texas. Having finished a European tour with Leon Redbone, she sought new musical opportunities in Nashville. After her arrival in Tennessee, she learned that Asleep at the Wheel needed a steel guitar player; better yet, the band happened to be in town at that time to tape a show for the Nashville Network. Cindy went to the taping the next day, scouting the road cones that marked the band bus's parking spot. Once the bus arrived, she introduced herself to the band's steel guitar player at that time, John Ely. After confirming that Ely was indeed leaving the band, Cindy gave the group one of her demo tapes. The band liked what they heard and requested a videotaped performance from Cindy.

Band leader and singer Ray Benson, who fronts the band with a mixture of good humor and high energy music, hired Cindy, with the condition that she come up to speed on the steel guitar—an instrument she'd been playing for about a year—in the next six months. Cindy practiced nonstop in between shows, taking lessons with steel experts John Ely and Herb Remington, who played steel guitar for Bob Wills and the Texas Playboys during the 1940s. Cindy's efforts paid off, and she stayed on the road with Benson and his band. During her eight-and-a-half years touring with Asleep at the Wheel, Cindy saw every state, along with several European countries. Of all the honky-tonks and larger venues the band played, however, Cindy never saw dance halls quite like the ones in Texas. Gruene Hall, in particular, where the group performed regularly on the main stage, became a touring favorite.

One time, says Cindy, Ray Benson performed at Gruene Hall in his shorts and cowboy hat, just as if he'd come fresh off the Guadalupe River from an inner tube float. "He'd played golf that day," Cindy says. "We were driving to the show, right past the San Marcos Outlet Mall, before Ray realized that he'd forgotten his pants." The bus driver made a hurried turn into the mall parking lot; it was just a few spare minutes before closing time, and Benson thought he might be able to buy some jeans or pants for that night's show at Gruene Hall.

"We knocked on all the doors, but they wouldn't let us in," Cindy says. "We gave up, got back on the road, and Ray played the show in his shorts that night." The unusual getup for the 6'7" lead singer with the booming laugh didn't impact the show. Instead, Benson

A picnic and seating area outside Gruene Hall allows people to sit around and listen to the music pouring out of the hall, but it also allows them to enjoy the Central Texas air in March.

breezed through the moment with his usual good-natured style. The dance hall crowd didn't seem to mind at all, Cindy recalls, taking the shorts and cowboy hat combination in stride.

Cindy, who wore a cowboy hat during performances with Asleep at the Wheel, still wears one depending on the weather and the musical nature of the show. Her regular stage attire includes vintage cowboy boots, jeans, and trim jackets and shirts with touches of color. One example is a fitted, kelly-green jacket with purple flowers that brings out her blue eyes. Cindy adopted the vintage western look not from Texas but from her native upstate New York. "I've been wearing it since high school," she

said. "The cowboy boots are comfortable." While many of her fashions originated in the 1950s and 1960s, Cindy also takes advantage of current styles, which in many instances renew vintage tastes.

But while there might be fancy stage clothes, dance hall life doesn't always offer a dressing room to change into them; rustic dance hall facilities can take some getting used to, particularly to those expecting posh conditions. "There aren't really any rock star amenities in dance halls, but that can be a good thing," Cindy says with a laugh, implying that the down-to-earth nature of dance hall life suits her just fine. She pauses to consider if dance hall life without a dressing room was ever much of

Gruene Hall

The Bret Graham band plays on a Saturday while the audience listens.

an issue on tour. "I always changed on the bus," she says. "I was fortunate enough to be in that situation."

The age and construction of the dance halls likewise doesn't impact the musical sound adversely, according to Cindy. "I've never noticed any drawbacks." The structure does affect performers in other ways, however. She remembers Ray Benson's height catching up with him at some of the dance halls, causing the singer to lean so he wouldn't hit his head on lower ceilings. "On some halls, you can see marks where the violin bow jabs the ceiling."

Another dance hall attribute Cindy notices, particularly with today's heavier equipment, is the strength it takes for her to lug gear in and out of the older structures. "In the old days, the amplifiers were a bit smaller," she says, explaining that stairs and a steep stage weren't considered obstacles at the time. Cindy's performance setup, which includes lap steel, Dobro, and triple-necked steel guitar, present a formidable task for any musician. Cindy often receives assistance during the shows by other performers or roadies, yet is willing and able to do much of it herself.

The afternoon at Gruene wanes, blending into the evening show to come. The crowd shows no signs of letting up; new visitors replace those who step out-

Texas Dance Halls

side in the warming sun. A squat wooden stove by the door sits undisturbed, asleep and unnoticed until next winter's cold winds. Ceiling fans make lazy circles over the wooden tables carved with names. A few Harleys chug by, drivers and riders both gaping in the hall's windows as they pass. With music that's hard to resist, a few park and come inside to hear their favorite band or maybe a brand new one.

After eight-and-a-half years with Asleep at the Wheel, Cindy decided to pursue a career on her own. "It was scary to leave such a secure nest," she says. Cindy didn't stay idle long. Her solo career blossomed into numerous opportunities, including performing with Bob Dylan on his *Time Out of Mind* CD, touring with Cajun band BeauSoleil, teaching Dobro workshops in Ohio, and releasing instructional Dobro and steel guitar videos. Cindy also worked with Lyle Lovett on Gruene Hall's main stage for an IMAX movie focusing on Texas music called "Our Country." To film the event, the production company hired hundreds of extras, including cars from the 1940s. Cindy remembers looking down into the dancers with their period costumes, swirling together across the dance hall floor.

Today, Cindy performs with a variety of Texas musicians in both live shows and studio work. She released her solo CD, *Slide Show,* in 2004 to critical acclaim. The Academy of Western Artists named Cindy Instrumentalist of the Year in 2003, the same year she was inducted into the Texas Western Swing Hall of Fame. In addition, Cindy is a regular on Garrison Keillor's *A Prairie Home Companion,* a Minnesota public radio program that airs nationally. Her Web site reveals concert dates and a growing discography of CDs on which she's performed, featuring bands such as Ryan Adams and artists she recorded with during her time with Asleep at the Wheel, including Willie Nelson and Dolly Parton. She also performs in Austin with guitar legend Redd Volkaert and recently has toured with Van Morrison and Rod Stewart.

Cindy needs to get back to packing her bags for a music festival in New York. Once home, she'll participate in studio work and freelance performances. The light at Gruene Hall turns a deeper gold. Among these musical commitments, there's no doubt Cindy will play a dance hall date soon; of whether she'll play future gigs in Gruene, the first hall she ever visited, there's no question.

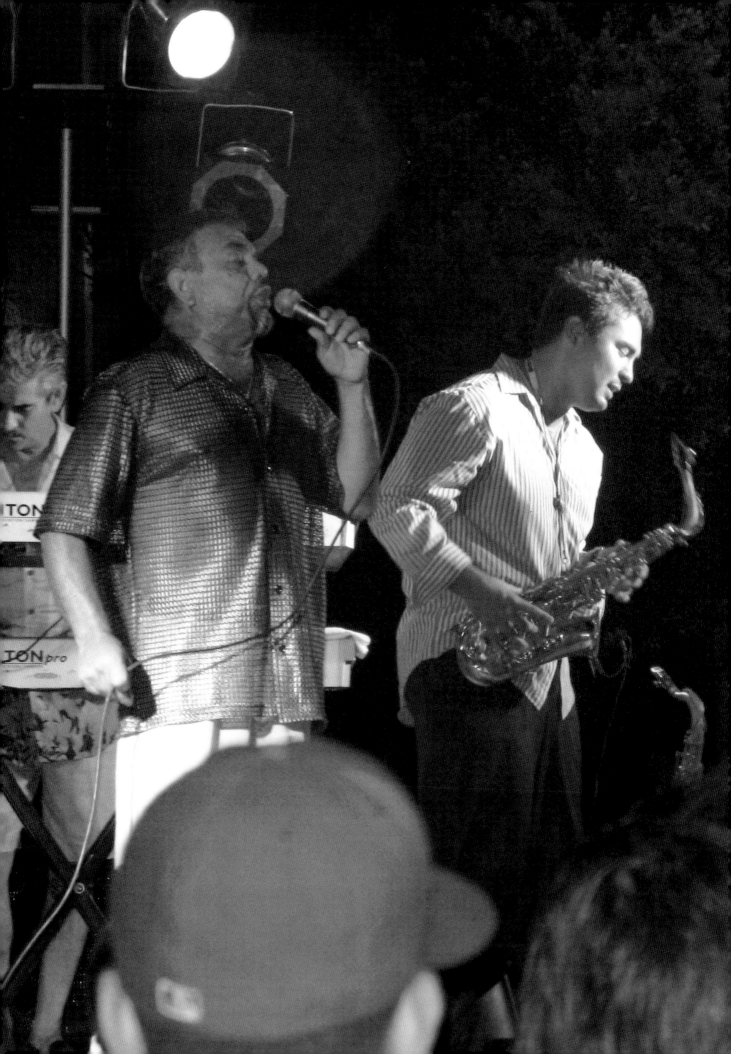

12 DANCING IN THE PARK WITH LITTLE JOE Y LA FAMILIA

■ *Indian Springs Park*

The audience in Waco's Indian Springs Park, 2,000 people strong, claps and rumbles their approval as Little Joe and his band la Familia take the stage. With the first chords of the night, those audience members still seated spring up from their folding chairs to get a better view. Marcus and I wind through the rows of chairs until we find our own spots near the stage. While I lean against the railing and scribble in my notebook, Marcus aims his digital camera at the Grammy-winning Tejano artist who's performed in both Texas dance halls and urban concert halls. The intimacy of tonight's event shows that not every dance hall is indoors.

Although small in stature, Little Joe's voice fills the park. Wearing an iridescent, silver-colored shirt over white shorts, the singer starts the evening with the National Anthem. Audience members, who stay quiet during the song, break into thunder cracks of applause and whoops when it ends. Building on the crowd's energy, the band jumps into a samba number that stirs the crowd onto the dance area. Men and women abandon their folding chairs and drift in pairs toward the paved, makeshift dance floor space in front of the stage. Two

(left to right) Frank Cajical, the keyboardist, Little Joe, on vocals, and Fabian Hernandez, the saxophonist.

Hispanic American women twirl together on the impromptu dance floor, while still other fans hoping for a better look crowd the railing near the stage.

After a few songs in English, Little Joe sings a number in Spanish. He urges the crowd to sing along with him. "C'mon, you're bilingual," he says.

A man in his early sixties encircles a girl's small hands in his, teaching her how to dance. Her blue tie-dyed dress wavers in the twilight breeze. "She's my granddaughter," the man says, his smile broad with pride as they spin across the pavement.

Although today's performance takes place outdoors near Little Joe's hometown of Temple, the artist has a vibrant past playing intimate clubs and dance halls around Texas, from Geneva Dance Hall in Elmott to the Manhattan Ballroom in Dallas and a South Texas hall in Victoria known as The Westerner. These smaller venues helped Little Joe build both his distinctive musical style as well as his career.

"People are still attracted to the halls," he says, praising their wooden floors and sharp acoustics along with the simple word-of-mouth advertising that draws people to the performances. It's

Rocking with Little Joe y la Familia.

the intimacy and sense of history that keeps these venues alive, he adds, along with the Texas-style music that's played within them.

Several years ago, Little Joe participated in a PBS Texas music special filmed in Gruene Hall. "It was about Texas legends in Texas music," he says. The film talked about conjunto music, one of many musical styles that have influenced Little Joe's songwriting and performing. The polka beat of Texas conjunto music, a working-class derivative of Tejano music, borrowed its sound from the accordion-based music of the 1940s and 1950s. This musical style eventually came to the ballrooms and dance halls, where it was adapted

for dancing. Little Joe's frequent adoption of various historical and contemporary musical styles comes, in part, from the music he grew up with.

The seventh of thirteen children, Little Joe was born Jose Maria DeLeon Hernandez in a three-wall, dirt floor car garage in 1940. When he was thirteen, his cousin David Coronado asked him to join a band called "David Coronado and the Latinaires." At fifteen, Joe played his first paid performance in Cameron, Texas, at a high school sock hop. The band was paid five dollars for their performance. "I was a shy kid and thought I'd throw up," Little Joe says of his first gig. "But getting paid a dollar or seventy-five cents made a big difference. It was

Texas Dance Halls

dreadfully needed at our house." After discovering he could get paid for playing, Joe decided that picking guitars beat picking cotton. "At the time I grew up, it wasn't cool to be Chicano," Little Joe says. "Music made all the difference."

In Temple, Little Joe grew up without Spanish music programs, but remembers "hearing music every morning from my dad, uncles, and aunts." In addition to his family, Little Joe listened to the country western played on the radio and the rhythm and blues blaring from beer joints as he grew older. "My older brothers and sisters played records from the swing era, including big band swing and jazz ensembles," he says.

He also heard music by artists such as James Brown, Chuck Willis, The Platters, and Lloyd Price. In addition to hearing these musicians' songs on the radio and in local clubs, Little Joe experienced several large live acts, such as Ike and Tina Turner in Waco's Walker Auditorium. From concert halls to the music that filled his home, Little Joe soaked in the music that surrounded him. "These acts were a big influence on me—they made me feel American," Joe says.

In 1959, after his cousin David left the band, Little Joe took over the lead position and renamed the band "Little Joe and the Latinaires." His younger brother Jesse joined on as the bass player. The band performed throughout Texas for several years. In 1964, following Jesse's death in an automobile accident, Joe made a vow to continue playing music in memory of his brother. Throughout the sixties, Joe made good

This couple danced to nearly every one of Little Joe's numbers that evening.

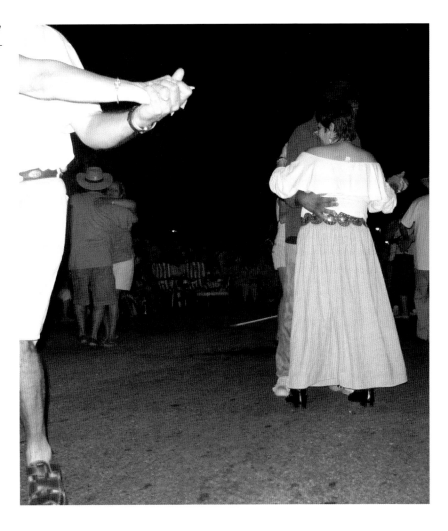

Little Joe (Hernandez) strives to bring people of different backgrounds together through his mix of Tejano, country, and blues music.

on his promise by signing with Texas-based, independent record companies: Corona Records in San Antonio, Valmon Records in Austin, and Zarape Records in Dallas.

During the 1970s, Little Joe expanded his performances to include the Bay area of California, contributing to the Latin movement that had first inspired him in the 1960s. It was at fundraising events for farm workers where Little Joe heard his first Latin-influenced music; he soon added this style to his existing blend of Tejano, blues, jazz, and country. Building the band's repertoire made him realize that their music was a combination

of many forms; this, along with a nod to the important role family played in the band, convinced Little Joe to change their name to la Familia. The new band name proved apt in other ways to this artist, who enjoys meeting new people and exploring different types of music.

"Diversity is like food," he says, comparing the musical styles he plays to trying new dishes. "I'd be bored with one type of music." A smile curls beneath Little Joe's mustache. "For instance, I'm not a jazz musician, but I love jazz. I take bits and pieces of varied musical genres that make up the 1940s, 1950s, and 1960s, from accordion groups to single

Texas Dance Halls

artists. You just mix it together for your own formula," he says.

At Indian Springs Park, the band plays a salsa number that inspires the crowd to dance faster. In the middle of the song, Wild Bill Perkins blasts a trumpet solo into the warm summer air. Everyone in the band takes a turn, from guitar and saxophone to bass and drums. After each solo, Little Joe introduces them: guitarist Tom Cruise, keyboardist Frank Cajical, trumpet player Wild Bill Perkins, drummer and vocalist Jesse Lopez, percussionist Sam Jones, bass player Jesus Gaitan, and saxophone player Fabian Hernandez. The band comes together as one and dives straight into a fast number.

Helium balloons float overhead; the area in front of the stage is filled with dancers. Children throw small colored balls to one another, just barely missing the dancers. Moments later, the impromptu dance floor is too full, and they take up fluorescent sticks in tropical hues instead. Others drop everything so they can twirl between the adults' legs and clap their hands, ever so slightly off beat.

Throughout his musical career, Little Joe has linked music and family. His own children, three boys and one daughter, all play a role in the music industry. Little Joe's oldest son, Ivan, serves as the band's booking agent; son-in-law Tom Cruise is both road manager and guitarist; and Little Joe's daughter Christy "is in charge of everything." His youngest son belongs to a band in Austin, while his next-to-youngest son is both a school principal and a drummer. Little Joe hopes his family can experience the same array of musical experiences that he enjoyed as a child. "When they were small I took them to all kinds of concerts, as they were real music lovers," he says. "It's grown into a family business, as they all just wanted to do it; I never pushed them."

Little Joe's wife, Criselida, has played an important role in his performances as both a supporter and overall boss. After their wedding in 1962, Little Joe went to work at a gig that evening. "It was a Wednesday, and I worked a half-day," he says. When an opportunity to perform in Tokyo came up thirty years later, Little Joe and his wife shared the trip as their honeymoon.

The band changes its style and takes up a slower song; the audience follows their lead and paces their swaying. Rather than sticking to one style in a particular performance, Little Joe prefers giving the audience a selection of rhythms and tempos and adjusting them according to the crowd's response. "I just read the audience," he says. If they seem ready to sway, he'll insert a salsa or blues beat. Other audience members, depending on the venue, might want to sit back and listen.

When entertaining the dancers, Little Joe finds that crowds will dance no matter what. "Certain kinds of people love dancing," he says. "I played Tierra Blanco near El Paso in a rodeo arena with sand." Even without a dance hall or as much as a wooden platform, "people started dancing in the sand and kicked up a whole dust storm." Little Joe's fans will dance on almost anything, he says, from carpets to grass and carpeted casinos with a small dance floor space. Little Joe rests his elbow on the table and smiles. "Music makes people want to dance. It's good for the soul and the body."

Tonight, the crowd dances to every song the band plays, from salsa to country and even a Texas Tornadoes-inspired song that makes the dancers scoot their feet in the quick-quick-slow motion of the two-step. I look for Marcus, who's taken a seat on a curb at the edge of the dance area. A few children wave their colored sticks beside him. I join him on the curb and watch the dancers float by.

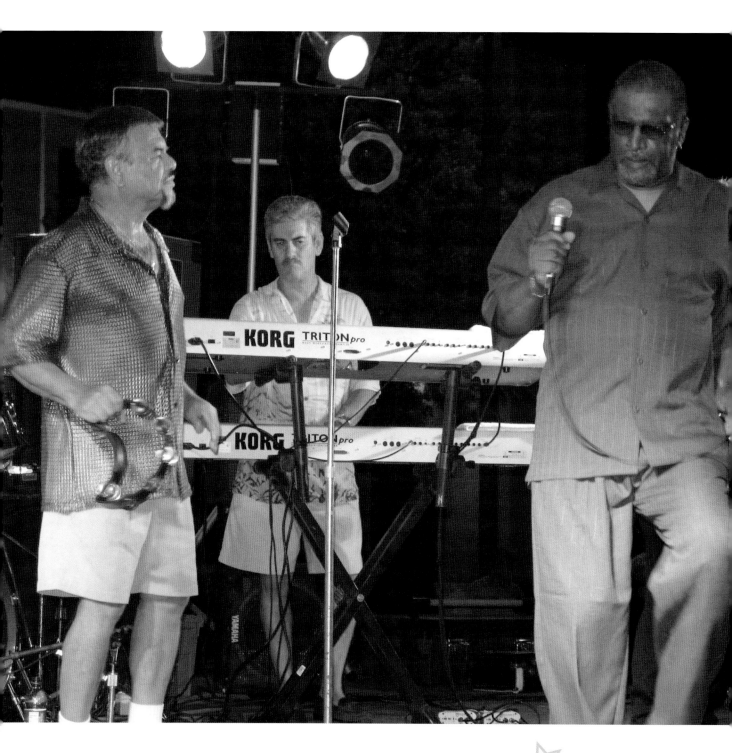

The next song is from a movie that Little Joe performed in, called *Down for the Barrio*. He raises his hands over his head, encouraging everyone in the audience to clap along with him. The message "stop the violence" is evident in the lyrics Little Joe sings, reflecting not only

a movie theme but also his belief in music as a means of uniting.

He has the opportunity to spread this message not only in Texas, but in venues throughout the nation and beyond. "I've been fortunate enough to travel abroad, and we're all the same, just a little differ-

Little Joe plays the tambourine (left) while Neal Sharpe sings and Frank Cajical plays keyboards.

Texas Dance Halls

ent," he says. One of his most memorable tours was the Tokyo trip. "They are tri-lingual there," he says, "speaking English, Japanese, and Spanish. They love American culture." His eyes flash above his silver shirt. "We're also the same height, so we can see eye-to-eye."

The dance floor area at Indian Springs stays packed. A soft breeze pierces the humidity. A woman in chunky jewelry and a gingham dress dances with a man in jeans and a plaid shirt; Marcus tells me that they've danced together for every song in the band's set. Rainbow sticks still flicker in the air, tired youngsters waving them less fervently now. Teenagers flirt on the sidelines while shy young adults just now creep out onto the dance floor. Middle-age and older couples, meanwhile, stay there most of the night.

While Little Joe plays the larger stages both at home and abroad, he plans to keep performing in Texas dance halls. There's something about these halls that keeps them personal, while still giving people plenty of room to dance, he says. "I'm real lucky that I still get to visit them. It's not about the money; it's about the joy of music and dancing." Some of Little Joe's most memorable experiences come from venues such as the Club Westerner in Victoria. "I'll always remember the time I opened for Isidro Lopez in 1957," he says. "He was one of the hottest Chicano acts at the time and we became really good friends." Lopez gave Little Joe the nickname "Big Time," perhaps sensing the artist's upcoming fame.

Little Joe remembers weekends playing a Friday night show at the Westerner in Victoria and a Saturday show at the Pan American Ballroom in Houston; sometimes, they added a Sunday show at the Pan American Ballroom in El Campo. "All the major Latin acts played there. It was torn down about six or

seven years ago; I always felt it should be kept as a historic monument. It should never have been done away with." The crowds, which grew as large as 2,500, came from local areas as well as nearby towns like Port Lavaca and Beeville. "It was the thing to do," says Little Joe, "getting all dressed up and going to the show." Since first performing at Club Westerner during the 1950s, Little Joe now plays an occasional gig there. "People who used to come out in the late 1950s and early 1960s still come out to the shows. It's great to visit with them. The club is a great family hangout."

While dance halls like Club Westerner helped influence Tejano music on both a regional and national level, today's Latino musicians have likewise made their mark on dancing and music. "Each generation brings their own fads," Little Joe says, adding that just as many people in the Chicano population are dancing; it's simply that their musical choices are more diverse, from DJ and dance music to Latin styles.

The crowd below the stage, reflective of most age groups and many nationalities, keeps moving their feet and hips. Almost without thinking, Little Joe adds an inspirational component to the songs he writes. Within all religious faiths, we're part of a greater spirituality, he adds. It's another way for people to connect with one another.

Little Joe y la Familia play their final numbers. Darkness makes the stage lights brighter, and the summer breeze is more insistent. From the couple who've danced every song to pairs of laughing teenagers making their first rounds of the night, the dance floor area stays packed. The man in his sixties takes another dance with his granddaughter in the tie-dyed skirt, giving her a final twirl. Almost everyone stays until the last song of the night, dancing each moment.

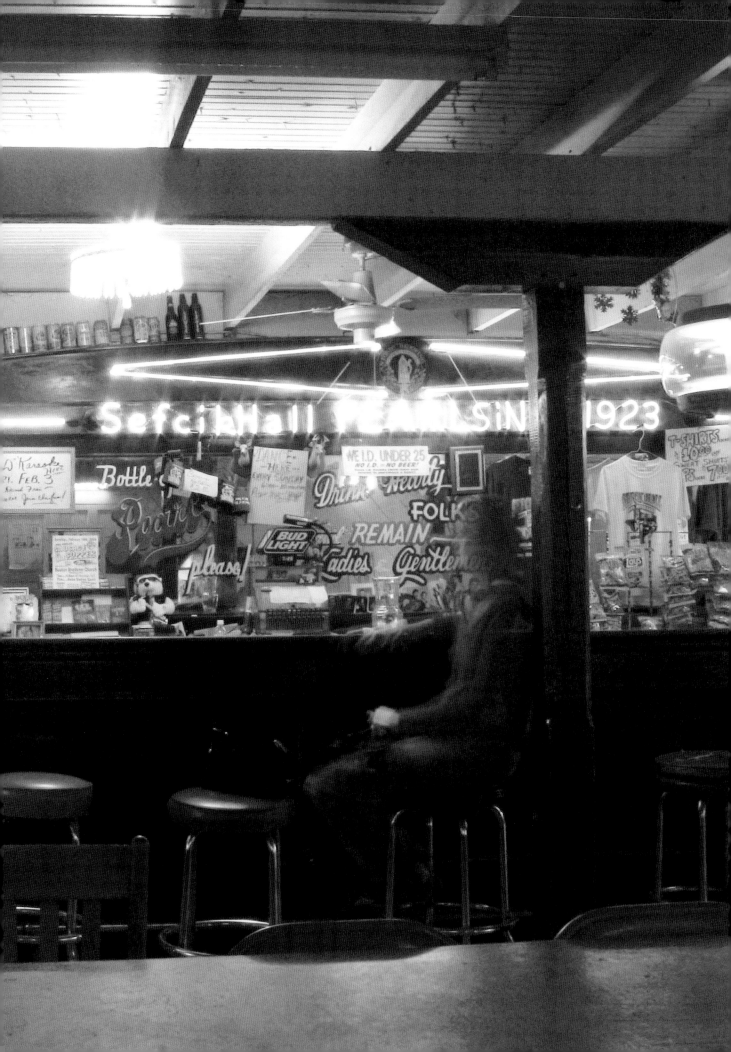

13 IF ALICE ISN'T HAPPY, NOBODY'S HAPPY

■ Sefcik Hall

When I walk inside the bar and meet musician and dance hall owner Alice Sulak, she asks me to work the door at Sefcik [pronounced SEF-chick] Hall. My husband John and I have just walked into the downstairs bar. John rests his bass guitar against his leg as we stare at the neon signs and colored flasks across the smooth wooden bar. Alice, in her late sixties, arranges bottles of beer from the antique cooler in front of her. Pastel flyers on the countertop announce upcoming dances.

Above Alice's head, the most prominent neon sign proclaims the hall's opening date as 1923. Another sign outside the hall repeats the date along with her father's name, Tom Sefcik. A farmer and former musician, Tom built a dance hall to offer local entertainment. He ran the hall until Alice took it over in 1970. An outdoor sign tells us that Sefcik Hall is open every day, starting at five in the afternoon. "I don't open early," Alice says of her hours. Twisting on my bar stool, I read another wall sign that says "If Alice isn't happy, nobody's happy."

A woman with short, dark hair and glasses walks into the downstairs bar and greets Alice. "This is Toni," Alice

says. She gives me a look that's part question and part command, shaking me from my barstool slouch. "Can you help Toni at the door?" A Czech accent thickens her words. Alice's parents spoke nothing but Czech, so Alice learned English in schools. "I don't get to speak it [Czech] that much," she says, "but I'll never forget it."

The two women lounge against the bar, Alice behind it and Toni in front of it, and wait for my reply. Alice tells us that she's advertised tonight's dance in area newspapers and predicts a good turnout.

I've never worked the door before. I wonder if I can claim the same authority that Alice demonstrates, although she's not asking me to be a bouncer; it's more about collecting change and less about brawn. As a waitress in college, I'd counted change for customers at the cash register. "Sure," I tell the two women.

Toni smiles at Alice but doesn't say anything; no need to fill the silence. Both she and Alice wear jeans and colorful tops. "We have a good friendship," Alice tells me later. "We went to school together here in Seaton." Toni works at

Toni Malcik, who's known Sefcik Hall owner Alice Sulak for years, sometimes tends bar at the weekend dances.

Texas Dance Halls

Sefcik on the weekends, selling tickets for the dances, helping out at the bar, and cleaning up after the crowd's gone home.

The jukebox behind us bursts into a George Strait song. Overhead, the ceiling creaks from band members setting up their equipment. John slides off his bar stool so he can help out upstairs. Toni and I follow him toward the dance floor door, which we reach from another door outside the building. We step onto the white painted porch with pale blue benches. The sun, although fading, still shines overhead. Spring flowers bloom with Indian Blanket spikes of yellow and red, sharing the field with softer pink primroses. Across the narrow road, a barn rests in a meadow.

Toni leads us around a corner of the porch to a solid door, which opens to a listing staircase. I grasp the hand rail while John clutches his bass. At the top of the stairs, another door creaks open. The first thing we see is a wooden desk positioned for collecting the night's cover charge. Floor boards run the length of the hall to the stage; strings of

Christmas lights drape overhead. In the daylight, they look like tiny specks, but as darkness grows, they'll turn to colored stars.

Alice tells me her father built the dance hall upstairs in hopes that windows would help cool it. Having an upstairs dance hall also left ample room for the main bar and game area downstairs. Still, the place got so full that Tom Sefcik had to turn people away when there wasn't enough beer, Alice says. The addition of a second, smaller bar upstairs in the 1950s helped alleviate this problem. Today's hall visitors, once stamped, can go upstairs and downstairs as they please.

TC Taylor bends over his microphone and sends the word *"check"* reverberating across the dance hall floor. A few mellow notes from the bass guitar join in as John tunes up. A moment later, the band members slip into the men's room to change into their stage clothes. Until 1968, visitors to Sefcik Hall used outhouses. "When we put water upstairs, that ended that," Alice says. Another addition to the hall was electri-

Sunday evening at Sefcik Dance Hall.

The door to the downstairs bar at Sefcik Hall.

cal wiring. "A long time ago, the lights ran on batteries," she says, with a large transformer humming outside the dance hall.

TC, dressed in a vintage western shirt and cowboy boots, greets Alice before the show. "How've you been?" he asks, smoothing his long hair back. Having grown up in the Temple area, TC and Alice have known each other for years.

Alice leans against her bar and smiles. "I've been busy," she says. "Working and playing music." An avid saxophone player, Alice is just as apt to be on stage as she is running a dance hall. A chalkboard sign near the bar announces that the band she performs with, Jerry Haisler and the Melody Five, will be playing at Sefcik Hall on Sunday.

"Should be a good night," she tells TC, one musician to another, as he walks toward the stage.

John and TC, along with drum player Doug and guitar player Dale, plug in their instruments and string together wires, taking full advantage of the outlets scattered throughout the stage. An

elevator that Tom designed hoists the band's speakers and monitors from the gravel parking lot to the second floor dance hall. I push an upstairs button, and the elevator hums down to pick up a waiting band member and more gear. I peer over the edge of the shaft, making sure to stop the elevator before it smacks into the ground. The elevator lifts not only band equipment but beer. "We had to add it because of the bar," Alice says, "Otherwise, it would kill you running up the stairs."

Anxious to learn the ropes before the crowd comes, I stride across the dance floor to my post at the entryway with Toni. Behind the tall fortress of a desk, Toni shows me where we'll keep money and tickets. The front of the desk has edges rounded smooth from resting elbows. On top of it, a worn piece of shelf paper flaps. Inside a drawer is a packet of money we can use for change. I take the slick bills from a rubber-banded cigar box and divide them into neat piles of ones, fives, and tens, placing each pile in one of the sectioned desk drawers.

Sefcik Hall

We each pull up a tall chair to sit on. "You can take the money and I'll stamp," Toni says, pulling her rubber stamp and a pad of ink close.

From downstairs, Alice bursts through the heavy entryway door with a sheaf of papers in her hand and sets them down onto the flap of wallpaper. "Cover is $6 tonight," she says, not expecting a reply. When Toni and I nod, she bustles over to the bar located a few paces across from our desk. With her own three sons grown, both music and the dance hall are Alice's primary occupations. Her management skills combine her father's example and her own experiences growing up in the hall. "I always helped Daddy," she says. "I was born in the house nearby." She motions to a house that's hidden in the trees behind the hall. "Live there now, and have lived there all my life. When you grow up with dance halls, you know what to do."

Tom ran the hall he'd built with a focus on tradition tempered with modernity. "After thirty years of serving Pearl beer, we finally talked him into serving different brands," Alice says. "He didn't want to do it. He used to peel off the beer bottle labels when they soaked in a bucket. Someone would order a Budweiser, and what they'd be getting was a Pearl beer." One man, she laughs, even said his beer, not a Budweiser at all, was the best Bud he'd ever tasted.

After checking her stock behind the bar, Alice wipes a paper towel across its surface. She moves to the dance hall tabletops afterward, making sure they're dust-free. Above her, advertisements from the 1950s and 1960s line the wall like a vintage border, selling products that range from soft drinks to local insurance. The placards show their age—each telephone number has only five digits. A man in a suit approaches Alice at the bar. He gestures to the advertisements as he speaks. Alice listens, but shakes her head. Later, she tells me that he wanted to put up his own sign. "Several people want their advertisements up there," she says. "But what's up there now is history." Like her father, Alice considers change but keeps her main focus on tradition.

Sefcik Dance Hall visitors wait for the band to start.

Texas Dance Halls

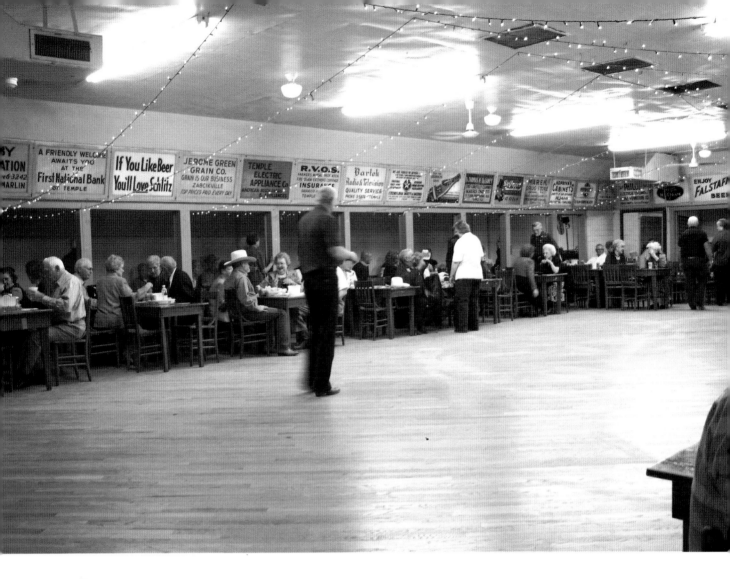

As the band warms up, a gentleman salts the dance floor to help dancers slide.

Toni and I pull our chairs up to the desk. Unsure how the man in the suit slipped by, we're determined not to fall down on the job. The Friday night performance starts soon. I open the desk drawer again to check the extra bills. As I shut the drawer, early customers stomp up the slanting staircase. The doorway opens to a tall man in jeans holding out a twenty dollar bill for himself and his blonde-haired date. The bill wavers between Toni and me before I grasp it gently, counting out eight dollars in return. Toni stamps each hand with a blue splotch. The man nods and leads his date to the bar.

I straighten the dollar bills and make sure there's a fresh place for twenties. Toni tells me she has a birthday coming up, her sixty-eighth. Having outlived two husbands, the dance hall helps her keep busy. She tells me about the dancing she once did in both this hall and neighboring halls. Another group of customers walks upstairs and pushes through the heavy door. This time, it's young men in cowboy hats who crane their necks for possible dance partners. They turn to one another when they don't see any young women. In quick tones, they converse before turning to Toni and me.

Come inside and be patient, I think to myself. I smile and promise them it'll be a good show tonight. They smile and present their careful piles of dollar bills. Toni stamps the backs of their broad hands in blue ink. As if on cue, three

young women in low-cut jeans and halter tops push open the door and plop down a five and dollar bill apiece. Their teeth gleam behind freshly painted lips. The group of men, who've since sauntered toward a side table, look up in interest as the women sidle by the bar.

The customers come in bunches now, making my fingers move faster between the softly worn dollar bills. There's no time for doubt in my duties; I just work. In the moments between groups of customers, I watch the young crowd, mostly in their twenties and thirties. Once inside, some angle for the

tables placed around the dance hall floor, while others visit Alice at the bar. It's hard to determine which customers are old friends and who she's just met; she chats and laughs with everyone. On a set break, she slides a beer down the bar toward TC, along with a glass of water for John.

Greeting old friends and making new ones is one of the perks of dance hall life, Alice says, although it's hard not to miss some of her older friends who've passed on. "But, you get to meet new ones too," she adds. "It's fun to see the people have a good time and enjoy

Texas Dance Halls

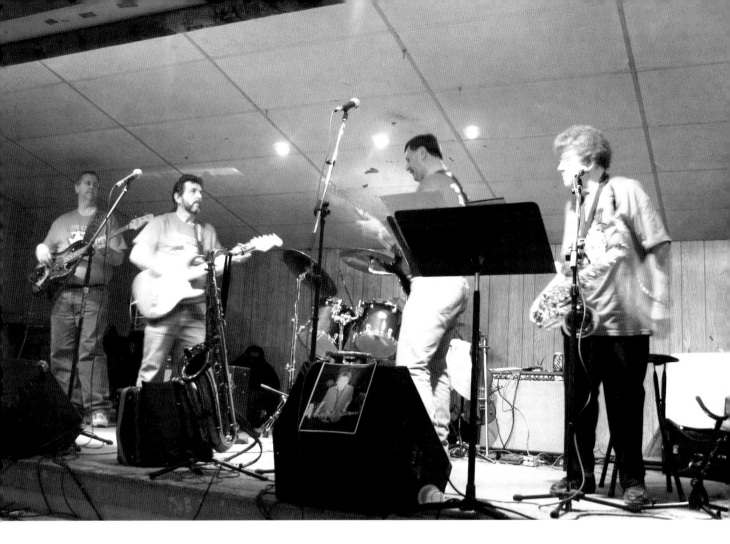

Jerry Haisler and The Melody Five. Left to right are Bob Haisler, on bass guitar, Robert Brought, on back-up guitar and vocals, Jerry Haisler, on lead guitar, on drums is Tony Chudej (out of view), and Alice, on saxophone.

Alice Sulak has performed with Jerry Haisler and the Melody Five for forty years.

themselves." On the downside, "There's also a limit to the beer business; you have to be sensible. Some people can't handle it." When they can't handle it at her hall, Alice takes notice. "When people get rowdy, I put my foot down. Some things you have to swallow, and sometimes you have to tell them how it is."

The band starts up again with a two-step number. The crowd that's formed rises in pairs to the dance floor, transforming into a sudden circle of dancers. Cowboy boots skim the diagonal floor boards in a widening circle. "They come here to dance, I tell you," Alice says. The floor fills with the dancers, the low ceiling keeping the sound between the stage and dance hall floor tight. The types of music Alice books at the hall include country and rock, along with the Czech

and polka music that she often plays. Tonight's music is a combination of country and Americana.

Alice gazes across the growing crowd, which now numbers around one hundred people. It's dark enough that the Christmas lights, which Alice put up eight years ago and never took down, stand out. Years ago, propriety dictated that dances be well lit. Alice remembers dances during WWII, when soldiers came in trucks from Fort Hood. "Girls came to dance with them, but they kept the lights bright back then." In addition, parents came, stayed, and watched. Starting in 1953, the lights dimmed.

A few songs later, the entryway door is constantly open from the flow of people coming upstairs. I count the change faster. Some fans know the band, while

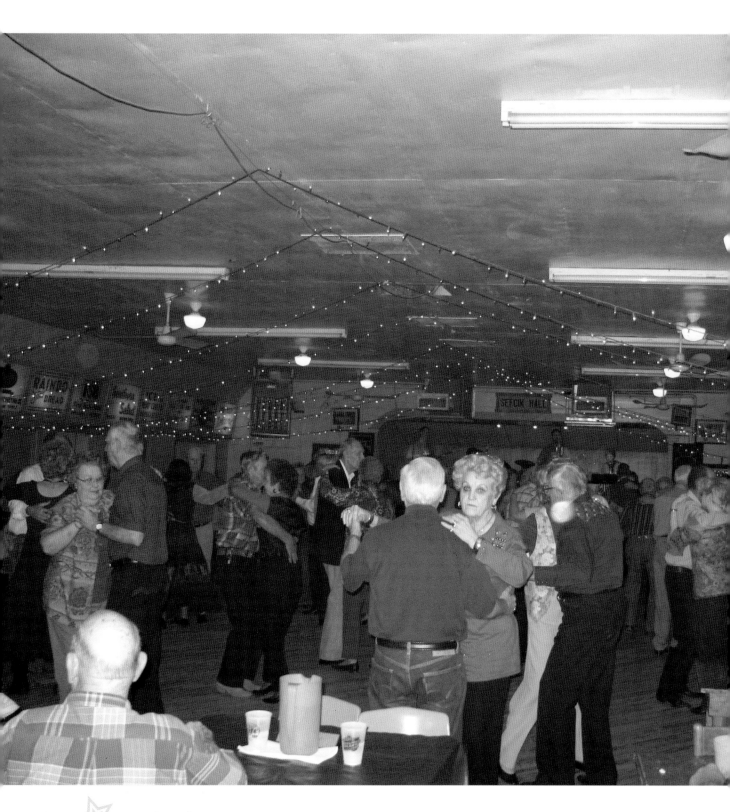

Older patrons show up for
Sunday afternoon dances,
while the younger crowd
dances on Saturday nights.

Texas Dance Halls

others ask about them. "Who's playing?" a man in a cowboy hat asks me.

"TC Taylor," I say. From the bar, Alice watches the band with an approving nod. I show the man tonight's band flyer and a few CDs, adding that TC Taylor and 13 Days are regulars here. While he's looking over the CDs, Toni stamps his hand. Satisfied, the cowboy hands me exact change and heads for the bar.

More dancers join the thick circle around the floor. Alice likes to dance, but hasn't in a while. "My mother danced and loved it," she says. More than dancing, Alice loves to play the saxophone. "My mom used to say, 'all you do is play music,'" Alice says. "But if you're going to be a musician, you can't be thinking about dancing."

In between customers, Alice focuses on the stage, a familiar place for her. "I've played music over fifty years," she says. Alice became interested in music through her sister, Adella. "She got me into a band when I was ten years old," Alice says. She also credits her sister with pushing her to improve. "She told me to learn it better or quit; I said I could, and I'm still with it."

Alice shows me pictures of her first band, Adella and the Music Makers. In one snapshot, Alice stands in a pink blouse and black pants, her saxophone held close. "It's been the biggest enjoyment of my life," Alice says. "When I play, I don't feel my problems or my

worries. Music helped me get through rough times, like my divorce in the 1960s." Along with sharing a love of music, Adella and Alice both worked at the hall, helping their father nail down a new dance floor when the old one grew worn. Adella, who died at forty-eight, would've been a big help with the dance hall today, Alice says.

Today, Alice divides her time between dance hall management and playing gigs with Jerry Haisler and the Melody Five. The band performs at Geneva Hall, West Fraternal, and Seaton. They also play at Alice's home turf at Sefcik Hall, particularly on Sundays. "I always have to make sure someone's here when I have a show," she says, gesturing at the hall. "It gets hectic for me to leave. But sometimes I just have to, once a week and sometimes twice."

On this Friday night, the hall fills to more than 200 people, most of them on the dance floor. Under colored lights, the dancers smile and twirl across the floor. Alice laughs with customers at the bar. Toni and I sit back in our tall chairs, ready to relax after another rush of customers. Alice isn't sure who will run the hall after she retires, but she does know one thing. "No one would do it my way," she says, and frowns. "But my wheels keep rolling," she adds, brightening at the room filled with dancers and the music that keeps everyone, including Alice, in motion.

14 TODAY'S DANCE HALL FAMILY

■ *Saengerhalle Dance Hall*

The band playing inside Saengerhalle, Full Throttle, whoops through a fast country song, urging the crowd to dance. The stage inside is out of sight, but it doesn't matter; you can hear the music just as well from the wooden porch and its soft lights, and imagine the crowd inside edging closer toward the stage. A few onlookers on the porch, both groups of friends and families, peer through side windows at the action taking place inside.

A mother, adult son, and grown cousin sit on the edge of Saengerhalle's outdoor porch. This group, the owners of Saengerhalle [pronounced San-ger-HALLA], could be any other family out to see a performance. Terrie Chase, a woman in her fifties with sandy-blonde hair, sits closest to the railing near the entrance. Wearing jeans and an easy smile, she greets dance hall guests who come in through the porch gate. Her thirty-two-year-old son, Eric, leans against the railing, his hands relaxed against his jean pockets as he scans the crowd that's starting to form. A few wisps of short hair slip beneath his cowboy hat as he crosses his arms in a long-sleeved shirt and rests one boot against the porch railing. It's the first Friday of

Spring Break, and business looks good. Justin Jones, Eric's twenty-eight-year-old cousin, sits at the wooden table with his hands wrapped around a beer. His hair, a little longer and lighter than his aunt's and cousin's, frames his face.

Unlike some dance hall families, who have owned and managed halls since the first German and Czech families built them in the late 1800s, the Chases entered the dance hall business right at the start of the twenty-first century, in 2002. They're a modern family who never realized they'd be dance hall owners. When asked if she ever dreamed of owning a dance hall, Terrie laughs in reply. "Never; we're from Abilene," she says.

Terrie grew up in this West Texas city, while her husband grew up in Fredericksburg. They both met at college in Abilene. After getting married, the couple started a communications business in Abilene, beginning with two-way radios and moving on to trunking systems, an early type of cell phone system. Both Eric and Justin also grew up in Abilene. Eric graduated from ACU in Abilene and Justin went to school at Texas Tech University in Lubbock.

The family moved from West Texas

Arriving for live music on a Saturday night.

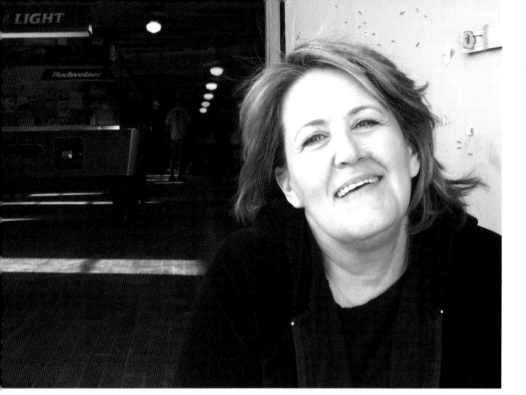

to Central Texas in the early nineties, looking for opportunities, fresh terrain, and a new way of life. Despite their adventurous spirit and ready camaraderie, Eric describes their family as no different from other long-time dance hall owners. "We're plain people, plain stories," he says. A whoop sounds from inside the bar.

With the family's Baptist background, Terrie admits she wasn't sure how her immediate family would take to their dance hall purchase, particularly her mother. The family, to Terrie's surprise, reacted with enthusiasm. "They all come help out when we have big shows," Terrie says. "I have an aunt who is seventy-four, and who had never been inside a place that sold alcohol." Terrie describes how her aunt, wearing a black leather jacket, walked into Saengerhalle with Terrie's cousin. "My cousin put a beer in her hand, and she just smiled when I took a picture; I used it as my Christmas card that year. She was a really good sport," Terrie says.

On the porch, a few onlookers sway. Inside, more dance. Although relative newcomers to the dance hall business,

preserving Saengerhalle's history remains important to the Chase family. "The history was all here," Terrie says, gesturing toward the black-and-white photographs that pepper the walls inside. "It was all just buried; piles and piles of it everywhere. The backstage was littered with photographs. We did everything we could to get it on the walls." Among the photographs, Terrie found dance hall programs from 1956 and 1971, both written in German. Eric adds that the photographs and artifacts will stay with the hall, whether the Chase family owns the venue or not.

"We don't want to do too much to it," Eric says. Everyone at the table laughs, insinuating that not much gets done at all. The hands-off approach he describes, however, lies not in a lack of motivation or funds, but has more to do with preserving the original character of the hall. "We don't want to lose what's already here," Eric explains. As part of their respect for the hall and its history, the Chase family keeps modern improvements to a minimum, focusing instead on outdoor maintenance projects, such as mowing grass and weeds.

The natural beauty of the setting takes care of itself, from the single oak trees that line the gravel driveway to the groves of trees that embrace the hall itself.

Likewise, the family keeps the interior of the hall clean but not necessarily pristine. "We don't keep it spotless," Terrie admits. "In some cases, we just leave it." In the brief lull between songs, we can almost hear a cue ball spin into a few others, scattering them down the pool table. Patrons on the deck clutch their beer bottles or glasses of water while the band starts up a new number.

Although Saengerhalle is younger than some dance halls—local German singing club members built the structure in 1959—the land where it sits was used for festivals and dancing since the 1800s.

Outside, patrons chat, dance, and listen to the music.

It's not hard to imagine the original rows of tents for beer gardens and dancing. Gilbert Becker, a farmer, singer, and director of one of the singing clubs, donated the land for the site. The German name of the hall, in fact, translates to "singing hall" or "singers' hall." To construct the hall, local citizens moved donated Army barracks from Fort Sam Houston to San Antonio. With a new structure in place, singing clubs formed a nonprofit corporation to operate the hall for meetings, singing fests, and other events. Saengerhalle survived on event donations until 1996, when owners decided to sell the structure.

Dance hall ownership for the Chase family began with Eric's neighbors, Bob and Shirley Saulle of Gruene. The Saulles had owned Saengerhalle since

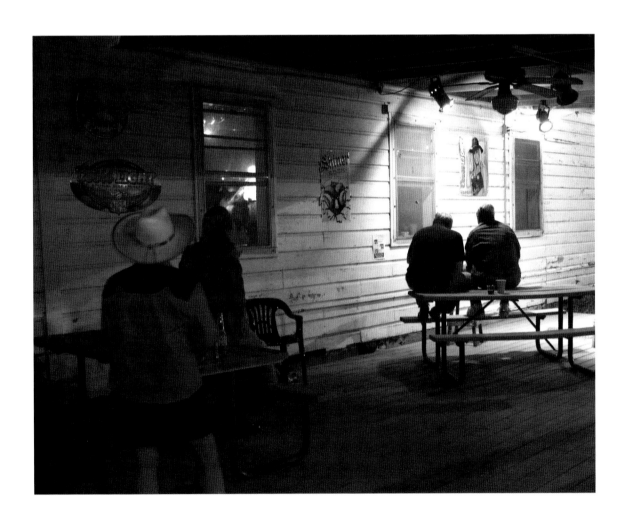

Saengerhalle Dance Hall

1996. Eric, who visited Saengerhalle on occasion to hear live music, liked what he heard and saw. "Plus, the beer's cheaper when you own the hall," he jokes.

"We just really appreciate music," Terrie says, "and thought it would be great to own a place to keep as a family business." Whenever Eric ran into Bob, he asked him to let him know when he wanted to sell the hall. One day, Bob called Eric's bluff and asked if he was interested. Two years later, the sale went through. In the meantime, the Chase family spent time in the dance hall as customers to learn the ropes. To this day, the Saulle and Chase families stay in touch.

The crowd inside the hall buzzes in-between songs, bustling with fans who can barely keep up with the band's energetic pace. Despite the success of the Chase family and a production company in keeping Saengerhalle filled through diverse musical acts, the family insists the dance hall venture is a hobby, one that keeps them busy Wednesday through Saturday nights. "We've put more money into it than we've made," Eric says. "It's for the long term." The dance hall is not a full-time venture for any member of the family. Eric and Justin operate their own businesses, a construction company and rental property, respectively. A common thread between these ventures and dance hall ownership is self-employment, with no bosses but themselves. Eric describes self-management "as the most critical part" of his job happiness.

Although Terrie plays a vital role in preserving the history of Saengerhalle, she describes her influence as minor. "They would tell you I'm the boss," she says, grinning from Justin to Eric, "but they don't listen to me." The band chooses that moment to turn up the sound, a guitar solo flirting across the dance floor. Although Terrie jokes with Eric and Justin about who's the real boss

of Saengerhalle, one has the feeling that at the end of the night, no one loses much sleep over it.

Dividing duties for the dance hall comes easily, Eric says. "We have a large construction company, and people are always asking about our roles. We just start doing whatever's needed. Once in a while you look over and discover you're doing the same thing, and you say well, okay. But most of the time, it's a natural division. We're all pretty different." The family runs the dance hall using a similar method of taking care of things that need doing. Even if Terrie, Eric, or Justin don't attend a particular performance, the hall manager, George, can reach them by phone.

Terrie's cell phone rings; she tells us it's her husband, announcing that he's going to bed. Terrie clicks off the cell phone and offers a grin. "His involvement is standing on the other side of the bar and ordering a beer," she says, although her smile lets everyone know she doesn't really mind.

Terrie says contemporary family dance hall ownership makes sense for them given the family influence of the dance halls as a whole. "The halls were built around the family," she says, with parents, kids, grandparents, and everyone in between. "Many were designed in a round, so the parents could check on the kids." She glances through the openings that separate the porch from the hall. Energy-charged music pours through the windows; a few people on the porch start to dance, including a woman in a skirt who begins a slow twist. Nearby, a man lifts up a curly haired boy so the child can see the band. The man puts him down on the ground a moment later and watches him amble across the wooden floor in an atmosphere the Chases' describe as both family and dog friendly.

Eric straightens up from the railing to glance at the crowd inside the hall. "People say that owning a dance hall is a

Texas Dance Halls

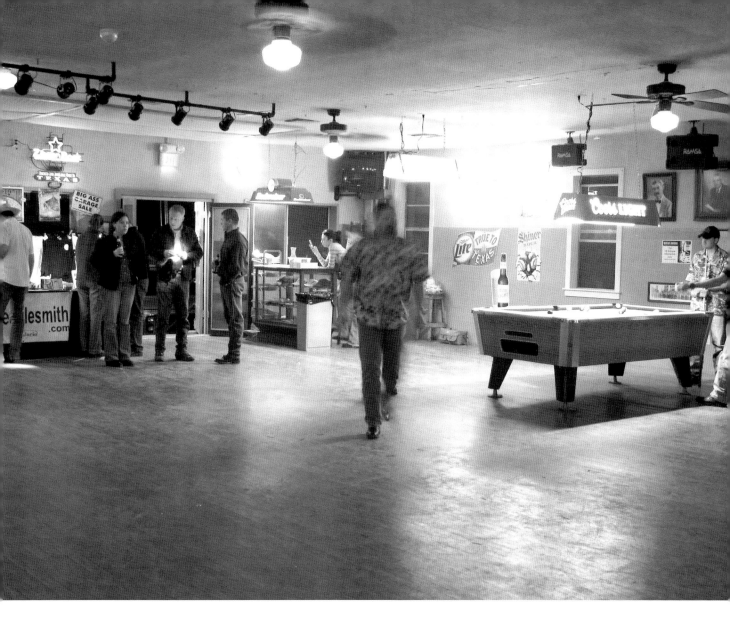

Once inside, Saengerhalle visitors enjoy music, play pool, or talk at the bar.

big deal, but it's not a big deal," he says. "All it takes is a banker with the same mental deficiency as you." A grin spreads across his face. His expression turns serious a moment later. "We're not a little beer pub. Some places open at noon no matter what. We're not that type of place. We're a destination venue; people come here for the music. That's what we wanted; we didn't want a bar."

The Chase family has placed a renewed emphasis on Saengerhalle music, which ranges from Texas country to Southern rock. Up-and-coming artists in the vein of Waylon Jennings or Johnny Cash fit in just fine, Justin says. Although a production company books

the musical acts, the Chase family has final say on who plays there. "We have regular meetings and talk about what bands we want to play, as well as those we can afford to pay," Justin adds.

Eric nods in agreement. "There's a lot of nostalgic value in having bands that play roots-based country. At the same time, it's a 10,000 square-foot building and we need to pay the bills. We try to find a happy medium between booking bands that pay the bills and booking those with an original feel." Happily, he adds, it often works out that the bands with the original feel end up filling the space, too.

The band onstage kicks it up a notch

with a faster song. The crowd dances both inside and out while the crowd cheers; the woman on the porch hastens her solo twist. Terrie and Eric look toward her with relaxed, approving glances. "People do dance here," Eric says. "We have the best dance floor around. It's solid oak, and in fantastic shape." He explains about dance hall salt, which helps the dancers' feet slide. "Once the dance hall salt gets on it, it's slick—a good opportunity to bust your rear." Saengerhalle dancers, both inside the hall and on the porch, stay on their feet as the guitar chords grow stronger and louder.

Near the dance hall bar, a security guard jokes with a few of the patrons, at the same time keeping a vantage point from the back of the bar. The average crowd for Saengerhalle is several hundred people. A sell-out crowd is 1,200 people. The age demographic varies according to the type of music featured at the hall on a given night. "People come here because they know who's playing," Eric says. "They're either in their twenties or their forties; we can have a twenty-year span in age from one night to the next."

Along with getting to know Saengerhalle customers, meeting the musicians who play there is another exciting part of the business. Eric leans forward from his perch against the railing. "We were here last Wednesday, and I had my four-year-old son, Parker, with me for an early show. Whereas most people are starstruck by certain performers, for anyone who's around a dance hall long enough, the relationship takes on a more personal level that makes even the biggest star real and accessible, and backstage just another place."

"We were always the people in the crowd," Eric says of their lives before dance hall ownership. Now, meeting and working with the musicians has become

a part of the everyday, a normal facet of life. Terrie and Justin agree that learning more about the musicians and the music industry in general have been happy by-products of their dance hall involvement. "We have a whole new respect for the music business," Eric says.

"We've enjoyed learning so much about it," he adds. "When the band is playing, everyone envisions all this stuff going on backstage. What you don't see is the real person. When people hear Robert Earl Keen at a concert, he goes crazy onstage. Backstage, there's nobody talking; he's resting and taking it easy for a couple of minutes. The musicians aren't having shots backstage, they're drinking coffee and talking about what color they're going to paint their kitchen. It adds a lot of truth to the saying that everyone puts there pants on one leg at time," Eric says. "They're not rock stars until they're onstage."

Terrie nods, adding that some bands who think they're rock stars play the gig, throw their trash, and then go home. Such bands aren't necessarily invited back, she says. But most bands not only play their show, but hang out backstage and in general make themselves at home. A few of these Saengerhalle regulars include the Randy Rogers Band and Cross Canadian Ragweed.

The guitar riffs wail from inside, bringing up a corresponding roar from the crowd. In addition to the electric chords of the weekend shows, the Chase family sets aside Wednesday afternoons and evenings for acoustic performances at Saengerhalle. Weather permitting, fans gather on the porch to hear their favorite artists. Half the musicians are scheduled, while the other half consist of whoever shows up for the evening, Eric says. In many instances, the performers are the same as those listed on the weekend bill. Fans never know when someone well-known might show up, he

A bartender welcomes Saengerhalle attendees.

Saengerhalle Dance Hall

adds, such as a member of Cross Cana-
dian Ragweed. "Many fans just like to
gamble, and see who's coming in."
Along with the Wednesday through Sat-
urday blend of acoustic and electric acts,
the Chase family opens up the hall for
weddings, showers, Christmas parties,
and birthday parties.

The band slows down with a ballad
that also serves as its last song. Some-
times, Terrie says, the shows keep the
family so busy that it's hard to notice the
music that's going on around them.
"When it's going on, you don't see or
enjoy as much," Eric says. Such high
energy nights go quickly for the family.

Everbody's got to leave some-
time. But on the way out,
you can buy a CD, a t-shirt,
or something else that strikes
your fancy.

Texas Dance Halls

Full Throttle finishes its set, but the crowd inside, not yet satisfied, claps loudly for an encore. The band members step back onstage and start a new song, to which the woman on the porch resumes her gentle turning.

Terri glances her way. Although the hall operates year-round, the family spends most of their time promoting events in fall, winter, and spring. "During the summer months, people are so distracted," Eric says, although the hot weather provides a good excuse to float down the Guadalupe River and listen to live music afterwards. Terrie says summer also gives the family a chance to take things a little easier themselves. At the end of the week, they often meet at the hall for Sunday picnics, spreading out on the green lawn beside the hall. "We bring out the kids and barbeque with family and friends, sometimes play volleyball," Terrie says.

Eric hopes that his own kids, six-year-old daughter Addison and son Parker, both carry on the dance hall traditions. Terrie nods like it's a given. "Addison said she wanted to sing on stage the other night. At the last minute, she said she wasn't ready. But I could see them taking over very soon," she says. "Justin will have kids eventually, too." Terrie shoots him a teasing look. "He promised me." In his chair across the table, Justin squirms, even though he has a steady girl.

A few songs later, during the lull between acts, Eric describes the peacefulness he sometimes finds in the hall. The moments before and after the bands play are those times when he sits back and envision dances past. "I walk in here and look at the stage, and think about some of the shows we've had," Eric says. "You can get as much pleasure from imagining it."

Onstage, Fred Eaglesmith starts his setup for the headlining show. Soon, he'll perform country-western with

Bill Kachine captures the crowd's attention.

bluegrass style. On the dance floor, a crowd lingers, ready for more. Someone tests the mike inside, sending a few gentle *"check-checks"* into the night. Eric straightens up in preparation to go back inside the hall. "When we came in here the first day, we couldn't get over how cool it would be to actually own it," he says. "When the place is empty and quiet like that, you realize all the history." The mike check stops, and the crowd lull dims. Eric nods his head toward the hall. "When it's quiet, you can hear every band that's ever played here."

[Author's Note: In July 2006 the Chase family sold Saengerhalle, which is in the process of becoming a church. Terrie Chase explained, "It was time for the building to take on a new life." So many housing developments have begun around the facility that it appears zoning would soon prohibit it as a dance hall.]

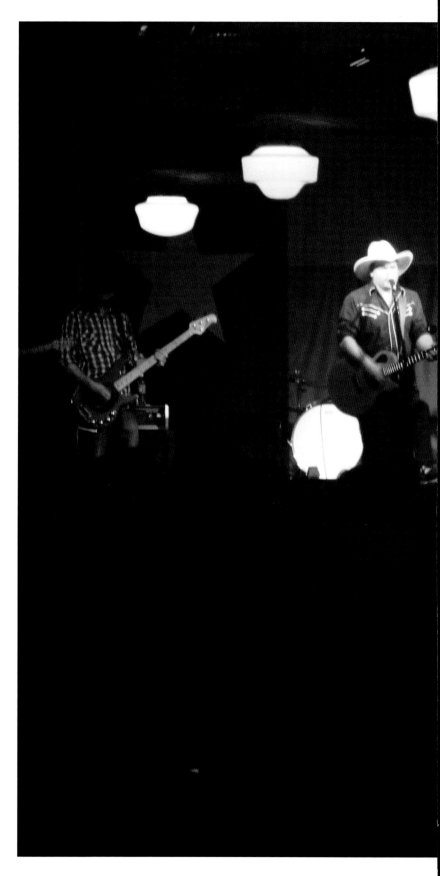

Headliner Fred Eaglesmith takes the stage at Saengerhalle.

Texas Dance Halls

Saengerhalle Dance Hall

15 SUNDAY LUNCH IN LA GRANGE

■ *Round-Up Hall*

A friend's teasing words pop into my head as the van rumbles down an access road—*You're' going to La Grange? Make sure and see the Chicken Ranch.* Although dance halls are my main mission, the Chicken Ranch is a bonus. Gary McKee, a historian who's taken me on an afternoon dance hall tour, pilots his tan van to what's left of the Chicken Ranch, one of the most famous brothels in the country. This particular part of the access road about an hour east of Austin is flecked in late morning sunshine. The Chicken Ranch, inspiration for the 1980s Broadway theatrical production and movie, *The Best Little Whorehouse in Texas,* now stands defunct.

Gary turns the van off the Texas 71 feeder and onto a gravel road, under trees green with spring rain. We stop just short of a gated driveway. A sign indicates in terse letters that this land is private property. Peering between the trees, we spot the outline of a building that looks as if it's barely standing. Established in the early 1900s by Jessie Williams, the house was dubbed the Chicken Ranch when the brothel's first visitors paid in chickens instead of cash, so the girls had something to eat.

"Everyone knew about it," Gary says.

Truckers needing to fix a flat tire stopped at a certain tire shop, whose owner would take them out to the Chicken Ranch while their tire was fixed. Gary agrees that despite the fame of the site, there's not much left to see. The Chicken Ranch shut down in 1974 following an exposé by Houston television reporter Marvin Zindler. After the ranch closed, two lawyers moved part of the structure to a restaurant in Dallas. What's left stays concealed in a grove of trees, unidentifiable to most unless you're someone like Gary, who knows every historical inch of this community. We stare through the trees at the remaining roofline, a covert taste of the past.

Gary looks up at what was once called Round-Up Hall at the La Grange Fairgrounds. A blonde-gray ponytail falls down his back; a shorter goatee rests against his chin. After growing up in Fayette County, he served in the military and later transitioned to seismograph work in Dallas and Corpus Christi. Gary returned to his hometown of La Grange in late 1970 and just stayed put for awhile, as he describes it. A photographer and vice chair of the Fayette

The unlit hall.

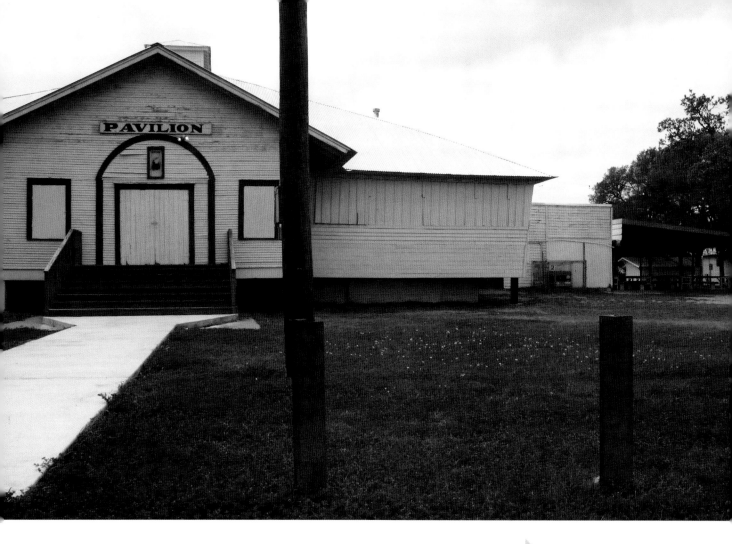

County Historical Commission, he recently finished a two-year position with the Texas Historical Commission where he organized their database. Later today, he resumes an archeology project.

Walking up to the Round-Up Hall, Gary explains that the structure once hosted regular weekend dances, a tradition started by Czech and German settlers in the mid-1800s that continued into the 1900s. With the waning of the big band sounds in the 1950s and 1960s, rock bands, such as the Triumphs, Roy Head, and the Traits, took over in the late 1960s and 1970s. Gary rattles off names like B. J. Thomas of "Raindrops Keep Falling on My Head" fame and Johnny Winter. In his yellow Hawaiian shirt and shorts, Gary stares at the hall a moment, as if he can still hear the electric guitars.

While growing up, Gary perfected the area dance hall prowl. If nothing was happening at the Round-Up Hall on a particular night, he and his friends had plenty of other options. "We were looking for the scene, so we'd drive to Weimar, which was about seventeen or eighteen miles away, to the VFW hall. If nothing was happening there, we'd go nine miles south, to New Bielau Hall that has since burned down, and then back to Schulenburg's KC Hall, and then back up to the Round-Up Hall." He and his friends followed the same circuitous route for church picnics on Sundays, hitting them all or staying at a choice few. Even on a Sunday night, dance hall entertainment was available. "You could visit Cistern Hall, which was in the middle of nowhere, for a Sunday night dance with the Velvets." He grins,

The Round-Up Hall is part of the La Grange Fairgrounds.

Texas Dance Halls

remembering bad versions of "Proud Mary."

Once they'd found a place to settle in, Gary and his friends employed strategic moves to keep out of trouble, particularly with the deputy officer who policed the dances. As minors, Gary and his friends sat around the dance hall edges and kept a low profile.

"We had one light bulb over us. So we'd sit in the bleachers, and unscrew that one light bulb, and sit back and clock the time it took the deputy to screw the bulb back in," Gary smiles. It was a game they played night after night.

An outdoor church service held next to the dance hall ends; parents, children, and seniors make their way toward a pavilion where hot lunch is served. Under an outdoor canopy, a band sets up, testing microphones and tuning their instruments. A table holds plates of desserts and pots of plants as part of a silent auction. Gary and I stand in front of the stage and listen to the band warm up. I take a quick tour around the auction table to see if there's anything I should bid on. Before we go inside the pavilion for barbeque, Gary laughs with a few of his friends, glances at the snaking length of the lunch line and suggests we hike to La Grange's new amphitheater first.

We walk past the Round-Up Hall and parking lot toward the natural amphitheater, snuggled tight against the bottom of a hill. From the top of this hillside west of La Grange, the landscape of the Colorado River Valley swoops below. An airplane riding through late morning clouds sweeps across our view. Gary points to the river bluff in the distance. He tells me that prehistoric cultures dating back twelve thousand years lived in the area; later, the Tonkawa made it their home. In 1687, the French explorer La Salle was the first European to venture up the bluff on his way to locate the Mississippi River. As part of this French influence, Fayette County was named for the Marquis de Lafayette.

From the pavilion, the sound of a public address system crackles, creating a modern counterpart to the brass-band sound brought overseas by the Czechs and Germans. These two cultures, who immigrated during the mid-nineteenth century in response to political pressures, stayed and farmed Fayette County. Over the years, many settlers moved to larger urban areas, such as Houston. Now, it's the reverse, Gary says, with folks from Houston coming to their weekend homes in the country. A man dressed in a suit approaches and asks about a particular building. In the distance, the lunch line thins and the smell of barbeque drifts toward us. With nonchalant ease, Gary points the man toward a building near the dance hall.

Gary McKee has been coming to the Round-Up Hall since he was a teenager. He and Folkins sit on the stage and compare history.

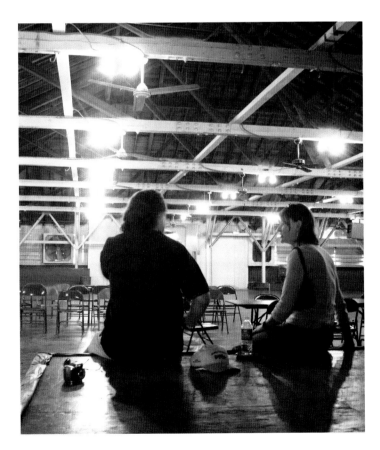

The man tips his hat and walks away.

Both German and Czech immigrants built numerous dance halls in the area as a means of fostering community, tradition, and music. Although the music has changed, the traditions and community remain, with both private owners and civic organizations maintaining and running the halls. In Fayette County dance halls, nighttime performances might be less frequent, but church picnics and community events are busier than ever, giving the halls renewed purpose. Gary shakes his head at the thought of fallen attendance and fading traditions. He blames falling attendance on two factors: contemporary reliance on air conditioning, which many of the old halls don't have, and migration to urban areas.

We walk through the fields to the pavilion. Once we're back in the crowd, we meet a few more friends of Gary's, who direct us inside for plates of brisket, potato salad, and pinto beans. In the lunch line, we introduce ourselves to Sarah and Walter Oeltjen, who join us at one of the indoor picnic tables for lunch. The Oeltjens answer our questions between bites of brisket. The couple, gray-haired and dressed for church, have danced together for decades.

Sarah remembers one Sunday night dance that went all night long. "My mother wouldn't let me go until midnight. So at midnight, my date picked me up and we went to the dance," she says. The rhinestone pin on her dress catches the light, sparkling just as it must have in nights past. "Dance halls were everywhere. One night I went to four in a row." She chuckles a moment.

Inside Round-Up Hall.

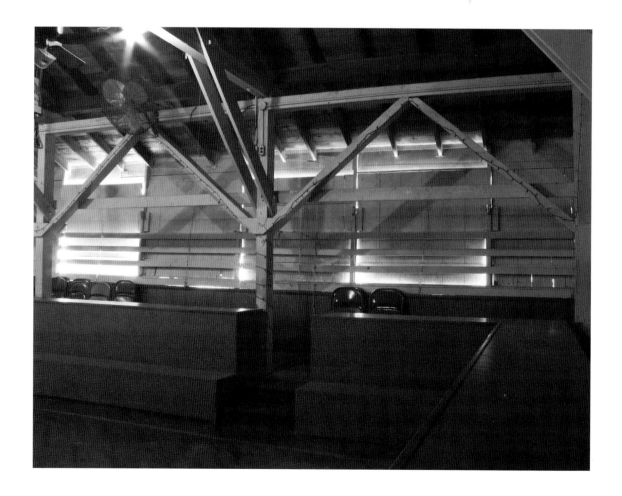

Texas Dance Halls

Look closely at the back door to the hall, and you'll see a figure of a man.

"The next day, I slept until noon. My mother didn't know what was wrong with me, sleeping in so late."

When she asked permission to attend a nearby Bastrop dance, her mother would only let her go if she had a chaperone, so Sarah's mother and sister-in-law went with her. She turns to her husband, who concentrates on his meal. "He was the best dancer around," she says. "I went to Baylor, and he went to A&M," she adds.

Walter smiles, neither agreeing nor disagreeing with the praise Sarah offers. "When I grew up here, there were dance halls everywhere," Walter says. "Round

Top had two of them. Everyone went to the local halls."

When asked about her favorite dances, Sarah tells us she likes the fox trot and waltz. "I love to waltz," she says. "It's such a pretty dance." She pauses a moment with her plastic fork midair.

"Did underage people attend the dances?" Gary asks.

Sarah nods. "When they weren't dancing, those who were underage sat in benches at the sides of the hall."

"Round-Up Hall still has those places," Gary adds. "One of my best friends says he knows the words to all

the songs because he sat under the benches and heard them over and over." Everyone laughs.

Walter wipes a napkin across his face. "We've danced on the Mississippi River, on the Ohio, the Cumberland, and the Tennessee," he says, giving Sarah a look to see if she remembers.

Sarah puts down her fork again and smiles. "We danced a lot."

"The Glenn Miller Band and Harry James performed on some of the trips," Walter adds.

"All ages came to the dance," Sarah says. "We were kind of teenagers then. But sometimes, all they [the teenagers] did was look at one another and move. They didn't dance." She laughs and shakes her head.

Walter nods. "If you came without a date, you'd stand in the middle and tap the girl you wanted to dance with. The man dancing with the girl had to

release his dance partner," he says.

"How did you two meet?" I ask.

"It was the second floor of the American Legion Hall in Smithville, Texas," Walter says without hesitation.

"That's when you learned to dance?" Sarah asks.

"That's when I asked you for a dance," he says. We all laugh again.

Sarah says that after that first meeting, Walter asked her to go to a Houston dance with him. "We went to Schulenburg one night, the next night La Grange, and the next night, West Point," Sarah says.

A dark-haired woman across the table shakes her head. "You were a party girl." Sarah laughs and beams at the same time. Two sugar cookies rest atop one another on her Styrofoam plate. It's hard to tell which is sweeter, the homemade dessert or their dancing memories.

Picnics, dances, and other social activities are held at Round-Up Hall.

Texas Dance Halls

On our way out of the Round-Up Hall parking lot, Gary frowns at the to-go procession, a fast-food line-up of cars where people pick up their food without sitting down for lunch in the pavilion. "Those people miss out," Gary sighs under his breath, "on friendship, gossip, and atmosphere." We watch the line of cars and pickup trucks snake around the building. I catch a glimpse of the Oetjens walking arm-in-arm back to their car. They don't seem to notice the drive-through line, its insistent procession a safe distance from the lives they've lived.

I climb into the passenger side of Gary's van. He puts on a pair of sunglasses and lists the halls on our itinerary, from Ammannsville to Schulenburg. The tour can't be as long as he'd originally planned, Gary says, because he needs to prepare for an archeological dig, a job where he gets to keep another part of the past alive. Under thick sunshine, Gary weaves the van along a spider web of roads. He tells me that sometimes he finds a new road, either dirt or paved, and just drives along it to see where it goes.

A few hours and a few dance halls later, we reach the city streets of Gary's hometown, Schulenburg. He remembers high school dances where the Flatonia crowd chased the Schulenburg crowd, and the Schulenburg crowd chased someone else altogether, the grass on the other side always greener. I watch sunflowers bob their heads along the road. "What made you come back here?" I ask.

"I saw the rest of the world, and I wasn't drawn to it," he says, peering through a canopy of trees. "So, I came home."

He recalls an acquaintance we spoke with at the start of our tour, who hinted that small-town life bored her sometimes. Gary shakes his head. "There is so much to be involved with," he says. "A person could be busy here eight days a week."

With eyes still straight ahead, Gary reaches toward the back seat with one arm and grabs a photo album. I take it from his outstretched hand and turn pages crammed with black-and-white photographs. A La Grange phonebook from the 1950s falls between us. Gary looks at it and laughs. "Pretty ironic that they picked that cover design," he says.

Unsure what he means, I stare at the phonebook's typical farm scene of a fluffy chick and a wooden chicken house in the background. The cover is bright yellow, with graphics etched in black.

"The Chicken House," Gary reminds me.

I chuckle along with him at this innocent match between a phone book and the town brothel. Setting the vintage phonebook aside, I thumb through postcards and images that range from modern to sepia brown. Photographs of the dance halls and churches we've just visited, spaces from the past instilled with community and purpose of the present, crowd the pages. Gary hums as he drives the van back to the Round-Up Hall. In the parking lot where we'd started that morning, I close the thick book filled with his favorite places and oldest friends.

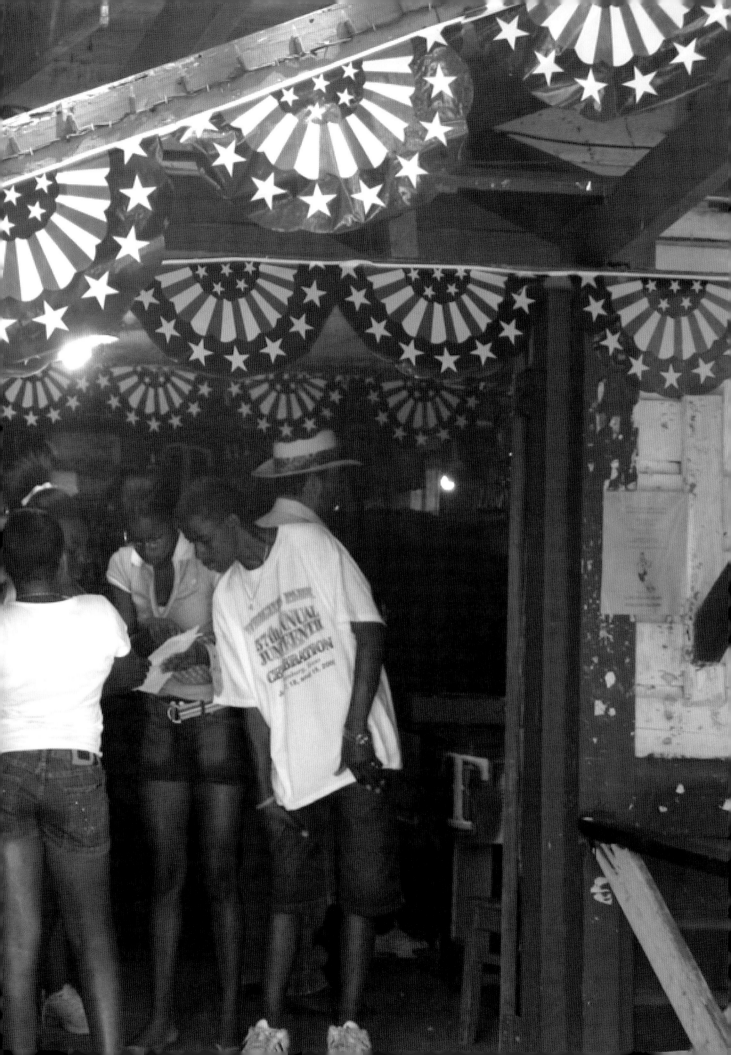

16 THE 57TH JUNETEENTH CELEBRATION

■ *Wright's Park*

We leave the car on a side street and chase the last of the parade—a pair of chestnut horses ridden by African American cowboys. The horses' manes whip back into their riders' faces as the group trots toward the festival headquarters at Wright's Park, a dance hall outside of Schulenburg. The men smile and wipe their faces with red or blue bandannas. Cowboy hats and long-sleeved shirts help them fend off the sun, while boots with slanted heels keep their feet from slipping through the stirrups. This group looks as if they've just stepped off the Texas range in the early nineteenth century, when according to historians half the cowboys were African American or Hispanic American.

Marcus and I find our car and move it to a field closer to the hall itself, a modest two-story building perched in a cluster of trees. A Juneteenth banner, honoring the 1865 proclamation of freedom for slaves in Texas, sweeps over the picnic tables set up outside. Publicity flyers posted on the door and around the tables promise music and a dancing contest to come. Men and women sit at picnic tables and laugh together, beer and

The front door at Wright's Park Dance Hall.

soft drinks scattered across the table in front of them. Children shimmy between the outdoor shade and the musical promise of a shiny jukebox inside.

At picnic tables underneath the trees, kids weave around the benches and race across the grass. Men and women sit in chairs set up near a small stage to talk about the parade they've just seen. Most of the parade's cowboys have tied their horses to parked trailers and joined the crowd outside. Blues music croons over a public address system, hinting at musical events to come.

The crowds and noisy banter are the opposite of the first time I'd seen the hall, on a lazy Sunday afternoon when it was closed. At the end of our dance hall tour, Gary McKee had turned his van into the dirt driveway in front of the hall. "I've always wanted to visit this place," he said, adding that our tour gave him a good excuse to stop by. We parked the van, walked past the picnic tables outside, and stepped into the dim light of the hall. That's when we'd spotted Robert, grandson of Olton Wright, the man who built the 1957 hall and gave it his name. Robert sat behind the bar

arranging pictures and text for an upcoming Juneteenth celebration.

"Hello," Gary said.

Robert waved us into the hall. "Come on in."

While Gary and Robert talked, I hung back to look at the back of the front door, which was covered in snapshots of past dance hall parties. Faces in the photographs, mostly African American, laughed together at round tables or cut a rug on the dance floor space in the middle of the room. Robert told us that the crowd at Wright's Park varies on any given night, both in terms of the crowd and musical tastes. From the pictures, most people look as if they know one another or have just made friends. Robert looked at the pictures along with me. "Anyone's welcome," he said. "It's not just for black people."

He motioned toward the bar, still covered with his flyer project. "How about a beer?" he asked. He walked behind the bar and reached into the cooler, handing a beer to Gary and the Coke I'd requested to me. Although Robert had written a short history of the hall, he told us that his mother, Ora Mae Moore, was the real expert. "She's the one you want to talk to," he said.

After Gary and I left, I made plans to return to this hall, a neighborhood secret not everyone seemed to know. When spring turned to summer, I remembered the clippings of Robert's Juneteenth flyer and called the Chamber of Commerce for more information. The voice on the other end of the line sounded doubtful. "You know we have other dance halls in the area," she said when I asked about Wright's Park.

"I've visited those," I said.

The silence on the other end of the line grew longer. "Okay. Here's the information I have." She gave me the dates and a name or two, along with a few phone numbers to call. It was enough to get me started, although I knew it would take a real visit to learn more. After experiencing Wright Park's version of Juneteenth, I called back the Chamber to follow up. The same contact answered. "I wondered about you," she said. "How did it go?"

"It was fine," I said. "Do you have any other information about the hall?" She claimed there'd been a fight at the parade but didn't offer much more. When I told Gary about my earlier conversation with the Chamber, he sighed and shrugged it off. Probably someone new, he said.

Men and women celebrating Juneteenth at Wright's Park lounge at picnic tables or linger in the hall doorway. Inside, a few teenage girls cluster around the jukebox. Adults line up at the bar, joking with each other or the woman who works behind the bar. Someone mentions the upcoming singing contest. The sun angles through live oak trees and enters the hall in a thin strip.

I find Robert, all smiles and action as he darts between the dance hall guests. He wears a shirt that says "boss"; his pickup truck, parked in the outdoor area next to the hall, has a matching "boss" sign. I catch his eye and ask him about the celebration as he mingles between tables of guests outside the dance hall.

"It's going really well," he says. "You just missed the parade." He shrugs, as if it doesn't matter and there's more to come. He glances at the crowd behind us and leads me toward the hall entryway. "My mom's in here," he says, pointing to where Ora Mae Wright, owner and manager of Wright's Park, tends the bar. "But she's pretty busy today."

In a black dress with pushed-up sleeves, Ora Mae takes the soft bunches of dollar bills she's handed. With a youthful smile and hair just barely gray, she hands out sweaty bottles of soda and

Texas Dance Halls

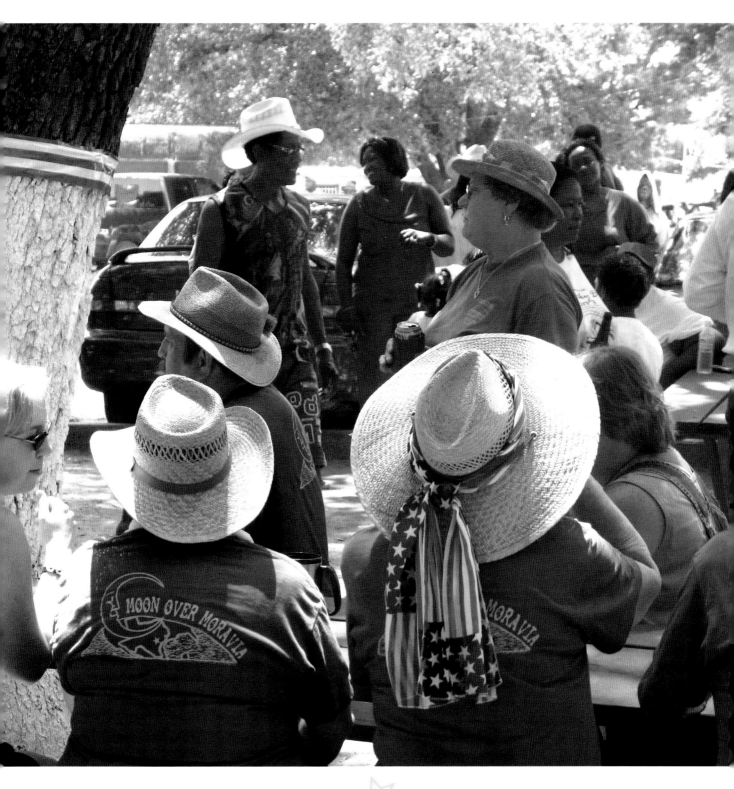

*Patrons at the Wright's Park
Juneteenth celebration.*

beer in return. There's no break in the line of customers approaching the bar, so Marcus and I look for a place to sit down instead.

A group of teenage boys on the dance floor form a laughing circle. Kids shoot in and out a side door of the hall, torn between the jukebox inside the hall and the sunshine and Moonwalk outside. Marcus sets down his Sprite and goes outdoors to take a picture. During a break in the bar action, I introduce myself to Ora Mae.

"If it's not too busy, I can talk," she agrees. A woman helping Ora Mae behind the bar shoos her off to the empty table where I sit. A few young girls cluster around the jukebox to point out their favorite songs. Their hair is carefully coiffed, and their laughter comes in quick bursts. Ora Mae joins me at the round table, smiling at them before she sits down. Although her movements are slow, she doesn't look her eighty-four years.

She tells me about her father, Olton

Wright, who opened Wright's Park as a business in 1948. An earlier brochure, designed and written by Robert, shows him smiling under a cap. When Olton passed away in 1984, he left the hall to Ora Mae, who had helped him run the dance hall for years. "In his will, he asked me to take care of the place and never to lose it," Ora Mae says. Her eye wanders again to the people that fill this hall run by three generations of family.

The hall began when Ora Mae's parents, Olton and Josephine Wright, decided to build a dance hall on their land on the outskirts of Schulenburg. To help the family raise funds, Josephine took their children, Olton Jr., Walter B., Ora Mae, and Henry to East Bernard, Texas, where they picked cotton for the summer. While Josephine and the kids worked in the fields, Olton kept his job in town, where he worked at a retail store. Josephine and her kids earned $500 that summer, which the family put toward the dance hall.

To obtain lumber for the dance hall,

Olton bought the town's Shafer hull gin house, which had been previously used to store cotton seed hulls. Olton, with the help of Daniel Cashaw, Clifford Stafford, Jim Jackson, Olton Jr., and Walter B., tore down the gin house and moved the lumber to the site of Wright's Park. According to Robert Moore's historical account, clearing the land and building the hall on the site was no overnight task, taking almost a year to complete.

Olton and Josephine Wright celebrated the official opening of their dance hall, which they named Wright's Park, with a 1948 Juneteenth celebration. Guests came from neighboring communities of Schulenburg, Hallettsville, Weimar, Oakland, La Grange, Moulton,

and Yoakum. After barbeque and baseball, the partygoers danced late into the night, melding their dance hall inauguration with the anniversary of freedom proclaimed in Galveston, Texas, in 1865.

Not satisfied with one annual event, Olton came up with other ways to celebrate both family and community in Wright's Park dance hall. On the Fourth of July, he opened Wright's Park for an event that became known as S. P. Picnic, named for the Southern-Pacific train that brought participants from as far as San Antonio. The train made a regular stop at the nearby Schulenburg Carnation plant, which was just down the street from Wright's Park. S. P. Picnic attendees began their day with a church service under the trees, followed by

Flags fly at Wright's Park.

dinner at noon, baseball games in the afternoon, and a dance late into the night.

Ora Mae's attention wavers back to the bar every so often to make sure the woman working behind it isn't too busy. A few of the younger men cluster on the dance floor nearby, laughing and telling jokes in this, the lull between the parade that's just happened and a singing contest soon to come. Although the flyer has a timetable for the Juneteenth events, there's a sense of letting things happen at their own pace. Ora Mae tells me they welcome visitors from the sur-

rounding neighborhood as well as communities further away.

"I'm more familiar here than with my own house," she adds, leaning back in her chair and scanning the crowd. Guests come up to our table to shoot the breeze with her; the dance hall crowd serving as her extended family. She's as well known here as a good host, just like her father. Olton entertained customers not only with his dance hall but also as a zoo manager. One picture in Robert's brochure shows him with a pet monkey wrapped around his neck. Visitors to Wright's Park and the zoo

Two friends check out what's going on outside at the Wright's Park Juneteenth celebration.

Texas Dance Halls

also had a chance to sample Olton's homemade grape wine, which was so good that guests often took a sample home with them.

I sip my Sprite as blues music drifts from the speakers outside. Years past, the hall had a history of live music as well. One of the first acts Olton booked at the dance hall was Lester Williams of Houston. Ora Mae says that many other bands played there in the late 1940s. "We had guitars and pianos, and people would dance," she says. Where the teenagers now cluster on the dance floor, still choosing jukebox songs, I imagine the bands and the crowds, with piano keys pounding and a blaring saxophone.

When Ora Mae took over the hall from her father in 1960, she bolstered the hall's musical offerings by booking well-known acts, such as B.B. King, Albert Collins, Tornado, Buddy Ace, and the Swinging Medallions. Today, the hall hosts live bands on occasion, although customer demand has shifted to DJs and rap, both of which are featured at Wright's Park. On nights without a band or a DJ, Wright's Park guests pick out songs on the jukebox. A few cowboys walk into the hall, dressed in their parade clothes. I think of how Marcus and I had just caught the last part of the parade and wished we'd seen more.

Even though Ora Mae ran the hall, Olton still contributed ideas. Working together, father and daughter solidified existing traditions while forming a few new ones of their own, such as the annual Easter celebration. After Sunday's church service, kids in the Schulenburg community would rush down to Wright's Park to find the Easter eggs and baskets that Olton hid around the dance hall.

Olton, who loved parades, established his own tradition of creating floats. In the summer of 1972, he built an "Old woman in the shoe" float and entered it in area parades. His float won first place in Schulenburg, Hallettsville, and Moulton. This early success inspired Olton to build a float every year after that, along with sparking a Juneteenth parade tradition at Wright's Park.

Another tradition started by Ora Mae in 1976 was the Schulenburg High School graduation party, an event that the hall still hosts. Ora Mae also played the neighborhood Santa Claus on numerous occasions. Amidst the festivities, she and her husband, Clarence Moore, renovated Wright's park in 1984 to give it an updated look and feel. In this newly remodeled space, they continued to host many parties and dances.

Half the fun, Ora Mae says as she watches me scribble in my notebook, is giving people a place to dance and getting to know their faces, whether they're from around Schulenburg or further afoot from communities such as Flatonia, La Grange, and Gonzales. Some business, Ora Mae adds, comes from those who just ride by in their cars to see what's going on.

With the help of her son Robert, Ora Mae has kept Olton Wright's community spirit alive by hosting dance hall gatherings on Christmas, New Year's Eve, and Halloween. The annual Juneteenth event is one that Ora Mae and Robert work hard to maintain. Ora Mae gestures toward a display of this year's T-shirt, which has a bold "57"graphic written across the front. "This is our fifty-seventh year," she says, her smile full of pride.

In 1995, Ora Mae stopped opening the club daily and concentrated instead on using the space for special events, such as receptions, dances, and parties. Ora Mae's son Robert took over where his mother left off and began managing Wright's Park in 1997. Robert made his own mark on the hall by establishing Wednesday night domino games. Following in both his grandfather's and

mother's footsteps, Robert has also kept the hall's traditional celebrations, including a Halloween youth party, a Christmas formal, a Red and White Ball on Valentine's Day, and the hall's fiftieth anniversary celebration in 1998.

A crowd forms in front of the bar; Ora Mae takes note, smoothes her dress, and tells me she'd better get back to work. She stands up with slow grace and makes her way to the front of the room. A minute later, she's lining up bottles on the counter and greeting the customers by name. Most people here know one another, and although they don't know Marcus and me, many say hello and ask about our work. I sit under the ceiling fan at my table near the dance floor and watch the young men waiting by the door, wondering if they're getting ready for the singing contest that's about to start. The girls by the jukebox, still twisting their hair in nervous giggles, are possible contestants.

Marcus and I can't stay long enough to find out, as we're due back on the road. We walk past the outside celebrants, who haven't moved far from their picnic tables and the Juneteenth banner that shades them from the late-day sun. No one's pressured to move along; this dance hall family treats its guests as if they belong. In this laid-back dance hall that not everyone knows about, people enjoy and accept one another. There's time for snacking and another conversation or two. The afternoon lengthens, at a comfortable pace, with relaxed anticipation of things to come.

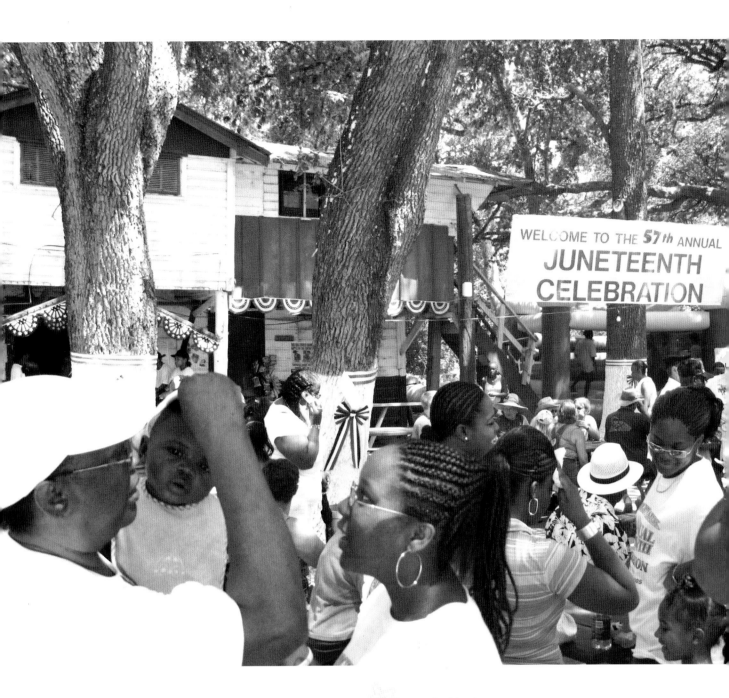

The Juneteenth celebration in Wright's Park takes place both inside and outside the hall.

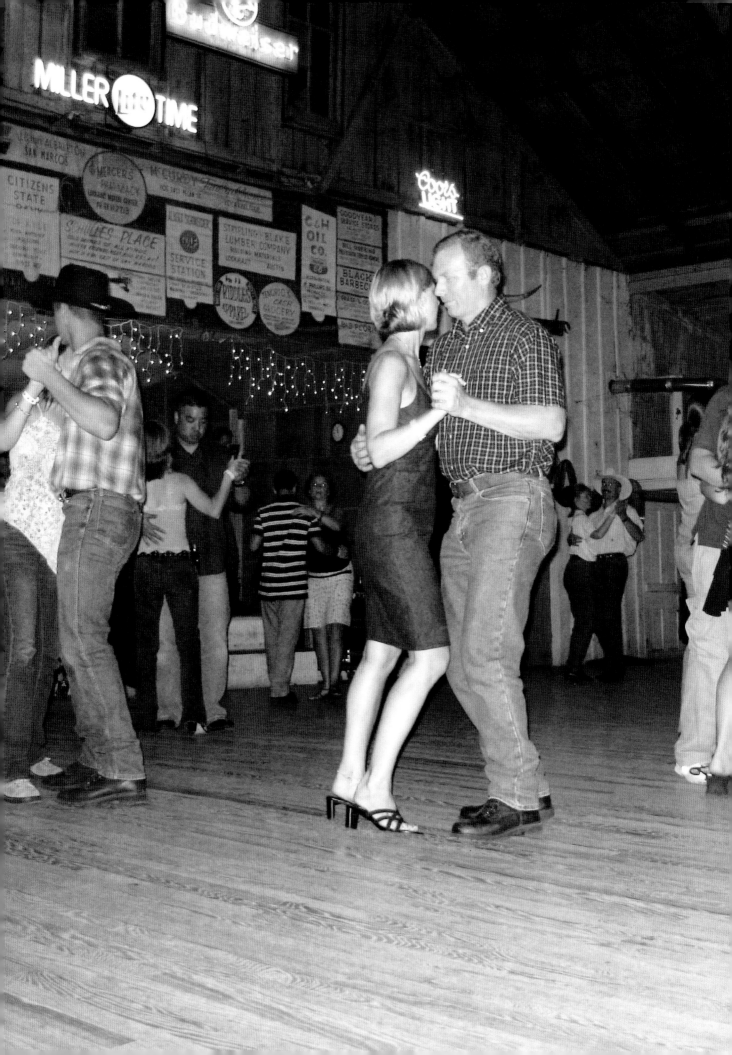

17 UHLAND SECRETS

■ Club 21

"I haven't been back to Uhland," Jim says. He runs a hand over his beard. I watch his blue eyes cloud with what looks like distraction before he returns to his fresh seasonings and a bowl of hamburger meat. Outside the Buda home of Jim and Johnnie, two long-time friends, birds flit around the garden they've planted, which bursts with vegetables from late summer rainstorms. The air smells green and dense.

"Why's that?" I ask Jim. Usually, he's never at a loss for words about places he's seen and things he's done. But tonight he just laughs and turns back to his hamburger mixture, from which he'll grill gourmet burgers over charcoal. Johnnie, a blonde woman in leather sandals and shorts, tears lettuce for a salad. Marcus and I sit at the table in expectant silence, hopeful that Jim will share his story.

Marcus and I are Jim and Johnnie's guests during this latest dance hall weekend in June. "There's a dance hall in Uhland," Johnnie told me on the phone a few days ago. It was a community I'd never seen, tucked southeast of Austin between Buda and San Marcos. Marcus and I hadn't planned on visiting Uhland [pronounced YOU-land], but now it's become the wild card in our dance hall tour.

"The hall has support beams that bow in an arc," Jim offers instead of telling us about his own past. "It's one of a kind." He makes perfect hamburger patty circles from the mixture. "I can't believe you haven't been there, bird legs!"

I smile and consider the bowl of olives Johnnie pushes toward me. I'm still curious about what happened to Jim but now he's focused on dance hall architecture and cooking. Marcus, whose interest shifts to the secret seasonings Jim uses, gives me a discreet shrug, probably hinting I should sit tight, like a patient reporter, and wait. While Jim takes the meat outside to grill, I scribble a few notes on my notepad, still in the dark about this dance hall that hides on a route of farm-to-market roads.

Later, after we've eaten our burgers and salad, Marcus and I take my Beetle and follow Jim and Johnnie in their midnight-blue pickup truck. Since the hours spent lingering over dinner, the afternoon has turned from gold to purple-gray, and cicadas buzz louder with the darkness to come. Jim drives with the brisk turns of a Texan, and I quickly lose him on one of the narrow roads near the railroad tracks. Johnnie leaves a mes-

The arches (visible in the far right corner) of the main hall were soaked overnight in nearby Plum Creek so they could be stretched.

sage on the cell phone, which doesn't pick up reception in this remote spot. A few minutes later, we hear it. "Gail, you missed your turn," she says. "Meet us at the Diamond Shamrock."

We manage to find the gas station with the blue truck parked up front. Jim shakes his head at me as if I've lost my Central Texas bearings altogether. "We're crossing I-35," he explains, talking slowly. "Then it's just left, right, left." Johnnie sips her water and gives us a wave of encouragement. I shut the door to the Beetle and hope for the best.

Back on the road, Marcus and I squint at the signs and try not to lose sight of Jim's truck. The landmarks around us start to blur into the darkness, as if Uhland itself is a secret.

"Do we turn right here?" I ask Marcus.

"Yeah," he says without conviction. Tree branches look as if they're reaching down to touch the car. I try not to notice, focusing instead on the thin slices of road the headlights show.

Jim and Johnnie are out of their pickup and waiting at the dance hall entrance when we pull into the gravel driveway of Club 21. I drive by the empty spot Jim points out for me, not noticing him until it's too late. "That was Jim," Marcus says as I steer the Bee-

tle between the rows of cars parked on the gravel street. I turn around and drive back to the porch where Jim and Johnnie stand. Johnnie looks as if she's trying not to laugh.

Without a word about the drive, the four of us walk through the swinging double doors inside the club, past a wooden bar with customers leaning against it. To the right, we glimpse alleys for ninepin bowling. Between the front bar area and the dance hall, a man in jeans and a baseball cap greets us at what looks like a folding card table. "Ten dollars," he tells us, waiting as we search our wallets. "Have a good time." He looks surprised when I hand him a twenty dollar bill for Marcus and me.

Marcus spots a catwalk above the dance hall floor and asks if he can climb it. Although the man with the cap smiles and chats with us about the hall, he won't let Marcus on the catwalk. "It's a safety issue," he says. I wonder if anyone has ever fallen, but he doesn't say and I don't ask.

Overhead, the dance hall's arched ceiling matches Jim's description, curved wooden beams making grand arcs above the dance floor. We look wistfully above us to the set of catwalk stairs, which would have been a natural for photos. In front of the stage, Christmas lights glitter and illuminate the band. Its members, none of them much past thirty, wear cowboy hats, jeans, and t-shirts. They start with a country song that motivates several couples to wander onto the dance floor. Jim, Johnnie, Marcus, and I take one of the tables along the sidelines.

A tall policeman from Bastrop sits nearby with a blonde woman. When he's not dancing, he glances at the notebook sitting in front of me. In between songs, he asks what we're up to and offers a tidbit I can add to my story. "The hall's been used as a gymnasium," he says. Despite the country music at the front of the hall and the dancers sliding

The front door of Club 21, a dance hall in Uhland, opens for business on a Saturday night.

around its edges, the open ceiling does make the space look like a gymnasium.

We find out later that despite the hall's spacious appearance and occasional use for sports by local schools, it's always been a dance hall. Builders of the hall soaked the wooden supports overnight in nearby Plum Creek. The next day, the beams were pliable enough to bend into arches, creating a roomy feeling of uninterrupted space. It's an unusual structure in any building, let alone a dance hall. No one seems to know why the hall builders chose this particular style.

The man at the door in the baseball cap points us toward Club 21 owner William Isle, who helps out behind the bar. William, in his mid-fifties, takes a break from his bartending and leads us to one of the tables in the front part of

the dance hall, which serves as a tavern area. After repositioning a standing fan to cool us off, he confirms that Uhland Middle School used the dance hall space for sports practice. "My father-in-law played basketball here," he says. "My mother attended school in the area in the 1920s." The building where she went to school is now the town's community center.

The Isle family's affiliation with dance halls began when Isle's mother bought the bar in 1964; she was only its second owner. The dance hall was originally built in 1912, with the bar area originating from 1893. The adjacent bowling alley, which opened in 1932, ran for many years before closing in 2001. William took over the family business when his mother passed away in 1989.

He now runs the hall five days a

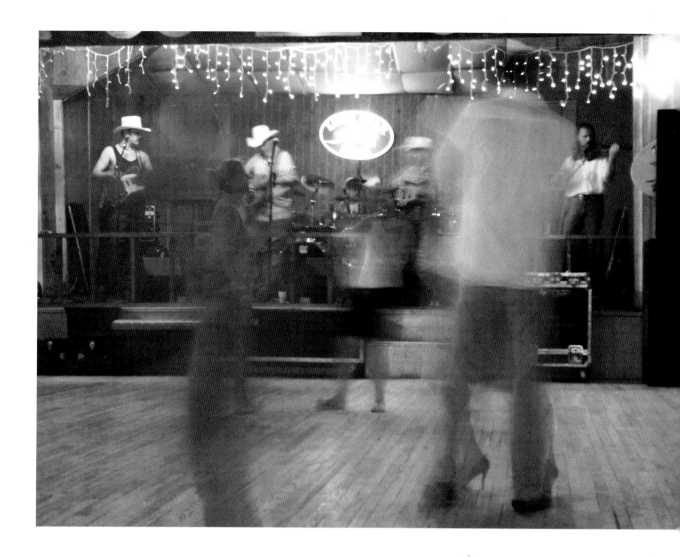

week, Tuesday through Saturday. The
hall is closed on "Sunday for God, and
Monday for me," William says.
Tonight's crowd draws a mixture of
locals from nearby communities of
Buda, San Marcos, and Lockhart. Some
have come from even farther, such as the
couple from Paris, France, sitting at our
table. They research the Texas bands
they like and follow them to the dance
halls, a serendipitous journey that's
taken the couple to Uhland.

William nods in the direction of
Highway 21, a road near the club that
serves as its namesake. Headlights fill
the window from pickups arriving.
Sounds of country music drift into the
bar from the nearby stage. Kevin Fowler,
Johnny Bush, Bob Wills and the Texas

Playboys, and Jimmie Vaughn have all
performed at the hall. "Keith Whitley
did a video here," William adds.

The suspension ceiling of the dance
hall also keeps the site in demand as a
movie set. Club 21 has appeared in films,
such as *Resurrection* and *The Last Picture
Show* with Ellen Burstyn. William still
remembers the day Burstyn brought in
$400 worth of liquor and treated every-
one in the dance hall to a party. He
walks to the bar and asks a woman with
bouffant-style hair a question. Back at
our table, he nods. "DJ. Qualls had a
movie here, called *New Guy.*"

Through an opening in the bar, we
can watch young couples circling the
dance floor in erratic circles. "I learned
to dance here in 1964," William says.

*Couples shake a leg while
Ricky Calmbach plays at
Club 21.*

Texas Dance Halls

"It's always been family-oriented, with people learning to dance." He glances at the wooden floor, which lists ever so slightly. In the humid bar area, wood, cigarette, and cheap perfume smells compete and finally mingle.

Leaving the glow of the beer signs that pulse over the bar, William takes us next door to the bowling alley. We gaze down narrow lanes that haven't been used in several years. "I used to set up the pins as a kid," Williams says. "I'd sit in a chair at the end and set them up." Now that the bowling alley is closed, William hopes to create additional seating and a game area. After Marcus snaps a few pictures, we walk past the bar to the table near the stage where Jim and Johnnie sit. Jim glances up and smirks, maybe thinking of the last time he was here.

The Bastrop policeman nods at us. The Parisian couple, who look to be in their late fifties, claim the edge of our table that's closest to the dance floor. I angle closer to them, curious to hear the secret that's drawn them here. Dominique, a slender woman in jeans and a plaid shirt, smokes a cigarette and watches the dancers circle under the

archways. Her husband, Gerard, wearing a checked shirt and jeans, takes pictures with a digital camera, shooting everything from the dancers to the architecture of the hall. I sidle across from Dominique. Nearby, Gerard crouches close to the dance floor and snaps photos of the dancers' boots.

"This is our first time at Uhland," Dominque says. She and Gerard have been to Texas on four separate trips to visit area dance halls; those on their already-visited list are Broken Spoke, Gruene, Helotes, and the Yellow Rose in Denison. The couple comes here for the singers in their cowboy hats and boots, she tells me, along with distinctive instruments like the fiddle. "We love Texas music," she says. "We go to New Mexico for the scenery and Texas for the music."

Some of their favorite performers are George Strait, Kevin Fowler, and Gary P. Nunn. Dominique looks at the stage. "This is the second time we've seen Ricky," she says. Young dancers wearing snug jeans and flip-flops make another tight circle over the wooden floor. Boots slide while the fiddle player solos. Gerard points his camera and captures

A patron at the bar in Club 21, formerly Uhland Hall.

Club 21

*Dancers at Uhland—a mix
of young and old—wait for
the next song to start.*

Christmas lights at the front of the stage.

"What do you like best about the halls?" I ask.

Dominique smiles. Her elbows rest on the wooden tabletop, and her eyes wander upward toward the arched ceiling, as if she's searching for the secret behind these halls and their allure. At a pause in the song she turns to me again. "It's the smell, the scenes, the country feel," she says.

A song or two later, Dominique remembers something else. "We like to dance." The next moment, she and Gerard are on the floor out two-stepping with the other couples, both of them at home. I watch the circuit of dancers, some of them experienced like Dominique and Gerard, others with the wide-eyed brightness of teenage years.

The youngest faces in the hall remind me of another secret this hall offers; a boy, William says, was shot and killed at the hall's double door entrance in 1956. At the age of nine or ten, he died in the cross fire of a gunfight. William can't recall what the argument was about; the boy was simply in the wrong place at the wrong time.

Marcus, back at our table from a

fresh round of pictures, reads my mind. "Are you going to write about the boy?" he asks.

I look away from the band and back to Marcus, whose camera rests in front of him on the table. I answer "yes," trying to picture a shoot-out in this Wild West-turned modern setting hall. It'd probably been over a woman or maybe an unpaid bar tab. The boy, coming in to see a father or an uncle, had looked up at the last minute but didn't have time to turn away. His straw hat drifting to the floor near those double doors had probably stopped those gunfighters midtrigger, but it was already too late.

At our table, Jim and Johnnie want to hear our discoveries of this place, but it's hard to hear when the band's in full swing. We end up gesturing, nodding, and writing on slips of paper instead. I smile and think about Jim's last visit to Uhland Dance Hall, which he'd finally decided to share with us over dinner.

He was on his way home from his job in North Austin and thought of Club 21, where he could buy something to drink and maybe catch a band. The midnight blue pickup truck practically drove down those dark, tangled roads by itself. Jim walked between the double doors of

Club 21, confident even though he was alone; he never had trouble making friends. Inside the hall, country music spilled into the night air. Maybe Johnnie would join him soon, even though she'd told him she had a tight publication deadline. Jim ordered a beer while he waited.

One beer turned to several. The music he'd come to listen to blurred into the background. Surrounding conversations grew louder, and Jim knew he should head home. He paid his tab and walked through the double doors to the parking lot. The breeze that broke through the humid air focused his mind a little; he knew he shouldn't drive. On the other hand, walking on these narrow roads seemed just as risky.

Jim slipped down into the roadside ditch and started walking. It couldn't be that far, he reasoned. He knew the way. Car lights passed while he tried not to stumble over branches or shallow pools of water. Most of the drivers looked straight ahead, not even noticing a man in the ditch. Jim didn't bother hitchhiking. The ditch grew deeper in some places and was nonexistent others. He wiped his brow. It felt as if he'd been walking along this dark road for miles.

An hour later, a silver van slowed down behind him. Jim peered up from the ditch and saw Johnnie's face leaning out the driver's window.

"Jim?" She narrowed her eyes to make sure this bearded man in the ditch was really him. Her blonde hair, whipped from the wind, tangled around her face.

He smiled and climbed up the side of the ditch toward the van. He would have liked to have said he walked the whole way rather than been rescued; then again, a mile or two had been plenty long.

From the table across from us, Jim looks as if he's already forgotten that night; maybe coming here had been just the anecdote he needed, creating better memories to replace old secrets. After all, I was the one who couldn't find my way this time.

It feels good to sit at this table of friends with most secrets answered, at least for now. No shoot-out takes place, and unless I get lost again, we'll all find Buda by car or pickup instead of walking. After Jim and Johnnie say goodnight and leave for home, I slide my notebook into my bag while Marcus tucks away his camera. It's not too late to do some sleuthing on our own, in nearby towns like San Marcos and Austin. We sit back, watch the band play another song, and plot where we'll go next.

Now that the bowling alley is closed, William Isle hopes to create additional seating and a game area.

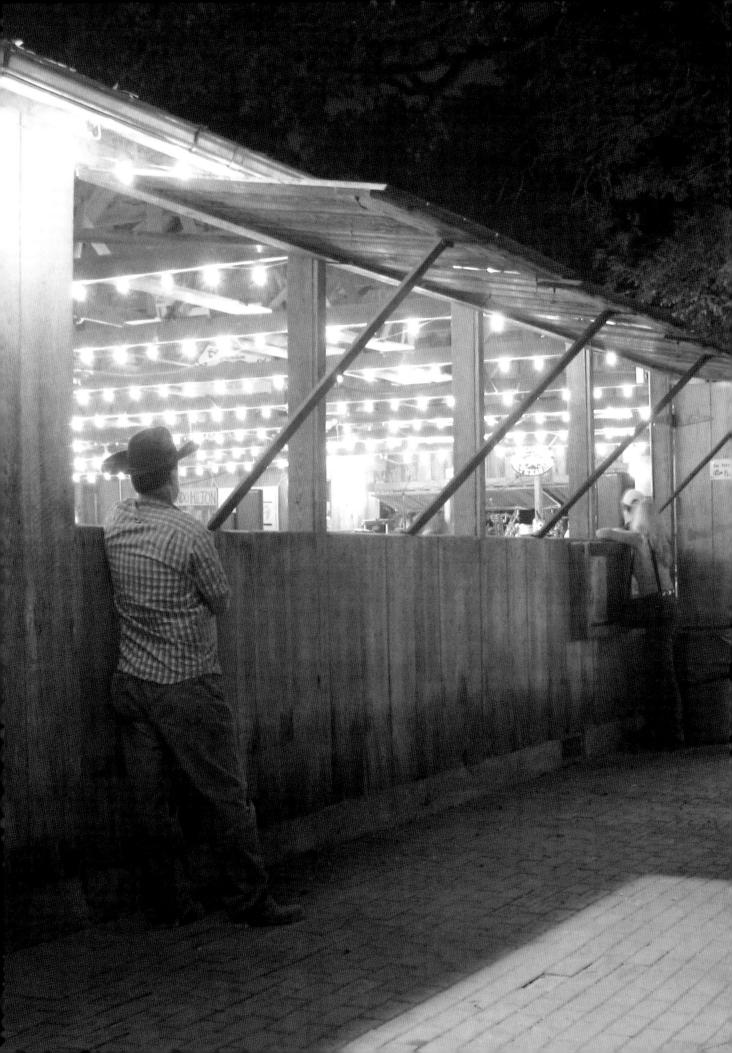

18 THE FUN EVERYBODY WANTS TO HAVE

■ *Luckenbach Dance Hall*

At Luckenbach Dance Hall, west of Austin toward the foothills of the Hill Country, the band Two Tons of Steel breaks into a rockabilly song. Kevin Geil holds a guitar at his hips and a microphone to his lips, driving eager pairs to the dance floor. I sit on a bench at the back of the hall and watch the couples whirl in tight circles. Benches like mine line the sides, while tables of seated men and women fill the middle. Through the open sides of the dance hall, oak trees dance in the night breeze.

A man with dark hair approaches two women dressed in matching light blue tank tops with the "Everybody's Somebody at Luckenbach" slogan written across them. The sound of the music, which rollicks in quick rhythms, drowns out the man's words, but I can tell he's asking one of the women to dance. She shakes her head and mumbles what looks like a "no thanks." The man walks back to his friend, who gives him a sympathetic look. The jilted man with dark hair catches me watching him, so I give him an "I'm sorry" glance. He mouths back words that look like "Do you want to dance?"

Stashing my notebook and purse

under the bench, I get up and follow him to the stage. He wears a t-shirt and jeans and is named Max. On the dance floor, my swing step is a little rusty and Max's is a little drunken, but we sway together anyway in wide arcs under the stage, some of our circles dangerously close to the other dancers. I take off a bracelet and stick it into the pocket of my jean skirt so it won't break when Max grabs my wrist for the fast turns. In between spins, I glimpse the small stand where band t-shirts and CDs are for sale. Another spin, I spot Marcus, a big grin on his face, crouched on the floor behind his camera to capture the colorful boots of the dancers. By the end of the song, I end up facing the stage, where Two Tons concludes its song in a final strum. With barely a break for the audience to clap, they dive into their next song, which is just as fast and tight as the one before it.

Back in my seat on the bench, I tap my boots to the driving sounds of this San Antonio band's first set. It's easy to hear the musical influences of Elvis Presley, the Ramones, Chris Isaac, and Johnny Cash. The band members, who include lead singer Kevin Geil, Dennis

Looking into Luckenbach Dance Hall before the music starts.

Fallon on electric guitar, Ric Ramirez on upright bass, Chris Dodds on drums, and Denny Mathis on steel guitar, have been together since 1991. In 1997, they changed their name to Two Tons of Steel after the Crickets of Buddy Holly fame contacted them about possible confusion with Two Tons' then-name, the Dead Crickets.

"It was a good time to change the name," Kevin tells me in a conversation before the show. "When we were called the Dead Crickets, people thought we were a punk band. I'm glad it got taken care of early on. To change the name now would be very hard." The band's current name, Two Tons of Steel, refers to a 1956 hardtop Cadillac that Kevin owned and sold. He hasn't had much time to work on cars lately, given the band's touring schedule. "It was hard to let go of the Cadillac and the Belaire," he says. "I'll get back to the old cars in the next few years, I guarantee it, not to work on them but to drive them."

Kevin, a slender man with sandy-red hair, describes the band's sound "countrybilly," a nod to both country music and rockabilly sounds. Their success over the past few years has expanded the locations where the band plays, from Texas honky-tonks to European concerts. Despite the more diverse venues, the band still feels at home in local dance halls like Luckenbach [pronounced LOO-ken-bock] and further south at Gruene Hall, where the band started playing its first dance hall shows.

"We had tried to play there [Gruene Hall] for a while, with no success," Kevin says. This changed when Pat Molack, the owner of Gruene Hall, saw the band at a local club in the San Antonio area and asked if they would open at Gruene for the well-known western swing band Asleep at the Wheel. Their performance as an opening act cleared the way for occasional afternoon shows

at Gruene, where Two Tons of Steel played for tips. "We built up a pretty good following and then started playing Friday and Saturday nights," Kevin says. Along with their weekend spot, the band secured Tuesday night shows that soon became known as "Two-Ton Tuesdays," which the band still plays each summer. The band recently made a live DVD and CD recording at Gruene Hall to capture this tradition.

"With Gruene, you have the river and the tourists; it's the perfect marriage. People want to have fun there, and that's what we want to do." Kevin looks across the wooden dance floor at Luckenbach; a breeze, Texas warm with a hint of autumn cold to come, whispers through the open sides of the hall. "With Luckenbach, it's the same thing," he says. "It's a historic dance hall; you can't get much better than playing here. The halls are legendary, and to be part of them on a regular basis is really good."

Away from home, Two Tons of Steel has played in the famous Grand Ole Opry in Nashville, as well as cities throughout Europe, including Paris, Geneva, and Barcelona. "The European fans are intense," Kevin says, adding that because the band's music is sold, played, and promoted there, the fans came to the show familiar with the music and the lyrics. He smiles and looks down at his hands, which are folded on the table in front of him. "They think you're a big star when you go over. It was the same thing when we toured Cuba seven years ago." During this trip, which inspired the song "Havana Moon" from the band's latest CD, Two Tons played for crowds of several thousand.

After playing their shows on the road, the band looks forward to their gigs at the Texas halls. "Our home base is the dance halls," Kevin says, glancing behind him as a pair of men onstage prepare for the show by adjusting the

Texas Dance Halls

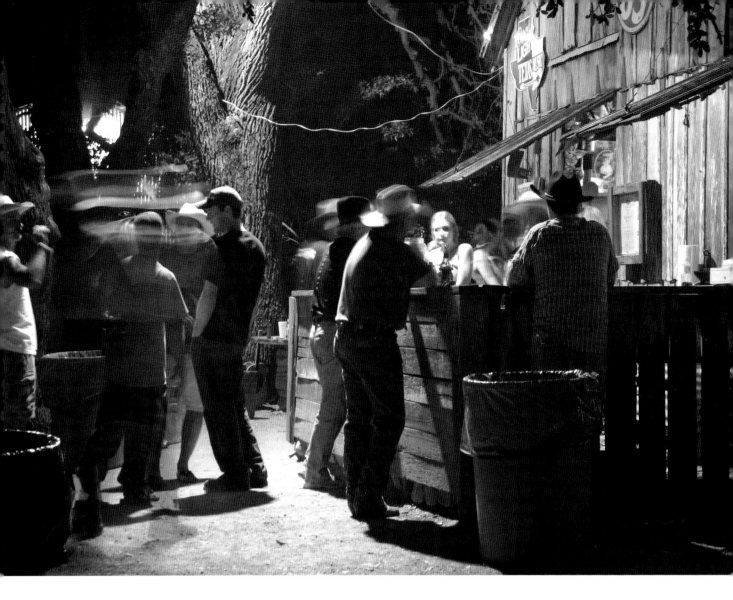

The bar behind the Lucken-bach General Store.

sound. Feedback squeals from a micro-phone. "Rock and roll," Kevin laughs.

"At least it's before the show," I say.

Kevin nods his head and smiles. "The dance halls are the real deal and can't be duplicated," he says. "You come in and drink a beer, sweat, and enjoy."

Before the show, Marcus and I toured the grounds at Luckenbach. The small com-munity, started with a post office in 1854, continues in self-contained style to the present day, made famous by the likes of Waylon Jennings and Willie Nel-son with their hit song "Luckenbach, Texas (Back to the Basics of Love)" as well as Jerry Jeff Walker and his Lost

Gonzo Band's 1973 live Luckenbach recording of the popular album *Viva Ter-lingua*. Willie Nelson's Fourth of July celebrations, which were held in Luck-enbach during the mid-1990s, helped add to the community's fame.

We walked through a country store and post office to a separate eating shack and bar area, all adjacent to the 1887 dance hall. Neal Brown, Luckenbach manager, told us that the blacksmith's shop and cotton gin, two of the oldest buildings in Luckenbach (circa 1873) were destroyed by a flood in 2002. On this Saturday afternoon, oak tree leaves shimmered in the day's last sun. Crowds from the women's chili cook-off held

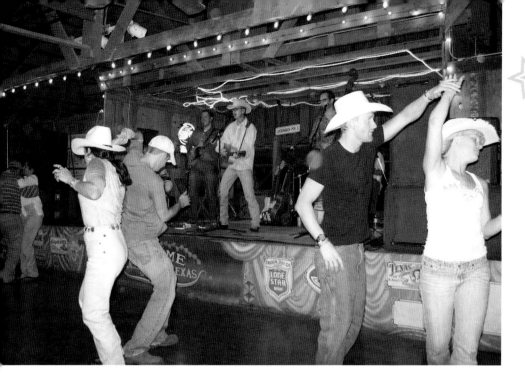

that afternoon lingered to share beers and stories. Bikers, wearing leather and do-rags, lounged at a picnic table next to the dance hall, their chrome bikes glinting in the afternoon light. A woman with long dark hair and skinny boots walked her restless pit bull past the table.

Marcus and I followed the sounds of karaoke warbling from a tent set up near the parking lot. The group onstage, who we guessed were part of a chili cook-off team, swayed and slurred the words of "Play that Funky Music" into the microphone. The lead singer of the group wore a baseball cat with horns that sprouted from either side of it. We watched for a moment before walking back to the dance hall.

I bought two cherry lime-aids at the food shack and followed Marcus inside the hall to find seats that gave us a clear view of the stage. The crowd around us ranged from kids in Luckenbach T-shirts to couples in their sixties and seventies, all eager to hear the band start up. Kevin had described their audience as a "crazy age mix, from twelve to seventy-two. College kids come see us, and then come back with their parents." I watched a five-year-old girl with long dark hair who kept checking the fluffy cocker spaniel that lay at her feet.

A warm-up act, singer-songwriter duo Jed and Kelly, took the stage first. Several couples around us rose from their seats and walked arm in arm to the dance floor. Fans outside the hall leaned across the short walls of the building as if they were looking through windows. Behind me, I heard a man in a black hat and t-shirt murmur "Texas is the best place on earth." I smiled and watched a pair of dancers, a man in tan pants and a girl in a green skirt, float across the floor.

At a table near my bench along the back wall, several friends in their twenties sat together in a group. The women wore matching red shirts and sandals; the men, jeans, boots, and black t-shirts. A man with dark bangs that fell around his face glanced at my notebook and leaned closer to look. "Are you keeping a journal?" he asked.

I told him about our dance hall project and learned that his name was Matt, that he came from Austin, and that he

was a property developer. He nodded his approval at our coverage of Luckenbach. "This place is my break-up therapy," he said. "My friends brought me out here tonight, and I've had the best time; it's taken my mind off of everything."

He turned to Marcus. "Can your camera take away these wrinkles?" he asked, pointing to his eyes and flirting.

"Not really," Marcus said, without offering more.

Stacy, a lawyer from Austin and part of Matt's support group, leaned in

onstage high. Ric's thick black glasses focus on his hands as he slaps the bass, while the guitar player's aqua-colored Fender guitar twangs, giving the song even more of a surfer feel. The band segues into a song called "Vegas," the title track of their new CD. Kevin, who writes the band's songs, says his wife, Elena, is his number one inspiration. "She likes Las Vegas and she likes to drive, so it just got in my head," he says. Kevin writes the melodies of his songs first; the words come later. The CD *Vegas* is number four on the Texas charts

A sign that Luckenbach can and does provide a brief refuge from any kind of storm.

closer. "From its history to its architecture, it's a beautiful place," she said. Her blonde hair stood out against the red background of her shirt. "It's a reset button," she added, looking at Matt, "no matter what's going on in your life."

Standing front and center in cream-colored shirt, jeans, and a cowboy hat, lead singer Kevin keeps the energy level

and number five on the roots music charts.

"I had planned to retire about three years ago," says Kevin, who is in his early forties; he and Elena also have two daughters. The other band members are in their thirties. "But it just gets bigger every year," he says. "Being with Palo Duro [Records] has been good for us," he says. "We've played in New York and played in L.A. We can't stop now."

From the back of the hall, I watch the girl with long dark hair, the one with the cocker spaniel, slump across her father's back. Her hair spills down his shirt in chocolate waves. Marcus still crouches at his place near the stage to catch both musicians and dancers on camera. While I'm mesmerized by the dancers, a tall man in a cowboy hat and white t-shirt leans across the wall from the outside and asks me if I'd like to dance.

The man, whom I learn is named Donny, leads me toward the dance floor. Two Tons of Steel plays a fast song that's a good example of their country-billy sound. Donny hesitates before taking my hand. "Not sure how we'll dance to this one," he says. While some couples two-step, others jitter bug. We choose the two-step, navigating between the faster dancers twirling in frantic circles around us. With every slow spin, I catch a glimpse of the band onstage, the t-shirt table with its display of new CDs, or Marcus taking more pictures.

When the song ends, Donny turns my hand over to Uncle Rob, a man in his fifties with a baby blue colored shirt. He wears a hat that looks like a cross between a cowboy hat and a fedora. I'm not sure if Uncle Rob is related to Donny, or it's just a nickname, so I smile and keep dancing. Uncle Rob's eyes stay wide open in a look of half-surprise. I two-step half the song and jitterbug the rest. People on the sidelines, who must be Uncle Rob's friends, laugh and give my dance partner friendly slaps on the arm as we pass by. Later in the song, I take the lead, cuing Uncle Rob when I want to spin or avoid another pair of dancers. At the end of the song, I thank Uncle Rob for the dance; he bows in return.

Uncle Rob doesn't really dance, Donny tells me later. "He's just crazy and trouble."

"Is he really your uncle?" I ask.

Donny shrugs without committing himself. "He's the fun everybody wants to have."

The band starts up with "Havana Moon," filling the dance floor with couples ready for a slow-dance number. Though Two Tons keeps the dance floor full on this night, Kevin doesn't necessarily write the band's music with dance halls in mind.

"The halls don't influence our music [directly]," he explains. "But if you're playing dance halls, it usually means you're playing more traditional music, with acoustic bass, steel guitar, and acoustic guitar." Two Tons uses all these instruments as part of its country sound, while their high energy leads to danceable, jitterbug rhythms. In terms of writing the music and lyrics, Kevin stays true to the band's blended countrybilly style without analyzing it too much. "I know what I like," he says.

Kevin grew up the youngest in a family with four brothers and one sister, almost all of them playing the guitar. "There's music that runs through us, but we're not a big musical family," he says. His great-great-grandfather was a violinist in the St. Louis Symphony in 1862. "Along with my first guitars, I have the violin," Kevin says, "and my brother's accordion." Kevin never studied music or took lessons, letting it come natural instead. "My dad played my great-great grandfather's old violin when he was young, until everyone figured out the violin was valuable. After that, it got taken away from him and put away in the attic." When Kevin's dad passed away, Kevin inherited the violin.

During a break between songs, Kevin waves his arms above his head and calls out "Two Tons!" to the audience. The crowd echoes back with their own cry of "Two Tons!" Some fans wave their arms at him. "Two Tons is our chant," Kevin

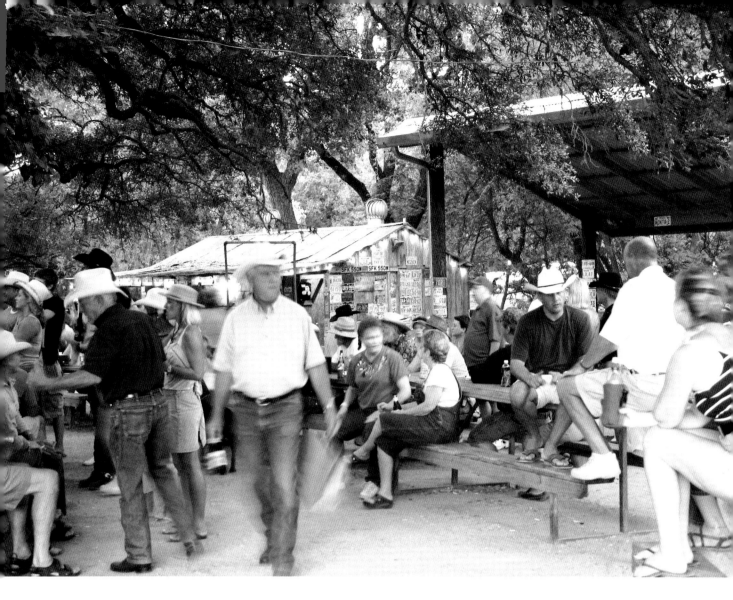

Luckenbach visitors linger before the dancing starts.

says. "I don't know where it comes from, it's just part of the show."

"Two Tons!" Kevin yells once more to the crowd. "Two Tons!" the crowd fires back. The band responds by launching into another song with a punchy feel that crowds the floor with dancers. Marcus joins me at the back of the room, and together we watch couples scoot, spin, and slide across the floor.

"We'll take a break and be right back," Kevin promises after the song ends. Band members leave their guitars in careful rows onstage and step down to the dance floor. Behind the t-shirt counter, they sign CDs for waiting fans,

me among them. I walk to the back of the dance hall and show Marcus my copy of the CD along with a band poster. He nods and untangles the camera from around his neck.

Donny saunters up behind us to ask if we need anything to drink, but I'm still nursing a Shiner, and Marcus has a bottle of water. We watch the women in light blue Luckenbach t-shirts laughing together. "You both need to get t-shirts," Donny says.

I consider the familiar design of this popular shirt. "I like it. But is it right to wear a t-shirt at the place where it's from?"

Luckenbach Dance Hall

"Sure," Donny says, giving me a "why not?" look. He walks outside to get a fresh beer.

"When do you want to go?" Marcus asks.

"This might be a good time," I say, although my heart's not in it. Most of the dance hall crowd stays in the hall, while a few others venture out to the beer stand with Donny. The food shack next to the dance floor still has a few customers who've worked up an appetite for burgers and fries.

"I've just gotten word it's last call for hamburgers," Kevin announces over the microphone. At midnight, Marcus and I wander outside the dance hall and sit on top of a picnic table, the same place the bikers had sat together earlier. A few Hogs are still parked in a shiny row close by.

"We can stay awhile," Marcus offers, setting down his tripod to prove it.

"A few songs," I say. My smile curls upward. The band members, some inside the dance hall and others on the grounds outside, mingle with the crowd. About twenty minutes after they end their first set, they're ready to perform again, bantering with the crowd over the microphone as they climb back on stage and listen to a few song requests.

"In a world where so many things are going on, it's good to know there are some things that haven't changed," Kevin told me earlier. "Americans change things, whether they need to or not. [With dance halls] a band can still roll in, set up on stage, and people will dance. It's good to know that's still available."

Donny, who's been outside talking to one of the girls in the light blue shirts, walks up to our picnic table, sets down a beer, and asks us how things are going.

"We're taking off pretty soon," I say.

He shakes his head and gives me a teasing look. "Not before you dirt dance," he says.

"What's that?" I peer into his mustached face, half-hidden under the cowboy hat.

"It's dancing outside, on the dirt." Donny takes my right hand. I put my left hand on his shoulder, and we two-step in the mix of dirt and grass just outside the dance hall, matching the cadence of the dancers inside. Through the open sides of the hall, we hear the band playing "King of a One Horse Town," a song from an earlier CD. Marcus snaps a few photos of our cowboy boots in the dust.

With a final twirl at the song's end, I thank Donny and drift back to the picnic table and Marcus. Donny looks straight at Marcus. "You need to dance, too," he says.

Marcus laughs. "No, I don't."

But it's too late. Donny has already asked one of his friends, Debbie, to be Marcus' dance partner. Marcus and I both reach out to catch the tall brunette as she begins a slow, drunken fall against our picnic table. Debbie recovers and stands up straight. Without a word, she takes the camera from Marcus' neck, places it on the picnic table, and leads Marcus inside the hall. On the dance floor, they spin in slow circles, both smiling. I grab Marcus' camera to take a picture of their dance from outside the hall, but end up capturing a collection of beer bottles on the closest table by mistake.

We can't top these last dances, Marcus' inside the hall and mine in the dirt outside and decide to head back to the place we're staying in Junction. After saying goodbye to Donny, who chats up another blue-shirted woman under an oak tree, we walk to the field where we'd left the Beetle. Marcus takes a few more pictures of signs sprinkled around the property. Two Tons' music follows us through the open sides of the dance hall. I walk extra slow to the car, making the night last.

Two Tons of Steel at the opening of their set. They are (left to right) Denny Mathis, on steel guitar, Dennis Fallon, lead guitar, Kevin Geil, lead singer, Chris Dodds, drummer, and Ric Ramirez, on upright bass.

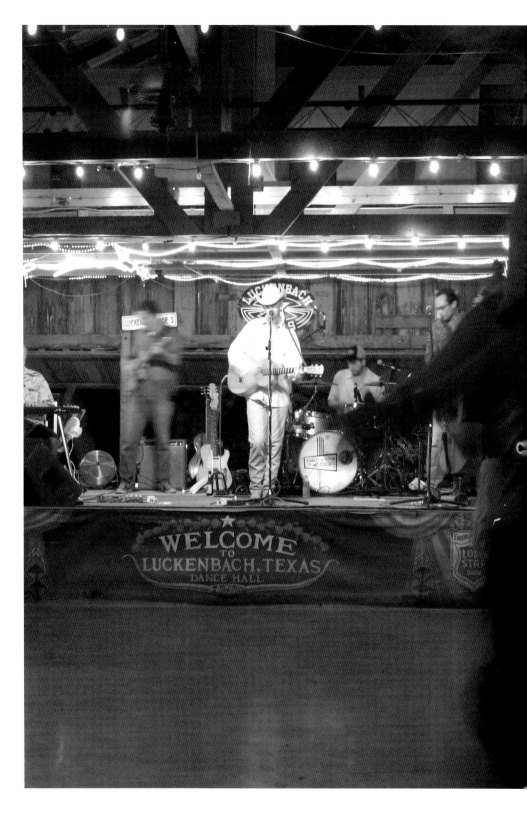

AFTERWORD

The Beetle crunches over a country road toward the highway, the sun already grinning from a point high overhead. I drive away from Junction, where we'd stayed for the night. Marcus and I should've been happy it was our last dance hall trip, but we're silent. I watch gray pavement narrow to a dot far ahead. Between the three of us, John, Marcus, and me, we'd logged hundreds of miles on our dance hall drives across Texas. The halls that a friend introduced me to and that John helped me understand from a musician's viewpoint kept Marcus and I busy for a year-and-a-half of badly creased maps, dusty roads, and interesting people.

Grasses whip outside the window, green and wispy with late summer rains as we take Highway 83 back north to West Texas. Soon, flat plains will replace the rolling hills, interrupted by the occasional mesa and the giant, free-standing wind turbines that never fail to surprise us on the bluff outside of Sweetwater. Along with finishing our dance hall research, we've also finished the Starburst candies that Marcus so wisely brought for our trip.

"Maybe we should stop and catch a few more," I say. He nods, knowing I

A reflection of Folkins at Dubina Dance Hall.

don't mean candies. As far as Texas dance halls go, we've just skimmed the surface. We never made it to Anhalt Hall in New Braunfels, a hall that TC suggested, or Possum Creek up in Williamson County, a venue where John performed several times. We could have tackled the German beer garden in Walburg, the site where John and I were married. There was also Nelson City Dance Hall, near San Antonio, a hall with slogans like "Texas' Best Kept Secret" and "The Newest Oldest Dance Hall."

"There's a lot more we could do," Marcus agrees. He stares out the window, pointing his camera at the scenery that rushes by too fast. We pass through communities like Eden and Menard. I squint at their main streets as we pass through, looking for a hidden dance hall behind the store facades. Window shoppers pass the store fronts in slow steps. I want to pull over and ask them if they've been to a dance hall, what stories they have to tell.

Marcus stares at something beyond the buildings. Our silence reminds me of my drives with John, where conversation makes the time pass but just keeping the driver company, even without words, is enough. I remember John and I driving

after a Bandera gig, two-and-a-half
hours straight to his parents' house. A
native Texan, John is used to folding up
his gear, buying a Code Red from the
nearest convenience store, and finding
home on remote roads that take an
hour's drive or more. It gives him time
to think, he tells me. This year, instead
of driving Texas roads, John is learning
stringed instrument repair in Minnesota
while I finish my work at Texas Tech.

Marcus fiddles with his camera, tak-
ing pictures of flowers, mesas, and
horses grazing along the road. He'll
have plenty to do in Lubbock, from
shooting more pictures to honing his
prose poems as part of a dissertation in
English. We're not sure where any of us
will be working when we graduate and
bounce around the idea that we could
end up in Europe writing a book about
castles.

I settle back into the Beetle and sing
along with Sheryl Crow—Marcus
doesn't mind. I smile at this freedom. Just
when you slip into a rhythm of things,

like school, a job, or dance halls, it's time
to start something new. I think back on
our conversations with dance hall
owners and friends, how several of them
told us to come back sometime, forming
an ever-expanding dance hall community.
I remember asking Little Joe about
musical styles and getting a box of CDs
in the mail a few days later or Terrie at
Saengerhalle, who chatted with us on a
Friday night and was just as gracious
when we showed up the next day for
afternoon photos. Or Raymond, who
didn't mind that I called him during a Sat-
urday afternoon football game to ask a
few more questions about his times with
Elzy growing up at London Hall.

Despite thoughts that linger behind
us, the Beetle takes an insistent course
north, aiming for Sweetwater without a
stop. I don't slow her down, lest we're
tempted to turn around. I smile and
imagine the car swerving back to dance
halls where music keeps its rhythms
strong, past and present dancing a Texas
two-step.

SOURCES AND FURTHER READING

Barkley, Roy R., ed. *The Handbook of Texas Music*. Austin: Texas State Historical Association, 2003.

Austin County Historical Commission. *Dance Halls of Austin County*. Austin: Austin County Historical Commission, 1993.

Billington, Barbara. Interview by Gail Folkins. Stamford, TX, September 5, 2005.

Blaylock, Raymond. Interview by Gail Folkins. Tape recording. London, TX, September 30, 2005.

Calhoun, Ron. Interview by Gail Folkins. Austin, TX, August 12, 2005.

Carr, Joe, and Alan Munde. *Prairie Nights to Neon Lights*. Lubbock: Texas Tech University Press, 1995.

Cashdollar, Cindy. Phone interviews by Gail Folkins. February 22 and April 25, 2005.

Chase, Terrie. Interview by Gail Folkins. Tape recording. New Braunfels, TX, March 11, 2005.

Clifford, James. *The Predicament of Culture*. Cambridge: Harvard University Press, 1988.

———. *Routes*. Cambridge: Harvard University Press, 1988.

Dance Hall Directory. *Honky Tonk Texas, USA*. (February 28, 2006), http://www.honkytonktx.com/dancehalls (accessed September 21, 2006).

Geil, Kevin. Interview by Gail Folkins. Tape recording. Luckenbach, TX, October 1, 2005.

Hartman, Gary. Phone interview by Gail Folkins. May 2, 2005.

Hartmann, Helmut. Interview by Gail Folkins. Austin, TX, June 11, 2005.

Hernandez, Joe DeLeon. Interview by Gail Folkins. Waco, TX, June 17, 2005.

Heide, Jean M. "Celebrating 'Das Deutsche Lied' in Texas." *The Journal of Texas Music History* 3, no. 2 (2003): 29–38.

Holck, Manfred. *A Century of Singing "Das Deutsche Lied" Austin Saengerrunde 100th Anniversary*. Austin: Manfred Holck, 1979.

Isle, William. Interview by Gail Folkins. Waco, TX, June 18, 2005.

Janecke, Ed. Interview by Gail Folkins. Dubina, TX, May 15, 2005.

Jensen, Joan M. "I'd Rather Be Dancing: Wisconsin Women Moving On." *Frontiers: A Journal of Women Studies* 22, no. 1 (2001): 1–20.

Kelso, Kathleen. Interview by Gail Folkins. Coupland, TX, August 27, 2004.

Kohutek, Adeline, Beth Rabrocker, and LaVerne Vanicek. *Lodge #47 SPJST Seaton Star Hall Hveza Texasu Centennial 1903–2003*. Seaton, TX: SPJST Lodge, 2003.

McBee, Randy D. *Dance Hall Days*. New York: New York University Press, 2000.

McKee, Gary. Interview by Gail Folkins. Tape recording. La Grange, TX, May 15, 2005.

Moore, Ora Mae. Interview by Gail Folkins. Schulenburg, TX, June 19, 2005.

Moore, Robert. *The History of Wright's Park*. Schulenburg, Texas: Robert Moore, 1998.

Morris, Nick. *A History of the SPJST: A Texas Chronicle.* Temple, Texas: Slavic Benevolent Order of the State of Texas, 1984.

Morthland, John. "Come Dancing." *Texas Monthly* 23, no. 3 (March 1995): 78–85.

Pechal, Edwin. Interview by Gail Folkins. Seaton, TX, August 28, 2004.

Peña, Manuel, *Música Tejana: The Cultural Economy of Artistic Transformation.* College Station, Texas: Texas A&M Press, 1999.

Porter, Glynis. Interview by Gail Folkins. Swiss Alp, TX, February 5, 2005.

Stokes, Martin. "Ethnicity, Identity, and Music." In *Ethnicity, Identity, and Music: The Musical Construction of Place,* edited by Martin Stokes. Oxford, England: Berg Publishers, 1994, 5.

Sulak, Alice. Interview by Gail Folkins. Seaton, TX, May 12, 2005.

Taylor, TC. Interview by Gail Folkins. Twin Sisters, TX, November 1, 2003.

Tietjen, Marian. Interview by Gail Folkins. La Grange, TX, December 30, 2004.

Trevino III, Geronimo. *Dance Halls and Last Calls: A History of Texas Country Music.* Plano, Texas: Republic of Texas Press, 2002.

White, James. Interview by Gail Folkins. Austin, TX, March 12, 2005.

ACKNOWLEDGMENTS

Thanks to John Koehler and TC Taylor and 13 Days for their inspiration on the dance hall tour and to all the dance hall owners, musicians, and fans who so graciously shared their stories. Thanks to Dennis Covington, whose nonfiction class gave this work a start and whose guidance furthered it; Jill Patterson and Rebecca Rickly for creative wisdom and encouragement; and J. Marcus Weekley for the complement his photographs create. Thanks to Margaret Lutherer, Texas Tech University Press, and Andy Wilkinson for their support; our families, for their support; and our friends in Texas, whose doors are always open. The hospitality of the TTU campus in Junction and the TTU Graduate School's Summer Dissertation Award both assisted in the completion of this work.

Portions of the Introduction and Chapters 1, 5, 6, 11, 16, and 18 appeared in *Texas Co-op Power* and *The Journal of Texas Music History*. Some photos appeared in *Boxcar Poetry Review*.

Raymond Blaylock, of London, Texas, passed before this work was complete; may his dance hall friendship and memory live on.

INDEX

Page numbers for images are indicated by italics.

accordion, xvi, 50, 118, 120, 180

Americana. *See* Texas music

Ammannsville, 45–48, 153

Asleep at the Wheel, xvii, 85, 105, 112–113,
 115, 174

Austin, 6, 15–16, 18, 61, 80, 85–87, 92, 98–100,
 102, 105, 115, 119, 121, 147, 165,
 170–171, 173, 176–177

Austin Saengerrunde. *See* Saengerrunde Hall

Bandera, 25, 186

Barons, The, 16, 18

Beam, Elzy, 36–42, *43*

Billington, Barbara, 57–58, 62, *63*

Blanco, 3, 121

Blaylock, Raymond, 36–42, *43*, 186, 189

Boerne, 4, 25

Bowling alleys, 96–97, *98*, 103, 166–167, 169, *171*

Bowling for Soup
 "Come Back to Texas," 25

Broken Spoke Bar and Restaurant, 85–93
 Rowdy, 87–88, 91
 "Tourist Trap" Museum, 86–88

Brown, James, 4, 119

Buda, xvii, 165, 168, 171

Calhoun, Ron, 55–63

Calmbach, Ricky, 168–169

Cash, Johnny, 139, 173

Cashdollar, Cindy, 105, 107, 110–115, *111*
 Slide Show, 115

Chase, Eric, 135–144

Chase, Terrie, 135–143, *136*, 186

Club 21, 165–171

conjunto. *See* Texas music

Corzine, Louis, *56–57, 59–60*, 62, *63*

Cosmic Dust Devils, xvii, 95

country. *See* Texas music

Coupland, 73–83

Coupland Dance Hall, *72, 73*–83
 inn and restaurant, 75–77, 80, 82

Crow, Alvin, 88–91
 Honkytonk, 91

Dance floor salt, xiii, 5, *129,* 140

Derailers, 81, 87, *89,* 90–92

Dixie Chicks, 105, 111

Dubina, 45, 48–51, 185–186
 Piano Bridge, 52
 Saints Cyril and Methodius Church,
 49, *51*

Eaglesmith, Fred, 143, *144*

Fajkus, Bobby and Dorothy, 47–48

Flag Hall, 3, 11, 70

Freyburg, 45, 52–53

Geil, Kevin, 173–*183*

Goodale, Michael, 26, 29, *29, 31*

Graham, Bret, 106, 112, *114*

Gruene, Ernst, 106–107

Gruene Hall, xv, *xv,* xvii, 6, 105–115, *108,* 118,
 174

Hartman, Gary, xiv
Hartmann, Helmut, *96–103, 99*
Helms, Bobby
 "Fraulein," 5
High Hill, 53
 St. Mary's Catholic Church, 53
Hilltop Hacienda, *24, 25–33*
Houston, 9, 15, 18, 52, 99, 123, 137, 147, 149,
 152, 161

Indian Springs Park, 117, 120–121
Isle, William, *166, 167–169*
Ivy, Billy, 35, 41

Janecka, Ed, 49–51
Jerry Haisler and the Melody Five, 127, *131,*
 133
Jones, Justin, 135, 138–140
Junction, 26, 39, 42, 182, 185, 189
 TTU Field House, 42
Juneteenth, 155–162

Kelso, Kathleen, 74–76, 80–83
Kelso, Larry, 74–75, 81, 83
KJT, *44, 45–49*

La Grange, 15, 45, 53, 65, 66, 147–153, 159,
 161
 Chicken Ranch, 147, 153
Little Joe y la Familia, xvii, *116, 117–123,* 186
 Down for the Barrio, 122
London Dance Hall, *34, 35–42*
 Hunter's Ball, *36,* 39, 42
Luckenbach, xvii, 31, 105, *172, 173–182, 183*
"Luckenbach, Texas (Back to the Basics of
 Love)," 175

McKee, Gary, *22,* 45–53, 147–153, 155–156
Miller, Glenn, 16, 152.

Nelson, Willie, 88, 90, 115, 175
New Braunfels, xiii, xvii, 101, 105, 106, 185

Oeltjen, Sarah and Walter, 150–153
O'Keefe, Danny
 "Good Time Charlie's Got the Blues,"
 31

Palo Duro Records, 9, 177
polka. *See* Texas music
Pechal, Edwin, 4, 65–71, *66, 67, 68*
Pettit, Lonnie, 52–53
 Von Minden, 52

Presley, Elvis, 15–16, 29, 58, 173

Round-Top Brass Band, *46, 47–48*
Round-Up Hall, *146–153*
Roundup Hall, 55–63
 Old-Timers Association, 55–57

Saengerhalle, 105, *134, 135–145*
Saengerrunde Hall, *94, 95–103*
 Austin Saengerrunde, 98–103
 Scholz Garden, 97, 99, 102–103, *103*
Saulle, Bob and Shirley, 137–138
Schulenburg, 45, 52–53, 148, 152–153, 155,
 158–159, 161
Seaton, 65–71, 125, 133
Seaton Star Hall, *64, 65–71*
Sefcik, Joseph, 65–69
Sefcik Hall, *124, 125–133*
Skynryd, Lynyrd
 "Sweet Home Alabama," 9
SPJST, 49, 65, 68–71
Stamford, 55–63
 Texas Cowboy Reunion and Rodeo,
 61–62
Strait, George, 70, 88, 105, 111, 126, 169
Sulak, Alice, *124–133, 131*
Swiss Alp Dance Hall, *12, 13–23*

TC Taylor and 13 Days, xiii, xiv, 3–11, *25–33,*
 65, 75, 81, 133, 189
 Baum, Doug, 6–7, 10–11, 25–33, 127
 Birch, Dale 6, 127
 Koehler, John, *vii,* xiii–xvii, 6–11,
 25–33, 35, 65, 71, 75, 85, 90, 95, 96,
 98, 103, 125–130, 185–186, 189
 Mathis, Kyle, 6–11, 27–33
 Putting the Western Back in Country, 6
 "She's in the Bedroom Crying," 5
Temple, 3, 4, 30, 65, 71, 117, 119, 127
Texas dance hall history
 German and Czech, xiv, xvi, 45
 multicultural influences, xvi
Texas music
 Americana, 6, 9, 95, 105, 107, 131
 big band, xvi, 107, 119, 148
 blues, 105, 110, 119, 121, 155, 161
 conjunto, xvi, 118
 country, xiv–xvii, 3–9,15–16, 28, 36,
 40, 51, 57, 85, 100, 105–107,
 110–111, 119, 131, 135, 139, 143,
 147, 149, 166, 168–171, 174, 180
 Dixieland, 15
 history, xv–xvii

Index

honky-tonk, xi, xvi, xvii, 6, 85, 112, 174

jazz, xvi, 107, 119

polka, xvi, 7, 46, 47, 51, 70, 118, 131

rock, xiv, xvi, 9, 11, 13, 15, 16, 18, 19, 28, 51, 110, 112, 113, 131, 139, 148, 175

rockabilly, 173, 174

Tejano, xvi, xvii, 57, 117–119, 123

western swing, xvi, xvii, 16, 40, 85, 105, 107, 110, 112, 115, 119, 173, 174

zydeco, xvi

Texas Top Hands

"Bandera Waltz," 85

Thomas, B.J., 15

"Raindrops Keep Falling on My Head," 148

Tietjen, Darryl, 13, 16, 18–19, 22–23

Tietjen, Egon, 13–15

Tietjen, Glynis (Porter), 13–22

Tietjen, Marian, 13–19, *22*

Triumphs, 13, 148

Twin Sisters, *xii*, xiv–xv

Twin Sisters Dance Hall, *xii*, xiv–xv, *2*, 2–11

Two Tons of Steel, 173–182, *183*

"Havana Moon," 180

"King of a One-Horse Town," 182

"Vegas," 177

Uhland, 165–171

Ustynik, Kevin and Donna, 19

Victoria, 15, 117, 123

Walburg, 4, 100, 185

western swing. *See* Texas music

White, Annetta, 85–87

White, James, 85–92, *88*

Wills, Bob, xvi, 7, 15–16, 56–58, 81, 88, 107, 112, 168

Winter, Johnny, 16, 148

Wright's Park, *154*, 155–162, *163*

Wright, Ora Mae, 156, 158–162

Wright, Robert, 155–162

Voice in the American West

You cannot step twice into the same river; for other
waters are ever flowing on to you.
HERACLITUS

It is the confluence of differences, in its lands and peoples, that forms the American West. The book series Voice in the American West seeks the headwaters from which the West arises, its stories in first person and in every iteration of voice, in images as well as words, in line and color as well as sound and speech.

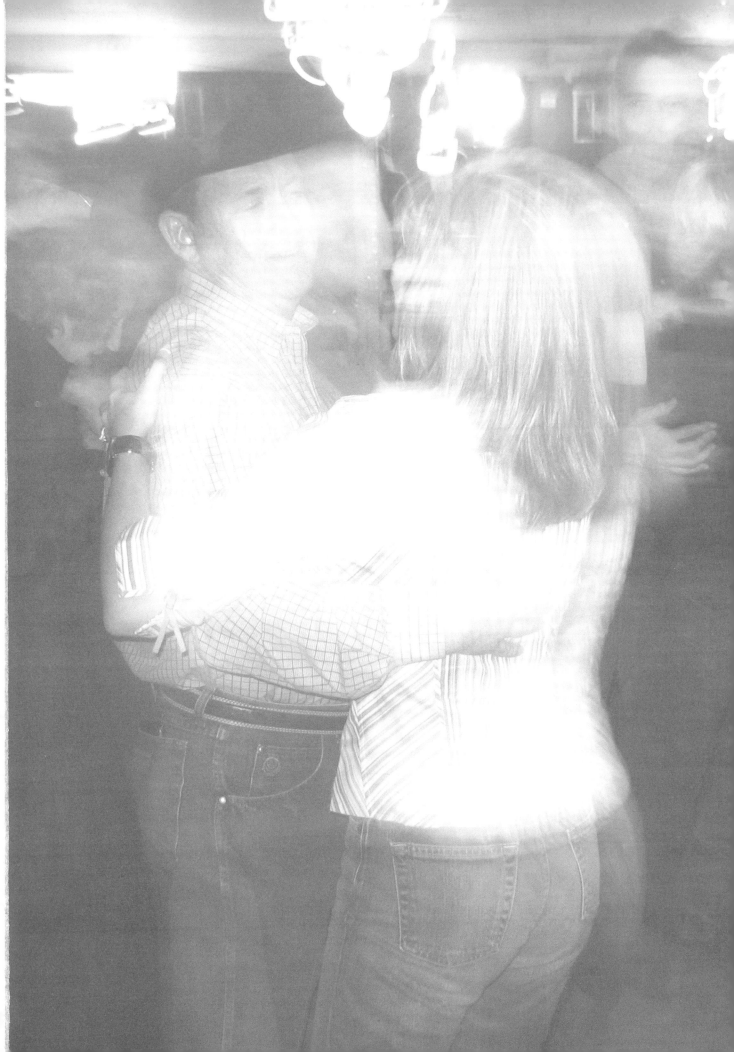